D1314775

The Johns Hopkins Studies in Nineteenth-Century Architecture

The Johns Hopkins Studies in Nineteenth-Century Architecture

GENERAL EDITOR
PHOEBE B. STANTON

ADVISORY EDITORS
PETER COLLINS
HENRY-RUSSELL HITCHCOCK
WILLIAM H. JORDY
NIKOLAUS PEVSNER

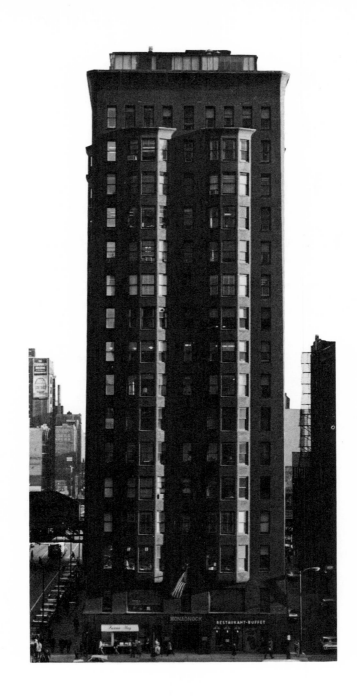

The Architecture of JOHN WELLBORN ROOT

Donald Hoffmann

The Johns Hopkins University Press

Baltimore & London

The Johns Hopkins University Press, Baltimore, Maryland 21218
The Johns Hopkins University Press Ltd., London

Library of Congress Catalog Card Number 72-4008
ISBN 0-8018-1371-9

Library of Congress Cataloging in Publication data
will be found on the last printed page of this book.

Frontispiece: *Monadnock Block. Jackson Street elevation.*
Photo by Richard Nickel.

Page xix: *Portrait of John Wellborn Root. Courtesy of*
the late Mrs. John W. Root II.

CONTENTS

LIST OF FIGURES

LIST OF FIGURES

PREFACE

This study is simply an attempt to recover some facts and thoughts and feelings about a body of architecture which already has become astonishingly remote. Too many years had passed without any intensive investigation of John Root's achievement. He was beyond the pale of living memory. I can nevertheless treasure the memory of his younger daughter, and the memory of my grandfather, whose work was in ornamental iron and bronze, and who spoke of his visits on Sunday mornings to a cabin on the Twin Peaks; there, sharing his remarkable enthusiasm, Daniel Burnham would unfurl his grand plans for the city of San Francisco.

It would be tedious to acknowledge every source of help, for this study has meant travel to more than twenty cities and it has drawn on the resources of some thirty-five libraries; but I must express my indebtedness to Mrs. C. L. Rast, formerly reference librarian of the Burnham Library of the Art Institute of Chicago; to Miss Ruth E. Schoneman, librarian of the Ryerson and Burnham Libraries; and to Mrs. Paul M. Rhymer, curator of prints at the Chicago Historical Society. And also to Mrs. David Crandall, formerly of the New York Public Library; to George E. Pettengill, librarian of the American Institute of Architects; to Mrs. John B. Lyon of Atlanta; to E. S. Fetcher of St. Paul; to A. M. Rung of Chicago; and to Miss Gwynne Bujarski, formerly of San Francisco. Among the scholars who so freely offered their help are John M. Hoffmann, Jon A. Peterson, and George B. Tatum; and among the architects are Edward B. Histed, Harry F. Manning, and Mr. and Mrs. Theodore Seligson.

In gathering the illustrations, I was particularly fortunate in having the help of William H. Sims, an expert in the photographic studio, and of Richard Nickel, whose concept of honesty in architectural photography set a very high standard.

Finally, this study would not have been finished without the assistance of a grant-in-aid from the American Council of Learned Societies and of a fellowship from the National Endowment for the Humanities; and it might not have been sustained without the encouragement of several of those scholars who have been the pioneers in the study of late nineteenth-century American architecture.

The *Architecture* of
JOHN WELLBORN ROOT

*The business buildings of
Burnham & Root were the first
tall buildings in which the
conditions both of commercial
architecture in general and
of elevator architecture
in particular were
recognized and expressed.*

—Montgomery Schuyler, 1895

*Yes, we made all these
buildings together, but they
are chiefly his, for he it was
who did the designing. . . .*

—D. H. Burnham, 15 January 1891

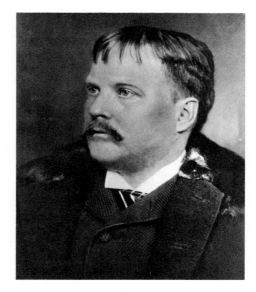

I · THE FIRST THIRTY
YEARS: 1850-1879

There were only two parts to the career of John Wellborn Root, the first thirty years and the last eleven. Almost all his buildings belonged to the short period after 1879. His early life, by contrast, was leisurely enough. And as his professional life began to unfold, its course seemed influenced to an unusual degree by outward fact and fortuitous circumstance.

He was born in the small town of Lumpkin, Georgia, on 10 January 1850. Mary Clark Root, his mother, was the daughter of plantation owners. She named him, in a fashion, after Marshall Johnson Wellborn, an uncle who had distinguished himself by taking a seat in the House of Representatives in the spring of 1849. Five weeks after the birth of his namesake, Wellborn rose from that seat and, in what was evidently his finest performance during the Thirty-first Congress, delivered an oration in defense of slavery. As a lawyer and former judge of the Georgia Superior Court, he found it reasonable to assert that the character of property in slaves was supported by the Constitution and that government had no right to propagate dubious moral creeds; "fanaticism," he said, "however ingenious, is proverbially impracticable."[1] Near the end of the Civil War, he underwent a mystical conversion. In a moment of ingenious fanaticism, he gave up the practice of law and pledged himself to poverty; he was later ordained a Baptist minister.

On the paternal side there was rather more promise. The Reverend Lucius Root, a preacher in Illinois, once wrote that the Root men generally were good mathematicians and good musicians, and notable "for sarcasm;

[1]*Appendix to the Congressional Globe*, XIX, pt. 1 (Washington, D.C., 1850), p. 110.

a strong anti-humbugitiveness."[2] Sidney Root, the father of John Root, arrived in Lumpkin from the North. His ancestors had come from England in the 1630s. Through eight generations they had moved slowly northward along the valley of the Connecticut River, settling in Hartford, Northampton, Hatfield, and Montague before reaching Craftsbury, Vermont, where Sidney Root was born in 1824. Sternly directed into the business world by his father, Sidney Root was successful in Lumpkin as a dry goods merchant, but he never forgot that he had once wished to become an architect. In spare moments, he wistfully pursued the aesthetic—even today he is remembered in the family for having designed the household silverplate. There is little doubt that he transferred his ambitions to his first son. Nothing about this, of course, was odd, except that he seemed to think of architecture as an escape from the world of commerce.

Sidney Root left Lumpkin for Atlanta, where he gave his son not only a piano but a drawing studio as well. For the first ten years John Root was educated at home, like Ruskin. He gained at least that basic respect for daily life which was to distinguish him, under the graying sky of Chicago and amid what Ruskin so nicely called the hurry of crowds and crash of innovation, as a man of rare amiableness and grace. At the time of the Civil War, Sidney Root was marked by loyalties rather more personal than political; he reaped profits from blockade-runners. On one such ship, in October 1864, his older son was to escape the South and the threat of conscription. For in September the city had fallen to General Sherman, who ordered the evacuation of the entire population. "If the people raise a howl against my barbarity and cruelty," Sherman wrote privately, "I will answer that war is war, and not popularity-seeking."[3] John Root arrived in Liverpool in November, and was welcomed at the house of one of his father's correspondents.

In no other city could he have encountered such a splendor of commercial architecture. "The wharfs are built of solid granite and surrounded by tall warehouses . . . the streets are lined with handsome buildings," he wrote on 17 November.[4] He was perceptive and precocious (Fig. 1), and he found Liverpool a grave and virile city, built from granite, brick, and cast iron. The city, indeed, could claim the prototypes of the most characteristic structures of the nineteenth century: the Brunswick Buildings of 1843 as the

[2] See James Pierce Root, *Root Genealogical Records, 1600–1870* (New York, 1870), p. 31.

[3] *Memoirs of Gen. W. T. Sherman*, 4th rev. ed., 2 vols. (New York, 1891), II, 111.

[4] As quoted by Harriet Monroe, *John Wellborn Root* (Boston and New York, 1896), p. 10.

Fig. 1. John Root in England, about 1865. Courtesy of Mrs. Denise Root Bertha.

3 FIRST THIRTY YEARS: 1850 -1879

earliest office block apart from factory or warehouse, and the Crown Street Station of 1830 as the earliest train shed. The great warehouses, walled in sweeps of brick and often bounded with bullnosed angles, presented a masonry architecture of monumental simplicity, while the office blocks that were penetrated by internal courts hinted at a spatial development rarely attempted even today. If in walking the streets Root came upon the Oriel Chambers or the building at No. 16 Cook Street—those strange creatures conceived by Peter Ellis, Jr., and constructed of plate glass and iron—he could hardly have forgotten either.[5]

He studied for a year and a half at the Clare Mount School in Wallasey, across the River Mersey, where the headmaster was the Reverend W. C. Greene. His letters home became self-consciously romantic and even religious in timbre. In June 1866, at the Liverpool center, he sat for the Oxford examinations and placed in the second division of the pass list by satisfying the examiners in preliminary subjects, rudiments of faith, mathematics, and English. He performed particularly well in drawing, although his lack of talent in rendering the figure still is evident in a delineation of 1872 for Peter B. Wight. Having gained the Senior Oxford Local Certificate, he was qualified to receive the title of Associate in Arts; but he was called home—his family by now was living in New York—and, in September 1866, was enrolled as a sophomore in New York University.

In 1866 there was no school of architecture in the United States. Richard Morris Hunt had sometimes taken pupils in his studio on West Tenth Street, where he valiantly attempted an atelier atmosphere like that he had experienced in Paris. William Robert Ware, one of Hunt's pupils, had gone on to form a partnership in Boston with Henry Van Brunt, another of Hunt's pupils, and had been appointed professor of architecture at the Massachusetts Institute of Technology only in 1865. In 1866, Ware published an outline for a course. He opened the department of architecture in October 1868. But not until 1873 was there a graduate, a student who never pursued an architectural practice.[6] Root's studies at New York University were thus directed toward the degree of bachelor of science and civil engineering. With the advantage of his schooling in England, he became outgoing and popular. He

[5] Cf. Quentin Hughes, *Seaport: Architecture & Townscape in Liverpool* (London, 1964), pp. 57–65.

[6] See Caroline Shillaber, *Massachusetts Institute of Technology School of Architecture and Planning 1861–1961* (Cambridge, Mass., 1963). By 1868, the University of Illinois also had a nominal department of architecture. It did not become effective until a few years later, when N. Clifford Ricker took charge.

joined a fraternity, took an essay prize, was named the junior class orator and then the commencement orator, played the piano for his friends and the organ for the Fifth Avenue Baptist Church, and, in his room at home—so recalled his younger brother, Walter—planned a meager church for a Negro congregation in Atlanta, apparently his first executed design. He was graduated in 1869, ranking fifth in his class, and the same year was taken into the office of Renwick & Sands as an unpaid apprentice.

James Renwick, Jr., suffered success all his life. His work was so consistently fashionable that today it seems merely fashion-ridden. Renwick had been graduated from Columbia College in 1836, before his eighteenth birthday; but what he knew about architecture he had taught himself, often following French models. In 1843, he won the competition for Grace Church, at 800 Broadway, with a handsome Gothic revival design inspired by Richard Upjohn's example of Trinity Church, on Broadway at Wall Street. In contrast, his design for the Smithsonian Institution, premiated in November 1846, was conspicuously "Norman"; considering it a curiously picturesque object, the sculptor Horatio Greenough said: "There is still a certain mystery about those towers and steep belfries that makes me uneasy. This is a practical land. They must be for something. Is no *coup d'état* lurking there? Can they be merely ornaments, like the tassels to a University cap?"[7] In the 1850s Renwick returned to the Gothic revival for St. Patrick's Cathedral on Fifth Avenue; the plaster vaulting of the cathedral rendered the granite buttresses grandiosely superfluous. Just before the Civil War, for the Corcoran Gallery in Washington, he turned to a kind of diminished Second Empire mode. Plans issued regularly from Renwick's office—whether with or without his supervision—for houses, churches, five hospitals, and the Main Building and other structures of Vassar College, including the gatehouse that the critic Montgomery Schuyler thought attractive—if only for the innocence of its pomposity. Joseph Sands must have been in charge while Root was apprenticed there; Renwick was making an extended tour through Italy and Egypt. One can surmise only that Root gained nothing of positive value sufficient to outweigh his experience of an attitude which accepted a rummaging through styles as the norm for the profession.

After about a year, Root left the office at 88 Wall Street to join the office of J. B. Snook, at 12 Chambers Street. There he began to be paid a

[7]Horatio Greenough, *The Travels, Observations, and Experience of a Yankee Stonecutter* (1852), facs. ed. (Gainesville, Fla., 1958), p. 47.

small salary. Snook, who was born in London in 1815, had lived in New York for many years and had built a successful practice in residences and modest commercial buildings. His particular good fortune was to enjoy the patronage of the Vanderbilts. Along with the railroad engineer Isaac Buckhout, he was then engaged on the first Grand Central Station. The façade on Forty-second Street, as the "architectural" part of the design, was of a commonplace mansarded style. But the train shed—designed for the most part by two engineers on the staff of the Architectural Iron Works, and obviously modeled on the shed of St. Pancras Station in London—was a splendid glass-and-iron vault (Figs. 2–3). At twenty, Root became Snook's superintendent of construction. Thus he had every opportunity to experience the largest enclosure in the country, the kind of industrial building that could only reinforce the impressions he had gained in Liverpool.

Root was ready to leave Snook when the station was being finished. The trains of the Harlem Road puffed in and out for the first time on 8 October 1871 (the same day that the great fire broke out in Chicago). Peter B. Wight once recalled that Root already had been in to see him:

My first acquaintance with him was when he called at my office in New York in the latter part of 1871. . . . I had a great desire to take him into my office, for he showed me original designs which were entirely in harmony with my ideas of the proper conception of architecture as a fine art, and they were like the designs of a mature scholar. But I had very little to do at that time and did not need assistance.

After my visit to Chicago to see the ruins after the Great Fire . . . I asked him to call at my office in New York, which he did, and then told him I would send for him as soon as there should be an opening. He then showed me sketches he had already made for Reed's Temple of Music in Chicago, and had a great desire to go West. . . .

I came to Chicago and sent for him in January, 1872. When he came he was made foreman of the office. . . . Mr. Root was essentially a self-taught man, possessed in his youth of the greatest acquisitiveness I have ever witnessed. . . .[8]

Wight outlived Root, as did almost everyone who worked with him; in fact, Wight lived so long—as he dismally remarked to the architect Thomas Tallmadge—that he thought all his own buildings had been destroyed.[9] It

[8] P. B. Wight, "John W. Root as a Draftsman," *Inland Architect*, XVI (Jan. 1891), 88.

[9] Shortly after Wight died in 1925, the architect Arthur Woltersdorf wrote that one of his finest houses was still standing on North La Salle Street. The Springer Block, on the southwest corner of State and Randolph streets, was also standing. In New York, the National Academy of Design "survived" to the extent that Our Lady of Lourdes Church, curiously enough, incorporated some of the stones from its façade.

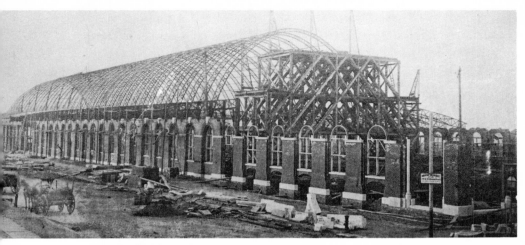

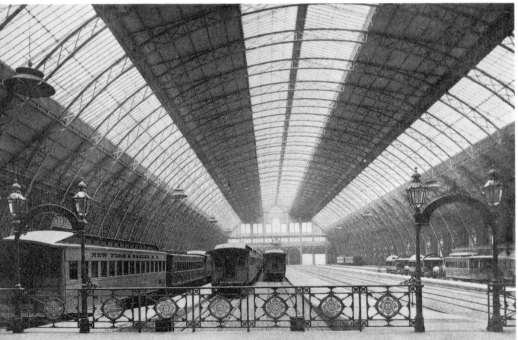

Fig. 2. (top) *Grand Central Station, New York, 1869–1871. J. B. Snook, Isaac Buckhout et al. Destroyed. Train shed in construction. Courtesy the New York Central system.*

Fig. 3. (bottom) *Grand Central Station. Train shed. Courtesy the New York Central system.*

7 *FIRST THIRTY YEARS: 1850–1879*

was Wight's opinion that Root showed no influence from either Snook or the office of Renwick & Sands. Wight considered Renwick a mere copyist, far inferior as a Gothic revivalist to Upjohn. He said that Root, because of his exceptional feeling for structure, could be accurately described as an exponent of the principles of Viollet-le-Duc. It was, in fact, Root's habit to judge a building either "architectural" or "not architectural"—the verdict evidently depending on whether the fabric impressed him with a strong sense of structural reality. Wight said Root was among the happy few who understood the Gothic revival in the best way—not as an effort to reproduce old buildings, "but to apply the constructive principles of the best Gothic work of the twelfth and thirteenth centuries to the materials, facilities and necessities of our own time. . . ."[10]

Wight was one of the first architects in America to pass beyond Ruskin to the contemporaneity and rigorous structural logic of Viollet-le-Duc.[11] He was born in New York in 1838, and in 1852, while he was attending the Free Academy in a building of Renwick's at Lexington Avenue and Twenty-third Street, he often went up to Forty-second Street to watch the construction of the Crystal Palace—it greatly informed him, he recalled, in the matter of cast-iron construction. When, with fervor, he began to read Ruskin sometime before his graduation in 1855, he was not at first dissuaded by Ruskin's dread of industrial building or his notorious inability to find architectural merit in structures of glass and iron. Late in 1858, at the invitation of a real estate agent who knew his father, Wight went to Chicago, where he was introduced to the architects Asher Carter and Augustus Bauer. Carter, a native of New Jersey, had supervised the Second Presbyterian Church, on the northwest corner of Wabash and Washington streets, another design of Renwick's (and a building, recalled William Le Baron Jenney in 1883, soon demeaned by a "very untidy appearance" due to the use of prairie stone with a high petroleum content, which collected dust and soot). Bauer once had worked for J. B. Snook, and also for Carstensen & Gildemeister on the Crystal Palace in New York.

[10]P. B. Wight, "Daniel Hudson Burnham and His Associates," *Architectural Record*, XXXVIII (1915), 6.

[11]Viollet-le-Duc's principles as they influenced architectural thought in America are outlined in my essay "Frank Lloyd Wright and Viollet-le-Duc," *Journal of the Society of Architectural Historians*, XXVIII (1969), 173–183. Hereinafter, *Journal of the Society of Architectural Historians* is cited as *JSAH*.

Wight soon moved into a building he had under construction at the southwest corner of State and Randolph streets; it was his only commission during an entire year. No one had warned him of the effects of the Panic of 1853. In 1859 he returned to New York and began to spend much time in the Astor Library. Soon he became an advocate of the Pre-Raphaelite movement in America: truth and sincerity were his bywords. By winning the competition for the National Academy of Design, early in 1861, he suddenly established his reputation. Still spellbound by Ruskin's incandescent rhetoric, he designed the National Academy in a Venetian Gothic style and sought to have the ornament developed directly by the stonecarvers, those souls whom Ruskin hoped to regenerate through "freedom of thought" and "healthy and ennobling labor." It was built at Fourth Avenue and Twenty-Third Street, only a block west of the Free Academy, and the carvers were of course all too anxious to return to prosaic buildings in which the ornament would be less programmatic. Near the end of his life, Wight looked back on the National Academy as a rather naïve design. Today, his renderings in tempera of the intricate polychrome decoration nevertheless seem hauntingly beautiful.

By the mid-1880s, Root could refer to the Pre-Raphaelite episode as the "Victorian Cathartic"—as too true to be good and too good to be true. "It came upon us all in the time of our virgin innocence," he said, "when architecture seemed the vale of pure Arcadia, and Ruskin was its prophet."[12] Wight probably had attracted Root because he was a young leader in the profession (Wight was secretary of the American Institute from 1869 to 1871) and an excellent draftsman. He was prepared to introduce Root to Viollet-le-Duc, if indeed Root was not already aware of Viollet-le-Duc's ideas. Wight said he himself discovered the truth about medieval architecture when he encountered Viollet-le-Duc's writings about 1866; but as a founder of the Society for the Advancement of Truth in Art, he must have noticed the frequent references to Viollet-le-Duc, beginning in 1863, in the brief run of the organ entitled *The New Path*. It *was* in 1866, however, that Henry Van Brunt, writing in *The Nation*, described Viollet-le-Duc as "perhaps" the leading architectural reformer of France, and announced rather coyly that an American architect had translated the *Entretiens* with a view to early publication. Van Brunt's translations were not published until 1875, some years after

[12] John W. Root, "Architectural Freedom," *Inland Architect*, VIII (Dec. 1886), 65.

Wight began translations of his own; in 1868, Wight read the first discourse to the New York chapter of the American Institute, and he soon published it in the early issues of the trade journal *Manufacturer and Builder*.

During these years, Wight maintained a correspondence with Asher Carter. Immediately after the great fire, Carter invited Wight to Chicago to form a partnership with himself and William H. Drake. The amount of work to be done was enormous. Carter found himself unequal to the strain and retired later in 1872. Most of the lost buildings, however, were merely replaced by ghost images—Chicago, for a time, was called the Phoenix City. Architecturally, almost nothing was accomplished. Wight confessed that little thought was spent either on design or good construction; Root himself recalled the inconceivable haste of the rebuilding:

> The older men of the profession . . . will all tell you that it was not infrequent that foundations were planned and constructed, even up to the level of the sidewalk, before the first and other stories were arranged, and one architect is responsible for the statement that in the rush of his work, one building of four stories was under roof before he "got around" to the design of its façades—the floors being supported at their outer lines by temporary stays.[13]

More significant than Carter's retirement was the arrival of a draftsman named Daniel Hudson Burnham. Many years later, Burnham was not embarrassed to recall that he had admired Root's stance at the drawing board, the strength of his arms, the whiteness of his skin, and his frank smile. Wight was thinking of advancing Root to partnership, but Burnham at once began cultivating Root's loyalty assiduously.

Daniel Burnham was born on 4 September 1846 in Henderson, New York. His paternal ancestry was much like Root's. The first Burnhams had landed in America about 1635, and his father, Edwin Burnham, was a rural merchant who moved to Chicago in 1855 and built a major wholesale drug house, ruined later by the dishonesty of one of Daniel's older brothers. He hoped to become a member of the class of 1865 at Central High School, but was notoriously inattentive to his studies, his performances often falling as low as 55 percent.[14] He was handsome, athletic, and so fond of drawing that before holidays he was excused from recitations to decorate the blackboards with pastels. Already he had organized assistants, one of whom was Edward

[13] John W. Root, "Architects of Chicago," *Inland Architect*, XVI (Jan. 1891), 91.

[14] "Alumni Who Are a Credit," Chicago *Tribune*, LIV (29 Dec. 1895), 26.

C. Waller, who, it was said, could not draw a straight line. At last, Burnham was sent away for private tutoring in Waltham and Bridgewater, Massachusetts. The correspondence of 1866 and 1867 between his father and mother is poignantly concerned with his tardiness. In the spring of 1867 he failed entrance examinations for both Harvard and Yale. He returned to Chicago where at first he could not hold a job. In a letter of 22 November 1867, his mother wrote of his being "afloat" again:

His whole course of study . . . has done very little to make him a bookkeeper, or a grocery-merchant—He always lacked application and *precision*. . . . I should say that a situation with an architect would be the best thing he has tried or thought of yet.[15]

Edwin Burnham, on 4 December, wrote that he was trying to inspire Daniel with zeal and energy. "He seems to like architecture," he added, "and says he *can* succeed." Burnham was at work in the office of Loring & Jenney, where it was Sanford Loring, rather than William Le Baron Jenney, who took him under his wing. On 27 April 1868, he wrote his mother that he had been to Lincoln Park to measure and sketch the bridges, for which he was to design some "rustic" work. "It is very engaging work and I enjoy it," Burnham wrote. "All that sort of work in the office comes to me." Another letter to his mother, dated 11 May, reveals a sudden burst of marvelous self-confidence:

A year's experience among businessmen makes me feel quite differently from my former self. I long to study now, and look back on the years that are gone. . . . But I shall try to become the greatest architect in the city or country. Nothing less will be near the mark I have set for myself. And I am not afraid but that I can become so. There needs but one thing. A determined and persistent effort.

Burnham's school friend Waller, who meantime had gone into the real estate business, asked him for plans for fourteen houses to be built on the West side. Waller later invested $40,000 in Nevada gold claims. Burnham caught the same fever and left Chicago. For three months, Waller joined him in Robinson, Nevada, where, as Waller later recalled, a politician named Pish Kelly persuaded Burnham to campaign for the state legislature. Burnham was no more successful at politics than at prospecting. He finally returned to Chicago and formed a partnership with a Frenchman named Laureau, who, according to P. B. Wight, also had worked for Loring & Jenney. At the time

[15]This letter and the letters quoted subsequently are now in the Burnham Library of the Art Institute of Chicago.

of the great fire, however, Laureau disappeared. Burnham then tried being a druggist. He was selling plate glass late in 1872 when his father introduced him to Wight's office.

Despite such a dismal résumé, Daniel Burnham believed he had the ability to promote grand schemes. The architect Irving K. Pond once said rather bitterly that Burnham's real interest was always exerted along lines of magnificent exploitation. Burnham's duties with Wight were not very demanding; nor, indeed, were Root's. The office was designing buildings of only three or four stories, the fronts marked by a random variation, from story to story, of the window heads—pointed, flat, segmental, and round. Wight's enthusiasm for the rationalism of Viollet-le-Duc proved, as yet, no guarantee of architectural accomplishment (even Greenough, in his own impassioned plea for a new American architecture, said reason could dissect but could not originate). Root was allowed to finish his work for Reed's Temple of Music, but the client built only a simple two-story structure. Root also designed a small building on Lake Street. Burnham did competent work: his watercolor rendering of 1872 for a front on Dearborn Street, which survives in the portfolio Wight presented nearly fifty years later to the Burnham Library, is as skillful as any of Root's early delineations.

Burnham soon was busy hustling commissions on his own. He worked nights, sometimes with Root at his side, in a room in a building on West Washington Street that Wight had designed. R. C. McLean once recalled Root saying their first house was on the southeast corner of Harrison Street and Ashland Avenue, and had its foundation already in place under Burnham's direction; Root added: ". . . my first work was to knock the design into shape."[16] Burnham, on the basis of a scheme for a suburb projected by some friends of his, finally convinced Root to leave Wight and to form an independent partnership. The first entry in their accounts was dated 5 July 1873. It was less than three months later that the Black Friday of 19 September signaled the Panic of 1873. Most of their first commissions were stillborn.

And so began what Wight called "the dark years" of the middle 1870s. Burnham & Root survived in a most tenuous way. The partners took turns hiring out to other architects. Root studied and drew, played the organ for the First Presbyterian Church, and occasionally reviewed music or art for the Chicago *Tribune*. He began to become something of a social butterfly. He

[16]R. C. McLean, "Recollections of Daniel H. Burnham," *Western Architect*, XXXI (1922), 68. McLean remembered this as the Sherman house, which of course it was not.

joined Burnham in ruminating on Swedenborgian notions of the spiritual and of the immanent Christ. (When only eight years old, Burnham had been sent to a Swedenborgian academy.) Root became convinced of the correspondences in "all art expression" of form, color, and light and shade. Those between color hues and musical tones he took to be particularly acute. Polychromy, at the time, was of course almost a general obsession; Théophile Gautier found it fashionable to boast that with the help of hashish he could hear colors, while Greenough some years earlier had called for an investigation of the functional significance of colors. Root accepted Ruskin's observation that color in nature existed independently of form. In the essay "Art of Pure Color," published in 1883, Root prophesied color instruments capable of projecting brilliant visual symphonies.

With the house for John B. Sherman—which Root and Burnham always regarded as their first real chance—it is not easy to imagine the tonal arrangement of red pressed brick, buff sandstone, dark blue granite colonnettes, black slate, and red and buff terra cotta chimney tops (Fig. 4). The house was built in 1874 on a lot with a 75-foot front at the southwest corner of Twenty-first Street and Prairie Avenue. Sherman was one of the founders of the Union Stock Yards and Transit Company. When he began thinking of a new house, he was advised by his protégé George Chambers, a real estate man, to choose a young architect; Chambers suggested his friend Root. Sherman called at the office when Root was out of town, but Burnham convinced him. The commission became especially important to Burnham, for Sherman's daughter Margaret was attracted to him; she contrived to visit the building site frequently in order to see him. Burnham conveniently married her and moved into the new house.[17]

Louis Sullivan, at the end of his life, recalled how he chanced upon the Sherman house when he was only seventeen and found it the best-designed residence he had seen in Chicago and a house possessing "a certain allure or style indicating personality."[18] This is hardly surprising, for Sullivan had al-

[17]Many years later, while Charles Moore was preparing his biography of Daniel Burnham, Mrs. Burnham said her husband and her father never quite understood each other. She said her father was upset by Burnham's drinking habits in the early years of the marriage. Sherman therefore arranged his estate so that his daughter received only the income from it during her lifetime. Burnham once managed the household after Sherman sailed to Europe with a woman previously intended to be the fiancée of Sherman's son Arthur, who had died.

[18]Louis H. Sullivan, *The Autobiography of an Idea* (New York, 1924), p. 285. Sullivan's descriptions of Root and Burnham, and of the nature of their partnership, were highly colored by the tragic decline of his own career.

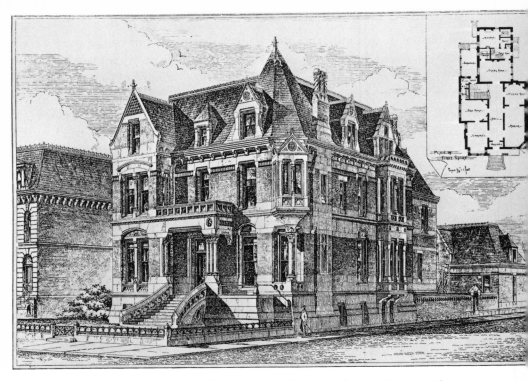

Fig. 4. John B. Sherman house, southwest corner of Twenty-first and Prairie, Chicago, 1874. Destroyed. Rendering by Root. From the American Architect.

ready worked for Frank Furness in Philadelphia, where he learned to admire a somewhat exaggerated expression of virility and character: the house for Sherman was much the same in spirit as Furness' houses of the same time, although Root did not visit Philadelphia until 1876. Much of the "personality" of the Sherman house resided in its almost impenetrable solidity and yet persistent denial of a simple wall. In the rendering, where the technique perhaps was in debt to the engravings typical of English architectural journals, Root even exaggerated the intrusions of spiky incident, as though he deemed these details the preeminent values of the design. The little oriel perched precariously atop the lone colonnette was all too reminiscent of the awkward structure shown in the drawings of Viollet-le-Duc, the kind of detail Furness learned in Hunt's atelier. In plan, the house was likewise fractured. The headlong approach to the dining room—through an extraordinarily long hallway—seemed to suggest a public establishment; the rooms on either side were stiffly compartmented; the stairs were held to a minor and delayed axis, and were nearly hidden; the verandah was but a parsimonious porch at

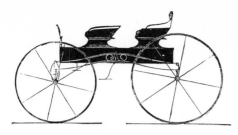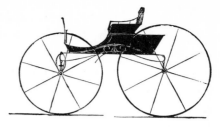

Fig. 5. Dexter carriages shown at the 1876 exposition in Philadelphia. From The Centennial Exposition, Described and Illustrated.

the rear of the house. There were no hints, then, of those values so soon to appear in the finest of the shingled houses along the East coast. One detail of the Sherman house Root never forgot: the lozenge-and-circle diaperwork of the gable he was to use again in 1890, at the ninth story of the Mills Building in San Francisco.

In the townhouse project of 1875 for Henry Demarest Lloyd, then with the Chicago *Tribune*, the entrance hall and stairs were peculiarly separated from both the front parlor and the library. Root did attain a more subdued street front and satisfied himself (though perhaps not the client) with a comparatively restrained corbeling in pressed brick, such as he would turn to again for the Grannis Block, his first office building. In 1876, when he and his brother traveled to the Philadelphia Centennial International Exhibition, they could have encountered anything from the fashionable Queen Anne revival residences of the British government to the faultlessly conceived Dexter carriages (Fig. 5)—so elegantly attenuated and such splendid proof of what Greenough had meant by declaring that "the mechanics of the United States have already outstripped the artists, and have, by the results of their bold and unflinching adaptation, entered the true track. . . ."[19] They walked around the city as well as the exhibition, and there is a hint much later that Root paid some attention to the work of Furness. Walter Root once recalled that his brother took notes in Philadelphia, but he neglected to say of what.

Of the very few published designs from the dark years, the house on Drexel Boulevard, projected in 1876 but possibly never built, was picturesque in the extreme (unhappily employing both sandstone and limestone), and internally more shattered than even the Sherman house. The house of 1877 for Edward Engle, built at 1312 North State Street, was neither so aspiring nor so unsuccessful; at the least it afforded a generous parlor, 15 feet by

[19] Horatio Greenough, "Structure and Organization," in H. T. Tuckerman, *A Memorial of Horatio Greenough* (New York, 1853), p. 181.

35 feet, opening to the dining room. If, in the houses of the 1870s, Root seemed intent on the obfuscation of form through a deliberate nurturing of the discrete details, many of his houses of the 1880s could be charged with the same fault. For his attitude toward residential architecture was consciously relaxed. A house was a lyrical and sometimes playful essay. "In a small house, or one which is greatly varied in plan so that each of its parts is small, a very broken and even restless outline may be good," he wrote as late as 1887. "In general, our whims of all sorts, our fanciful vagaries, whether in color or form, may, perhaps, be safely put into small buildings. . . ."[20]

In the 1870s, Burnham & Root had a small and disappointing practice, resulting in only some fifteen houses. William Holabird, whose partnership with Martin Roche was to become central to the commercial architecture of Chicago, beginning with the Tacoma Building of 1888–1889, worked for them briefly. Clinton J. Warren joined them in 1879 and stayed seven years. Burnham & Root as yet played no role in commercial architecture. P. B. Wight, a reliable witness, said that until the end of the decade most of the commercial buildings of Chicago were derived from business blocks in Boston and New York; while an anonymous contributor to the Chicago *Times* wrote in 1879 of the "general inferiority" of the business blocks, as well as of the residences, to the buildings in older American cities.[21] Some of the blocks in Chicago had mansarded roofs, and a few attempted to blend the Second Empire mode with pointed window openings and High Victorian Gothic polychromy. The quaint little structures with keystoned window heads and impoverished classicistic details that Montgomery Schuyler so despised as the "commercial Renaissance"—observing that such pretentious façades represented translations from stone to cast iron imitating stone and then back to stone that imitated cast iron—were to be found nearly everywhere. In the public mind, architectural Chicago was perhaps epitomized by the U.S. Post Office and Custom House, a Victorian Gothic pile designed by A. B. Mullett, the government architect, in association with John M. Van Osdel. Although, as Wight said, almost every government building in America was an object beyond redemption, the post office in Chicago remained a special case. It was founded on a continuous pallet of concrete—what amounted to a thin beam and the worst possible footing for the soil conditions of the city—and it soon suffered violently uneven settlements, which caused fissures in the walls and topplings from the projections.

[20]John W. Root, "Style," *Inland Architect*, VIII (Jan. 1887), 99, 100.
[21]"Architectural," Chicago *Times*, XIV (2 Nov. 1879), 9.

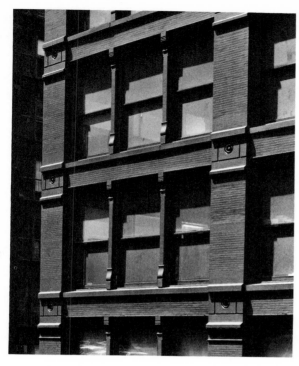

Fig. 6. Leiter Building, northwest corner of Wells and Monroe, Chicago, 1879–1880. Destroyed. W. L. B. Jenney. Façade detail. Photo by Richard Nickel.

Wight discerned that the most significant commercial building in the Middle West was the Shillito Store in Cincinnati, by the architect James McLaughlin (whose later work seems consistently disappointing). In looking elsewhere, however, the architects of Chicago found little vigor or direction. H. H. Richardson was beginning to build mightily, but his work at first must have seemed an odd recrudescence of the Romanesque architecture of southern France. Its implications were not immediately apparent. In England the professional journals reported the Queen Anne revival, the *Architect* having noted already in 1874 the acceptance of "piquant, unpronounced, disguised Classic."[22] Henry Van Brunt, in Boston, seemed unable to decide whether he should welcome or deplore what he called the picturesque and uneasy groping for a style in the mother country, as manifest in long rectangular windows, brick paneling, attenuated orders, and fretted gable lines.

At the end of the 1870s, Wight nevertheless believed the clouds to be lifting. He detected the arrival of a new rationalism. He thought the emphasis

[22]Professor [Robert] Kerr, "Architectural Prospects: The Queen Anne Style," *Architect*, XI (Jan. 1874), 1–2; see also Henry Van Brunt's introduction to Viollet-le-Duc, *Discourses on Architecture* (Boston, 1875), p. ix.

on straightforward building, on structure, was "largely influenced by the study of mediaeval Gothic architecture and the works of Viollet-le-Duc"; and he defined the characteristics of the new tendency in Chicago:

. . . straight lintels placed flush with the walls and in connection with horizontal bond courses; also continuous sills and visible bond courses in piers, cornices for wall protection only, and not for shadow effects; and, generally, ornamentation of the *surface* of walls and *within* the surface plane.[23]

What he meant could be seen in William Le Baron Jenney's first building for L. Z. Leiter, at the northwest corner of Wells and Monroe streets (Fig. 6). Here was a building as clear and pure as any ever to come from Jenney's office, just as the Borden Block, by Dankmar Adler with Louis Sullivan, at the northwest corner of Dearborn and Randolph streets, was to rival any building *they* were to design in the next five years. After surviving seven lean years, Burnham & Root in 1880 at last began to gain commissions for commercial buildings.

[23]P. B. Wight, "On the Present Condition of Architectural Art in the Western States," *American Art Review*, I (1880), 138.

II · A BEGINNING: 1880–1885

The truly heroic years of downtown Chicago were the 1880s. The partnership of Burnham & Root rather quickly attained an architectural ascendancy, their commissions becoming more frequent (Fig. 7) and their buildings more often notable than those of any other office. Root and Burnham both attracted eager and ambitious clients. Many years later, Louis Sullivan recalled that the men responsible for the modern office building were Owen Aldis and William E. Hale[1] —both of whom were clients of Burnham & Root. Aldis, at the beginning of the decade, was a young lawyer. He met Root at a reception, found his conversation fascinating, and brought him a commission the next day.

Very likely, the commission was that for the Grannis Block (Fig. 8). In February 1879, Aldis had been retained by Peter C. Brooks, of Boston, to manage the Portland Block, at the southeast corner of Dearborn and Washington streets, a property Brooks acquired through a mortgage foreclosure.[2] Shepherd Brooks bought the lot immediately south of the Portland Block and, wary of putting up an office building on pure speculation (his letters were consistent in revealing him to have been a cautious and timid soul, entirely unlike his brother), soon asked Aldis to seek a tenant. In 1880, Aldis

[1] Louis H. Sullivan, "Development of Building—II," *Economist*, LVI (July 1916), 40.

[2] Aldis (1852–1925) became so involved in real estate that by 1888 he had given up his law practice. He acted in the name of the Brooks Estate in the hope of obtaining lower assessments. The Aldis & Co. correspondence, comprising a large number of letterpress volumes and a few MS letters, was happily revealed by Earle Shultz and Walter Simmons, in their *Offices in the Sky* (Indianapolis, 1959) as a source of crucial documentation in the history of downtown Chicago architecture. Graham Aldis, a nephew of Owen Aldis, kindly gave me permission to quote from these papers. Within a few years after his death in 1966, the company gave up its vault, sold the Monadnock Block, moved, and reorganized into Chinnock & Doughty, Inc. The letterpress volumes were destroyed.

Fig. 7. Burnham & Root in downtown Chicago, 1880–1892

1.	Grannis Block	1880–1881
2.	Montauk Block	1881–1882
3.	Burlington Office Building	1882–1883
4.	Calumet Building	1882–1884
5.	Counselman Building	1883–1884
6.	Norman Ream Warehouse	1883–1884
7.	Rialto Building	1883–1886
8.	Insurance Exchange	1884–1885
9.	Traders Building	1884–1885
10.	McCormick Warehouse	1884–1886
11.	I.N.W. Sherman Factory	1885
12.	Art Institute	1885–1887
13.	Commerce Building	1885–1886
14.	Phenix Building	1885–1887
15.	The Rookery	1885–1888
16.	Argyle Apartments	1886–1887
17.	Rand-McNally Building	1888–1890
18.	Chemical Bank Building	1889
19.	Reliance Building (lower stories)	1889–1891
20.	Monadnock Block	1889–1892
21.	Herald Building	1889–1891
22.	Chicago (Great Northern) Hotel	1889–1891
23.	Woman's (W.C.T.U.) Temple	1890–1892
24.	Masonic Temple	1890–1892
25.	Daily News Building	1890–1891
26.	Central Market	1890–1891
27.	Art Building project	1890

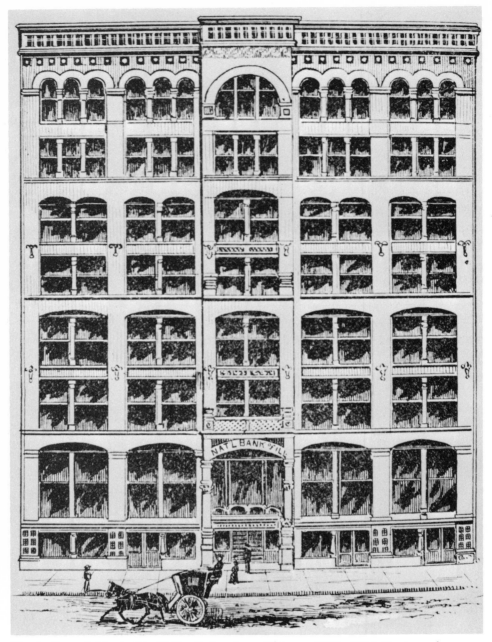

Fig. 8. Grannis Block, 21–29 North Dearborn, Chicago, 1880–1881. Destroyed. Shown rebuilt as the National Bank of Illinois. Also destroyed. From Commercial and Architectural Chicago.

arranged to lease the lot to Amos Grannis, a building contractor, and to furnish him plans for an office building. The plans were by Burnham & Root, and the building fronted for 90 feet at 21–29 North Dearborn Street, with a depth of 120 feet. The plan was based on an internal light court.

Through a *piano nobile* arrangement, two floors of "prime" commercial space were offered, a high banking story above a row of storefronts. In seeking some way to organize the street elevation, Root came very close to suggesting a cross—inappropriately enough. With the severe sillcourses and the advanced portions of the center bay, he broke the flow of the piers and spandrels. Most of the qualities Wight had noted as characteristic of the new rationalism were nevertheless present; while certain details, such as the corbeled hood, the keen edging of the segmental window-heads, the diminutive colonnettes and struts, and the fleurs-de-lis in low relief, were even more direct evidence of Root's acquaintance with the great French architectural reformer, Viollet-le-Duc.

Burnham remembered the Grannis Block particularly for its color, evidently ruddier than the cherry. "Here our originality began to show," he told his biographer, Charles Moore. "We made the front of the building all red, the terra-cotta exactly matching the brick. It was a wonder. Everybody went to see it, and the town was proud of it."[3] More modestly, Root recalled the effect of the pressed brick walls of the Portland Block next door—walls which, in spite of the stone trim, already had been in strong contrast to the miles of street fronts in limestone from the Lemont quarries. In his mind, the flamboyant deployment of red brick, though a hallmark of the Queen Anne revival,[4] found its justification in an aesthetic of glowing color and in a pragmatic response to the industrial pollution of the city:

The color effect produced in a building should be studied from the plane of climatic influences. In Chicago, colors should be used which are least injured by the inevitable accretions of smoke. What are best and what worst in this respect can be easily determined by overlaying any doubtful color with a thin glaze of asphaltum. This will indicate the superiority of warm over cold colors.[5]

[3] Charles Moore, *Daniel H. Burnham*, 2 vols. (Boston and New York, 1921), I, 24.

[4] William Makepeace Thackeray, devoted to what he considered the era of Queen Anne, built a house in Kensington in 1861–1862 which he proclaimed "the reddest house in all the town." See Sadayoshi Omoto, "Thackeray and Architectural Taste," *JSAH*, XXVI (1967), 40–47; and Priscilla Metcalf, "Postscript on Thackeray's House," *JSAH*, XXVIII (1969), 115–123.

[5] John W. Root, "Architectural Ornamentation," *Inland Architect*, V (April 1885), 55. In a speech of 27 Nov. 1883 before the Chicago Academy of Sciences, William Le Baron Jenney said brick and terra

In a fire of 19 February 1885, the Grannis Block was proved most vulnerable in its essential parts: the cause, evidently, was excessive friction of the elevator counterweights against their wooden guides. Shepherd Brooks unfortunately had bought the building from Grannis only the previous October, having finally decided that it was a safe investment. The embarrassment to Burnham & Root was of less import than the loss of their drawings and documents from more than a decade of practice—their own offices were on an upper floor. The only plans protected in a vault were those for work-in-progress.[6] Peter B. Wight, who spent most of his later years perfecting technics for fireproofing, thought of the Grannis Block fire even as late as 1902:

Cast-iron columns, covered with porous terra-cotta two and one-half inches thick, fastened to the iron with tap screws, were tested in a fire in the Grannis Block. . . . they were pulled out of the ruins with all the fire-proofing attached. There was nothing fireproof in that building except the columns.[7]

One thing Peter Brooks made sure of in commissioning from Burnham & Root the Montauk Block of 1881–1882 (Fig. 9) was that the structural members would be sheathed by hollow tile; and when, in December 1883, a fire destroyed the Crozer Building immediately to the northwest, Aldis hastened to write Brooks that the Montauk Block escaped serious damage— "a triumph," he said, "for your fireproofing." The spaces between the wrought-iron floor beams were filled with flat arches of hollow tile 6 inches deep. The lower flanges of the beams, however, were still without protection. Wight thought this use of flat arches of hollow tile especially significant— although it was not the first such use—because it reduced the dead-load to only 30 pounds per square foot; previously, he said, the average dead-load of fillings between I-beams, whether of brick arches or of corrugated iron covered with concrete, had been 70 pounds.

What made the matter of loads so crucial was a geological fact. Chicago was a marshland, and thus, as the Boston architect C. H. Blackall observed, it occasioned foundation problems "probably not equalled for perverseness

cotta were "far superior to any stone" in fire resistance. Such rational factors underlying the "Brown Decades" are commonly overlooked. In 1881, Chicago adopted an antismoke ordinance. By 1884, some seven hundred smoke-inhibitors had been installed on furnaces. The smoke problem was not overcome, but there was at least a show of civic conscience.

[6] In publishing renderings of the two Strahorn residences in Kenwood, the *Sanitary Engineer*, XIII (May 1886), 537, reported that the floor plans were lost in the Grannis Block fire.

[7] P. B. Wight, "The Fire-Proofing of High Office Buildings," *Brickbuilder*, XI (1902), 147.

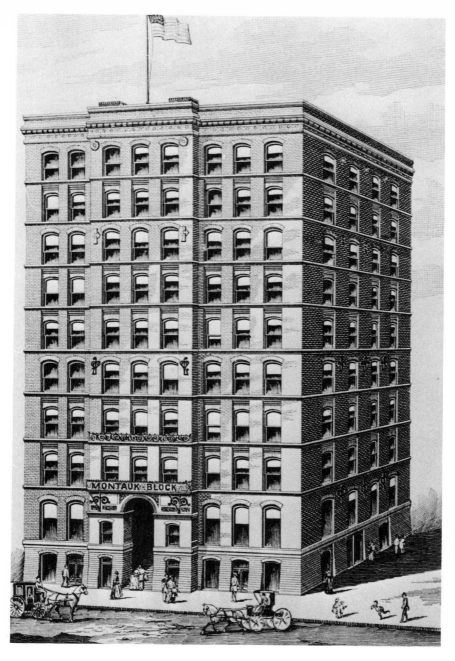

Fig. 9. Montauk Block, 64–70 West Monroe, Chicago, 1881–1882. Destroyed. From Industrial Chicago, *courtesy Illinois State Historical Library.*

anywhere else in the world."[8] In short, Burnham and Root were obliged to build the most massive commercial structures on the most ineligible kind of soil. In the Montauk Block, as in the Grannis Block, they followed the method of isolated piers advocated by Frederick Baumann. Each footing was composed of large cut stones piled into a pyramid and placed on a bed of concrete. The theory, as Root understood it, was that each footing could be proportioned to the weight it was to carry; consequently, settlements would be nearly equal. In a very heavy building, however, the footings could easily become so large that they would protrude into the basement, where they obstructed space quite as valuable, said Root, as that of the first story. The huge stones could not be set deeper, because the soil beyond 12–15 feet down consisted typically of a soft blue clay absolutely unsuited to bear loads. Thus the footings were confined to a bearing upon a shallow and dessicated crust of blue and yellow glacial clay which dated back 6,000 years and which, in the 1880s, was known as "hardpan." This crust usually was most firm at a depth around 12½ feet.

The stone pyramids so occupied the basement of the Montauk Block that there was not even enough space for the mechanical equipment. But at the point beneath a stack of safety vaults, where he estimated the load to be so great that a stone pyramid might well reach into the first story, Root conceived a special footing of steel rails, criss-crossed and surrounded with cement as protection against rust. A footing of steel was much more shallow (see Fig. 44); a steel footing 1 foot 8 inches high, in fact, could perform as well as a stone pyramid of 7 feet; moreover, it could be put in place faster and easier, and it was lighter. Stone pyramids, said Root, sometimes added as much as 20 percent to the gross weight of the entire pier. Aldis had called in Wight as a consulting engineer, and in later years Wight liked to claim this innovation as his own—just as he was given to overlooking the contributions of others to fireproofing. Surprisingly—and perhaps because of the high price of steel—Root failed to take immediate and full advantage of his own idea. When he did, beginning in 1885, the rail-grillage footing was accepted as the most satisfactory solution in Chicago. It remained so until the belated appearance of deep caisson foundations, which were pioneered in Kansas City, the engineer Louis Curtiss ingeniously employing a steam-powered auger to perform the excavation.[9]

[8] C. H. Blackall, "Notes of Travel: Chicago—V," *American Architect*, XXIII (March 1888), 147.

[9] This episode in Kansas City is explored in detail in my note, "Pioneer Caisson Building Foundations: 1890," *JSAH*, XXV (1966), 68–71.

Root found the engineering aspects of the Montauk Block more congenial than some of the functionalist demands of the client. As far as Root could see, Peter Brooks was oblivious to matters of style. Root thought Brooks was asking for a building as bald as a factory. Brooks, indeed, was a capitalist of the kind Van Brunt had described (in his introduction to the *Discourses* of Viollet-le-Duc) as not often disposed to incommode himself for the sake of an architectural idea. In frequent letters to Aldis, Brooks pronounced upon the materials, mouldings, wiring, windows, fire escape, ventilation, wash basins, and the lowly urinals. "The building throughout is to be for use and not for ornament," he said. "Its beauty will be in its all-adaptation to its use."[10]

The Montauk Block was built at 64–70 West Monroe Street, with a front of 89½ feet and a depth of only 70 feet. The plan must have been cramped. To relieve the forbidding and heavy-lidded expression of the two elevations in red face-brick, Root attempted a semblance of composition. He varied the lintels by discreetly placing bits of terra cotta and decorative ironwork to divide the stories into four layers. The unrelenting sills, of course, took command of the wall. They occurred so near the lintels that they worried the eye about where the floor levels might be, the building taking on an uneasy aspect as if it were compressed. That the piers were at least as wide as the window openings betrayed a certain timidity. With a street front of eight bays, Root chose to advance three, thereby displacing the high and gaping portal from the center. He was not happy with the Montauk Block; but Burnham and P. B. Wight remembered it as the first building in Chicago to be called a skyscraper.[11]

[10] Letter of 25 March 1881, as quoted in Carl W. Condit, *The Chicago School of Architecture* (Chicago, 1964), p. 52.

[11] The question of "the first skyscraper" has elicited many candidates—some embryonic and even amusing, and not in the least characteristic of the high office building. Any answer, of course, depends on how the skyscraper is defined: in terms of passenger elevators, program, the earliest use of the word itself (orally or in the public prints) in application to a building instead of a ship, a visual impression of great height, attainment of some arbitrarily chosen height, or some expression deemed suitable to the height, program, or system of metal framing—the last being both the most common and the least reasonable criterion. Long ago, the Monadnock Block, contrary to common opinion, proved the irrelevance of steel framing. Recent high buildings with bearing walls of reinforced concrete make the same point. From a broad and social point of view, structural detail (except in the matter of safety) is of almost no importance. When buildings are thought to be rising excessively high, we are nearer the heart of the question. (A. D. F. Hamlin quite simply identified skyscrapers as "excessively lofty office-buildings.") In 1883, William Le Baron Jenney already remarked that "we are building to a height to rival the Tower of Babel." When there is a cry for legislation to limit office building heights, as there was in Chicago during the 1880s, then surely we are dealing with skyscrapers.

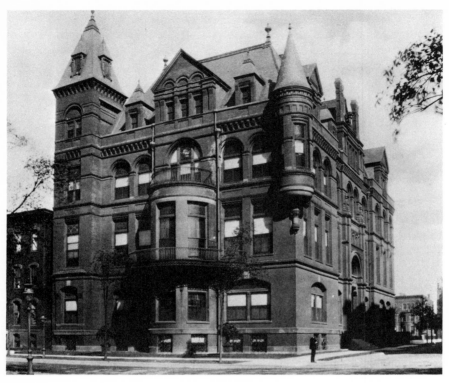

Fig. 10. Calumet Club House, northeast corner of Twentieth and Michigan, Chicago, 1881–1883. Destroyed by fire. Photo by Kaufmann & Fabry.

When the Montauk Building was being planned, Burnham and Root were invited to enter the competition for the new Board of Trade Building. They prepared several entries and all were eventually rejected. The winner was declared to be W. W. Boyington, whose familiar water tower on North Michigan Avenue and building for the first University of Chicago at 3400 Cottage Grove Avenue spoke of the lingering "Norman" influence of the Smithsonian Institution. Boyington's design was a notorious aberration. (Root said, kindly enough, that it seemed to have been designed hastily. Montgomery Schuyler thought it combined the dignity of a commercial traveler with the repose of St. Vitus. Frank Lloyd Wright called it a thin-chested, chamfered monstrosity.) Root's competition drawings disappeared in the Grannis Block fire. He had worked out a plan in which the program would have been thoroughly articulated, the grain trading hall in one wing, most of the office space in the other wing, and an elevator tower rising be-

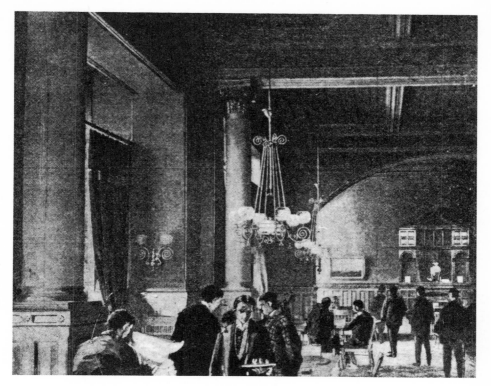

Fig. 11. Calumet Club House, interior. Drawing by Charles Graham. From Harper's Weekly.

tween them. He was to adopt the same point of departure in the competition of 1886 for the Kansas City Board of Trade.

What signaled Burnham & Root's rise to architectural leadership in Chicago, said R. C. McLean, was the commission for the Calumet Club House of 1881–1883 (Figs. 10–11). His estimate may have been colored by the fact that he had published a rendering of the building in the very first number of the *Inland Architect*. But in terms of patronage the commission *was* significant. Although the club was younger than the Chicago Club downtown, its site at the northeast corner of Michigan Avenue and Twentieth Street was so convenient to the houses of the very rich that it soon became known as the most aristocratic club in the city. The building fronted 160 feet on Twentieth Street and 82½ feet on Michigan Avenue. There was nothing unusual about the program: lounges, rooms for billiards and cards, sleeping quarters, dining rooms, and a banquet hall serving three hundred. The outer

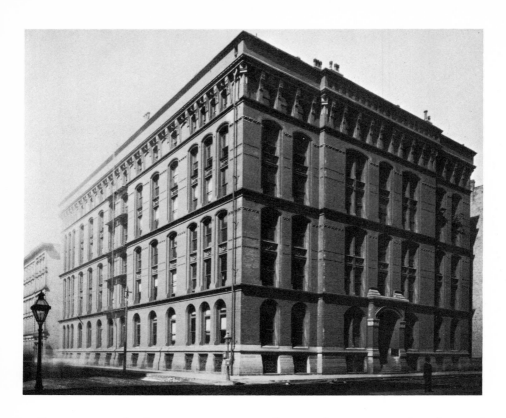

walls were vaguely châteauesque, in a mélange of picturesque details in red pressed brick, cut brick, and terra cotta. What was perhaps curious about the club house was the colossal scale of the windows and ceiling heights; but it was, simply, a rich man's house grown to Brobdingnagian dimensions.

Chicago was the first truly great city in America to be developed by the railroads. The source of the important commission for the general office building of the Chicago, Burlington & Quincy Railroad Company (Fig. 12) was probably James M. Walker, general solicitor for the railroad and, for a short time, Root's father-in-law. (Root's first wife, Mary Louise Walker, died of tuberculosis only six weeks after their marriage in 1879. Root lived a couple of years in the Walker home, at 1720 Prairie Avenue.) Root immediately discerned that the corporate commission, in contradistinction to the speculative office building commission, which was more common, posed the special problem of projecting the corporation itself. Such a building, as he put it plainly, gained an advertising value. Thus he intended the Burlington Office Building as a "suitable architectural expression of a great and stable

Fig. 12. (opposite page) *Chicago, Burlington & Quincy General Office Building, northeast corner of Franklin and Adams, Chicago, 1882–1883. Destroyed. Courtesy the Chicago Historical Society.*

Fig. 13. *Burlington Office Building, internal light court. From the* Daily Graphic, *courtesy of A. M. Rung.*

railway corporation,"[12] and it became the first of his office buildings in which he pursued a symbolic expression.

The plans were finished early in 1882 and the building was finished early the next year. Its type might be traced to the banks and office blocks of Victorian England, and from there to the *palazzi* of the Renaissance in Italy; yet Root shunned the travesties of the "commercial Renaissance." The entrance front, measuring 122 feet on Adams Street, was less impressive than the side elevation on Franklin Street—a wall of 199 feet, all within the same plane and without a single interruption for an entrance. With no store fronts, the basement could be held low to the ground; and the velocity of the sill-courses—abetted by the ribbons of cut brick defining the spandrels and by the clattering rhythm of the attic mullions—gave to the mass the momentum of a car stroking down the track. The internal court (Fig. 13), despite its

[12]The description in the *Inland Architect*, I (March 1883), 18, may have been phrased by Root himself; he uses nearly the same words in his paper "A Great Architectural Problem," *Inland Architect*, XV (June 1890), 71.

spare and seemingly penal aspect (surely much exaggerated by the drawing, so far out of scale), even suggested the ambience of a train shed.

Here was the first office building in Chicago in which a significant amount of space was sacrificed for lighting. Every office in the building was lighted from the court as well as from the openings in the outer walls. Root must have thought of his days at Grand Central Station. He fitted the building with gates of wrought iron; and, in an anteroom, tickets were sold (of course, one was obliged to catch a train elsewhere). The floor was of white marble, the court walls were painted a brilliant white. The corridors were merely cantilevered galleries, with slender iron railings on stanchions of polished butternut and Georgia pine. Nothing was to get in the way of light. The three passenger elevators were walled partly in mirrors and partly in plate glass. Root made light thematic. He had begun to contemplate the internal court as an arena in which to explore the aesthetics of motion through light and space.[13]

More than twenty other railroad commissions were to come to Burnham & Root. Although most of them were for stations, none seems to have enjoyed a space as dominating as the court of the Burlington Office Building. The reason was that Root's stations were linear buildings, addressed to the tracks but not spanning them. His celebration of the romance of travel was far more personal than that which became a formula by the turn of the century: the immense head house decked in a colossal order and aspiring to a civic gateway, with the train shed largely concealed.

One of his earliest stations was the Union Depot at Main and Elm streets in Burlington, Iowa (Fig. 14). Burlington is not a large city even today. Yet, in the 1880s, the depot served as many as six different roads. (It was only a few years later that Samuel Bing, the Art Nouveau dealer from Paris, remarked on the prodigious mobility of the American people.) The first train arrived on 31 December 1882, some weeks before the depot was finished. The local newspaper felt constrained to identify the style of the depot as Queen Anne revival. But the reminiscences were in fact French; the tower perhaps suggesting an austere variation on the tower of le Châtelet at Chantilly. If the triple entrance porch could, in fairness, be called Richardsonian, it nevertheless was not precisely like anything Richardson had done by 1882.

[13]It is characteristic of Louis Sullivan that in his most celebrated essay, "The Tall Office Building Artistically Considered," *Lippincott's*, LVII (1896), 404, he declares: "Only in rare instances does the plan or floor arrangement of the tall office building take on an aesthetic value, and this usually when the lighting court is external or becomes an internal feature of great importance."

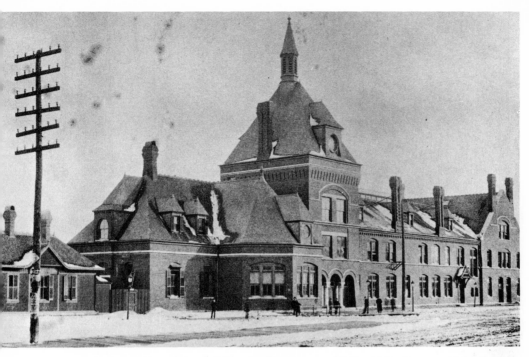

Fig. 14. Union Depot, Main and Elm, Burlington, Ia., 1882–1883. Destroyed by fire. Courtesy of A. M. Rung.

The building was 264 feet 3 inches long, its spire rising 117 feet. To the north of the porch, the well-lighted polygonal space was given to the dining hall. Kitchens and pantries were on the flank, with a helical staircase ascending to servants' quarters. To the south, the waiting rooms for men and women (distinguishable, no doubt, by the presence of cigars) were separated by the ticket counter; then came the baggage rooms, the mail room, and the express office. Some of the administrative offices on the upper stories were disposed about a narrow light well. The outer walls were mostly of a locally manufactured red brick, pressed to a dense and smooth facing. Root concentrated on the sharp wall plane, preferring segmental arches for their skipping rhythm. By repeating in the frequent chimney necks the corbel-table motif of the tower, he countered the steep pitch of the roofs and the batter of the end walls of the porch. It must have been a most handsome building.

By now Burnham & Root's commissions were becoming larger and more public. Root rarely chose, however, to delegate even a single-family residence to the office staff. For one thing, he found such clients (who often were men

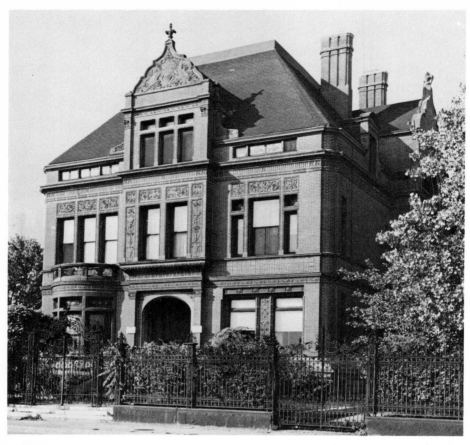

Fig. 15. Sidney Kent house, 2944 South Michigan, Chicago, 1882–1883. Photo by author.

of considerable wealth) almost ideal. They had devoted little of their time to art. Thus, he said, they came to him with "a large openness and unbiased attitude of mind."[14] One of the last surviving houses of the early 1880s was that for Sidney Kent, whose fortune, at the end of the decade, the Chicago *Tribune* somehow estimated at $5 million. Kent was among the incorporators of the Union Stock Yards. The house he built at 2944 South Michigan Avenue, in 1882–1883, again bore reminiscences of the early French Renaissance

[14] John W. Root, "The City House in the West," *Scribner's Magazine*, VIII (Oct. 1890), 433. Some years later, Frank Lloyd Wright similarly expressed his gratitude for the reasonableness of the businessman client.

but was more notable for the degree to which the east front was opened to the light (Fig. 15). In the same years, Root's dancing academy for A. E. Bournique, at 315 East Twenty-third Street, showed he had hardly escaped the Queen Anne revival—which, in his speeches, he was soon to mock.[15] The large gable of the façade was hung in scalloped shingles; and among the motley window openings was one with a tiny pediment.

With the Montezuma Hotel (Fig. 16), Root was to challenge the best shingled architecture of the East coast. The dating is problematic. In 1879, the Atchison, Topeka & Santa Fe Railroad purchased the site, about six miles northwest of Las Vegas, New Mexico. A hotel built in 1881–1882 burned in January 1884. A new hotel, on a different site, was built in 1884–1885, evidently with more sandstone in the wall, only to suffer damage from another fire in August 1885. The fire must have had much to do with the decision, before the campaign of 1884–1885, to light the hotel entirely by electricity. It was intended as a hot springs resort (Burnham, in his journals for the summer of 1883, described the steam baths, which he found exhilarating). There were three hundred guest rooms and a dining hall serving five hundred persons. While the informality of the gables and dormers and window openings did much to dissipate any strong rhythm in the building, the *basso ostinato* was to be found in the verandah, which Root carried entirely across the longer fronts. The verandah, moreover, defined the podium. The roof lines answered to the surrounding Sangre de Christo Mountains, and the mass turned its corners obliquely, settling softly into the foothills.

In August 1883, Burnham left the hot springs resort for Guaymas, Mexico, where the Santa Fe Railroad had commissioned another resort hotel. Later, the trip took him to San Francisco, and on 3 September, while he was staying at the Palace Hotel, he went out to buy a drawing board and T-square; he made a plan-sketch for the hotel in Guaymas. Root seems to have been working on the design at the same time in Chicago. In October, the *Inland Architect* described this elusive project as entailing a courtyard surrounded by "Moorish" portici, with heavy concrete walls for protection against vermin and the sun.

Amos Grannis and two masonry contractors, George Tapper and W. E. Mortimer, had commissioned the Calumet Building in 1882 as one of the

[15] A photograph of the academy is in Paul Gilbert and Charles Lee Bryson, *Chicago and Its Makers* (Chicago, 1929), p. 504. The Strahorn houses in Kenwood also were eminently Queen Anne. A view of one is in Harold M. Mayer and Richard C. Wade, *Chicago: Growth of a Metropolis* (Chicago, 1969), p. 172.

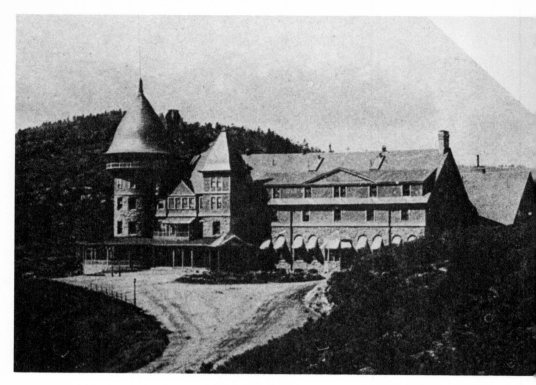

Fig. 16. Montezuma Hotel, near Las Vegas, N.M. Built and rebuilt 1884–1885.
Courtesy the Native Sons of Kansas City.

first speculative office blocks projected in anticipation of the new Board of Trade Building. But the construction was detained to allow the stone footings to settle, and the building was not finished until 1884 (Fig. 17). The site, at 111–117 South La Salle Street, had a front of 78 feet and a depth of only 51 feet, offering less than one-sixth the ground area of the Burlington Office Building. Root was left with little but the façade on which to concentrate. He was reluctant to choose a dominant rhythm, either vertical or horizontal. He indulged in various intricacies (even ceramic patterns) in an effort to create a strophic arrangement of the stories, unwittingly devaluing the wall almost to the point of suggesting gingham. To express the second story of "prestige" space he again handled the entrance as a two-story element and left the vestigial arch to droop miserably below the line of fleurs-de-lis that suggested capitals.

But in the same years, and again for the Santa Fe Railroad, he designed a fine office building in Topeka, Kansas (Fig. 18). Here was a performance

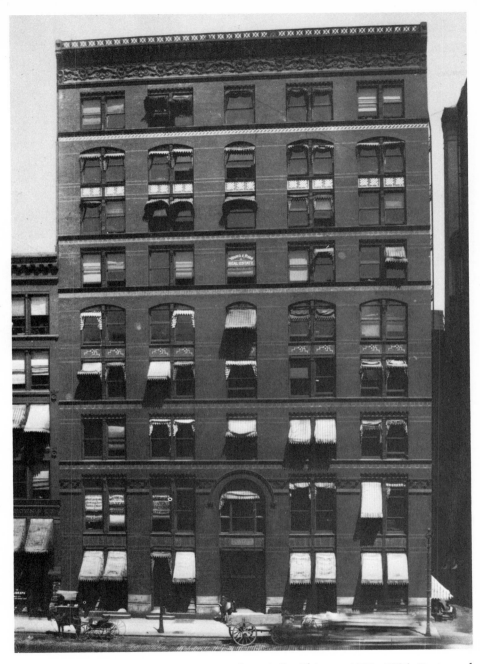

Fig. 17. Calumet Building, 111–117 South La Salle, Chicago, 1882–1884. Destroyed. Courtesy the Chicago Historical Society.

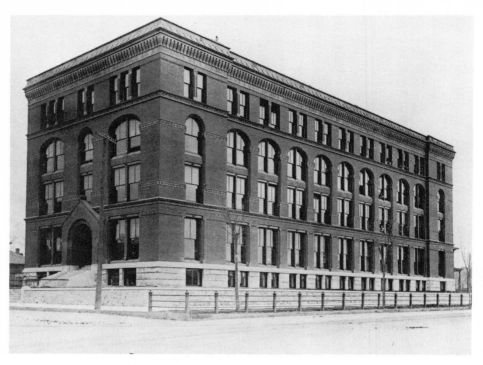

Fig. 18. Santa Fe Building, southeast corner of Ninth and Jackson, Topeka, Kans., 1883–1884. Destroyed. Courtesy the Kansas State Historical Society, Topeka.

which grew in significance when compared to such a building as the Ames wholesale store of 1882–1883 in Boston, whether the Ames building was from Richardson's hand or merely representative of his office work. The Santa Fe Building, constructed in 1883–1884 at the southeast corner of Ninth and Jackson streets, was clearly a descendant of the Burlington Office Building, although there could not have been an internal light court of great importance. In withdrawing the entrance porches to the narrow elevations, Root perhaps alluded again to railroad cars; but there was a more important intention. The rails had played a major role in the growth of the state, and the Santa Fe was, in fact, the only large industry in Topeka. The long west front of the building, bounded by the suggestion of end pavilions, addressed its absolute symmetry to the Kansas statehouse, directly across the street. Most of the ornamentation, of which there was very little, expressed the lintels, imposts, or plinths, and thus was easily subsumed by the wall. Sober

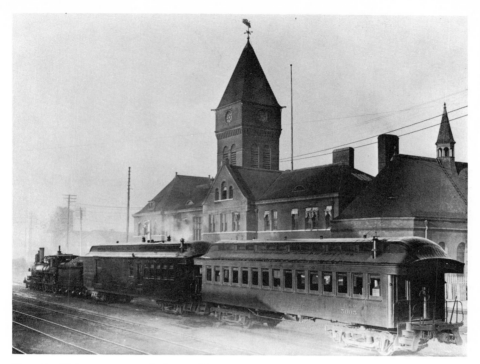

Fig. 19. Union Depot, Galesburg, Ill., 1883–1884. Destroyed by fire. Courtesy of A. M. Rung.

in color and mass, and severe in its sense of order, the Santa Fe Building attained nothing less than a prototypal exposition of the modern corporate house.

Of the several commissions from the Burlington Railroad in 1883, the most notable was that for the Union Depot in Galesburg, Illinois (Fig. 19). It was a variation of the depot in Burlington, Iowa. The tower was much narrower, and it was surmounted by a weathervane and outsized finial representing a locomotive. Again, most of the window heads were segmental. Root shaped the gable with great care and diapered the upper register. His adoption of the eyebrow dormers now spoke directly of his familiarity with the work of Richardson.

With such a palpable failure as the Counselman Building (Fig. 20), Root confessed his habit of working very rapidly, so rapidly that his art, while steadily maturing, was vulnerable at any moment to a sudden and resounding

Fig. 20. Counselman Building, northwest corner of La Salle and Jackson, Chicago, 1883–1884. Destroyed. Courtesy the Chicago Historical Society.

reversal. He designed this ten-story office block in 1883, for the grain broker Charles Counselman. It was built at the northwest corner of La Salle and Jackson streets, conveniently across the street from the Board of Trade site. The lot was small, fronting 56 feet on La Salle Street and 60 feet on Jackson. Although each elevation was dominated by four massive piers, Root reversed the arrangement of the window openings so that the south front gained a window on each story. In separating the stories, he inverted the meter of the Calumet Building, with no more success. In place of the ceramic patterns, he resorted to paneled brick and odd cofferings which may have reflected the ground plan but which, in any event, were not felicitous. He also reverted to the *piano nobile*, giving the base a suppressed appearance, even though it was executed in rusticated red granite from Jonesboro, Maine. The Richardsonian entrance arch mediated between the stories most awkwardly. Finally, when the corner of the ground story, in later years, was glazed for a cigar display, the pier was revealed to have been much broader than necessary, as anyone could have guessed—despite the fact that the desideratum had always been light.

To a great extent the Rialto Building was another obvious disappointment (Fig. 21). It, too, was a speculative block occasioned by the Board of Trade Building, to which in fact it communicated by bridges over an alley. Sidney Kent and P. D. Armour originally projected the building, but it was constructed later in the name of the Chicago Deposit Vault Company, a stock company organized by W. K. Nixon. Real estate syndicates had begun to resort to such guises: even in 1889, when Illinois law prohibited corporations from speculating in real estate, "banking" associations were still allowed to own the land and buildings deemed necessary for their own premises. Most of the so-called vault companies, noted one observer, consisted of little more than "a closet in which is stored a trunk containing a watch or two."[16]

The Rialto Building was larger than any other building Burnham & Root had done. Plans were begun in 1883 (in a letter of 25 July 1884, Owen Aldis mentioned that the "Armour-Kent" building had been under close study for a year and a half), but the construction did not get under way until the sum-

[16] "Chicago," *American Architect*, XXV (Feb. 1889), 79. Cf. *Illinois Revised Statutes*, corp. act of 1889, chap. 32, sec. 5, and banking act of 1889, chap. 16a, sec. 9. I am indebted to Fred B. Hoffmann for investigating these legal niceties. The role of safety deposit vault companies in promoting the early skyscrapers is also cited in *Sixty Years a Builder: The Autobiography of Henry Ericsson* (Chicago, 1942), p. 234.

Fig. 21. Rialto Building, 132–148 West Van Buren, Chicago, 1883–1886. Destroyed. From the Inland Architect.

mer of 1885, a few months after the Board of Trade occupied its new home. All the footings were evidently of criss-crossed steel rails; at last Root put to work on full scale his innovation of 1881. The south front extended 175 feet on Van Buren Street, the block reaching north 157 feet along Sherman and La Salle streets. This generous site accommodated external light courts on the east and west, and an H-plan opening the four hundred office suites to daylight and natural ventilation. Root now treated the second story as an

entresol and joined it with the ground story by inset oriels very handsomely delineated. The entrance screens on the east and west opened to skylighted circulatory courts. The plan, indeed, was far superior to the elevations, where Root seemed intent on pursuing the unpromising course of the Counselman Building. His proportioning of the principal piers was again gross; he stepped back the intermediate piers as if they were buttresses, until they arrived at the brackets beneath the ponderous balconies (suggested, perhaps, by a less conspicuous detail of Richardson's Cheney Block of 1875–1876, in Hartford), whence they lurched past the cornice into barbaric terminals. The only reasonable apology for the roofline lay in its response to that of Boyington's perverse Board of Trade Building.

The spring of 1884 brought commissions for two major office blocks. The first was a project for the "John Quincy Adams Building," which would have stood at the southwest corner of Dearborn Street and Calhoun Place, nine stories above a raised basement. But it was abandoned by July 1884. The second was the Insurance Exchange Building, finished in the summer of 1885 (Fig. 22). Again, the stock company was organized by W. K. Nixon, who also rebuilt the Grannis Block after the fire of 1885. The plan of the Insurance Exchange Building measured 165 feet on La Salle Street and 60 feet on Adams Street, at the southwest corner. An external light court was at the west, with an oriel stair tower climbing the wall. C. H. Blackall, a Boston architect who had been graduated from the University of Illinois in 1878, saw the building soon after it was finished, and remarked on the strong cherry hue of its walls. He saluted the brickwork as one of the finest examples in Chicago, if not in the entire country; while R. C. McLean, as late as 1922, in recalling the 1880s in Chicago as a face-brick romance, said the Insurance Exchange was the city's greatest achievement in brickwork.[17] The building could stand comparison, certainly, with Richardson's Sever Hall, at Harvard.

Root gave the east front the same number of bays that he was to give the Mills Building in 1890; but he organized the façade in a more academic way by enlarging the piers that flanked the entrance. The problem then became one of relating the cyclopean entrance arch to the much lesser scale of the fenestration. First he echoed the elegant tourelles of the angles. (Blackall, having returned from a Rotch Traveling Fellowship in Europe, thought the tourelles were inspired by the brick fortress-church of Ste. Cecile, at Albi.)

[17]C. H. Blackall, "Notes of Travel: Chicago—III," *American Architect*, XXIII (Feb. 1888), 89–90; and R. C. McLean, "The Passing of the Woman's Temple," *Western Architect*, XXXI (1922), 14.

Fig. 22. Insurance Exchange Building, southwest corner of La Salle and Adams, Chicago, 1884–1885. Destroyed. From the Inland Architect.

Above the balcony, at the fifth story, he broke the march of segmental lintels by displacing three to the story above; then with both stories eccentric, he gave them heavy sills on corbel tables. But apart from such problems, he lavished attention on bounded areas of brick enlivened by details in cut brick, rounded brick, razor-edged brick, stratified courses of brick, and, occasionally, foliated terra cotta. In each angle pier the arris sliced halfway through the corbel of the tourelle with astonishing accuracy: the pencil in Root's hand, as it were, could be read in the wall.

R. C. McLean once said Root was such an impassioned critic of his own work that he would often mutter how he wished he could employ a first-class incendiary. But the failures served, at the least, as measures for his successes. The speculative office building at 305–315 South La Salle Street, announced in September 1884 and finished the next year, was one of the failures (Fig. 23). It was only eight stories high, and thus inexplicably heavy. The archaic Romanesque porch aspired to a monumentality irrelevantly reminiscent, and the corbeled parapet assumed a grotesquely warlike posture. The building was named for the Traders Safe & Trust Company, which evidently occupied only one room.

The commission for the warehouse and office building for the McCormick Harvesting Machine Company was announced in September 1884, four months after the death of Cyrus Hall McCormick. Although the architect for the estate was A. M. F. Colton, in this instance Colton's role was confined to supervision. The site was at the edge of the wholesale district, on the southwest corner of Wacker Drive and Jackson Street (Fig. 24). When the program was changed to the extent that six stories, instead of seven, were called for, Root eliminated a heavy sillcourse at the fourth floor and unified the stories between the base and attic under a broad and shallow arcade. The capitals, which he ornamented with an interlace expressive of the structural connection of piers to spandrel beams, were held within the same plane. He striated the arcade spandrels to prepare the wall for the sillcourse of the attic; and beneath the machicolated cornice he rigorously incised the attic openings. The wall, then, was keenly delineated with a straightforward and rational spirit, and with a great deal of refinement.[18] The first set of plans

[18] Condit, in *The Chicago School*, pp. 58–59, praises the same kind of wall in the Dexter Building, at 39 West Adams Street, which he identifies as an 1883 structure commissioned from Burnham & Root but designed, for some reason, by Clinton J. Warren. The Dexter Building, however, must be dated after 1890; it was built some time later than Cobb & Frost's Owings Building next door. Probably it was a steel-framed building. Warren after 1886 was on his own.

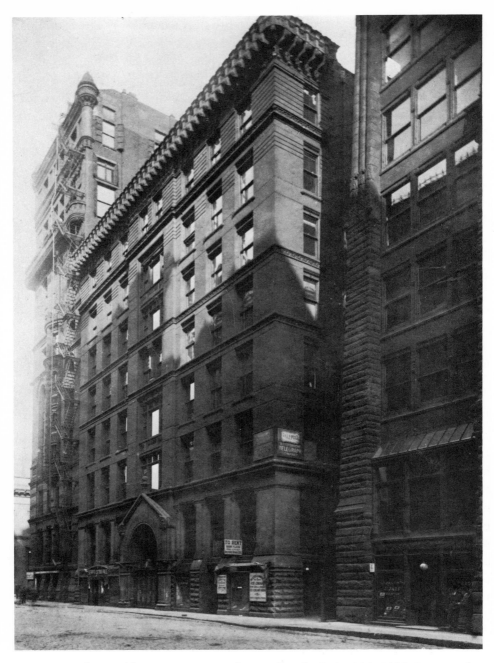

Fig. 23. Traders Building, 305–315 South La Salle, Chicago, 1884–1885. Destroyed. Courtesy the Chicago Historical Society.

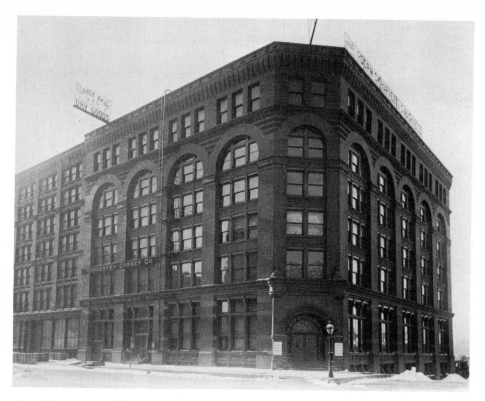

Fig. 24. McCormick Harvesting Machine Co. Offices and Warehouse, southwest corner of Wacker and Jackson, Chicago, 1884–1886. Destroyed. Courtesy the Chicago Historical Society.

had been finished by December 1884; in April 1885 the commission for the Marshall Field Wholesale Store, at a site only two blocks away, went to H. H. Richardson. To get the benefit of his thinking on foundations, Richardson called on Root in his private office in the Montauk Block.[19] Not only is it likely that Root showed Richardson what work he had on the boards, but that Richardson took note of the general character of the city's wholesale district; and Richardson's finest commercial buildings, the Harrison Avenue Ames Building in Boston and the Field Wholesale Store, will never be fully understood without some attention to what he saw in Chicago.

[19] J. K. Freitag, *Architectural Engineering*, 2nd ed. (New York, 1901), p. 311, reports that Richardson nevertheless reverted to the Eastern practice of estimating the live loads on both the interior columns and the exterior walls, with the result that the floors of the store buckled at the center.

In 1885, Burnham & Root and Richardson came into direct competition as contestants for the Chamber of Commerce Building in Cincinnati, Ohio. Richardson's entry, although it was virtually a parody of his own better work, was premiated on 8 June. (More than twenty years later, Burnham told Charles Moore the building was merely "a château badly lighted and arranged, and entirely unfit *per se* for street architecture.") Root's performance was no more commendable. A surviving holograph drawing (Fig. 25) seems to represent his search for a motif, although the sketch is clearly inadequate to the program, which called for several floors of commercial space in addition to a three-story hall for the Merchants Exchange. Both the sketch and his competition entry (Fig. 26) illustrate his greatest weakness: the tendency to have recourse to a historical type.

Several lesser commissions of 1885 may be mentioned. One was for a spare brick structure at 512–520 South Wells Street to house the wagon factory of I. N. Walter Sherman, the brother of Burnham's father-in-law. It stood four stories high and fronted for 107 feet. As to the little house built at 60 Bellevue Place for Edward A. Burdett, a stove manufacturer, one could not deny it a certain piquant charm (Fig. 27); the critic Schuyler observed that the Queen Anne revival had grown to embrace the Flemish Renaissance. Another railroad commission, the Kansas City, Fort Scott & Gulf Depot in Fort Scott, Kansas, resulted in a modest and appropriate building (Fig. 28).

The commission for the Armour Mission, at the southeast corner of Thirty-third and Federal streets, was announced in September 1885. The drawings are dated October and November, and the building was dedicated in December 1886. Joseph Armour had left $100,000 for a memorial. The mission, as a nonsectarian welfare institution, offered medical services, child care, manual training, lectures, and prayer meetings—all within one building which measured 84¾ feet on the north front and 135 feet on the side elevations (Fig. 29). The plan took form from a galleried and skylighted assembly hall seating 1,300 persons. The hall was spanned by great wood trusses which supported the high hipped roof, and was expressed in the side elevations by the arcades. The ground story was of Marquette brownstone, the rest of the wall in red pressed brick with details in cut brick and terra cotta. The octagonal stair towers, stationed about 45 feet back from the entrance porch, gave to the mass a kind of zealous militancy symbolic of a program devoted to the improvement of the poor. Root was to turn again to this sturdy and almost Byzantine articulation for his Church of the Covenant.

Such symbolic content in Root's architecture should never be overlooked. Even in the house for E. E. Ayer, built in the same years at the northeast corner of State and Banks streets (Figs. 30–32), it is important to note that Ayer, an amateur anthropologist, had made his fortune in lumber, mostly railroad ties. The massive oak door was strapped with iron hinge-plates, the steps of the splendidly paneled stair hall clattered down over the flues of the fireplace, and the principal rooms—glowing in the light from the amber-colored facets of the windows—were shaped by great ties of oak. Root addressed the house south, pinning its salient with a large turret and carrying the mass gradually down to the east. He kept strict control of the sills and frequent window openings in order to conserve the sober texture of the rubble wall in split granite boulders, and when the chimneys and dormers threatened confusion, he imposed a strongly textured roof in red tiles. That the motif of the Syrian entrance arch was reminiscent of Richardson's rectory for Trinity Church in Boston and contemporary with the servants' entrance of the house Richardson had under construction for J. J. Glessner, in Chicago, was of less significance than the evidence that Root had recognized in Richardson's work—for all of what P. B. Wight called its "constructive rudeness"—the values of studied massing and disciplined vigor.

The building for the Art Institute of Chicago bore much the same witness to Root's debt to Richardson (Figs. 33–34). Incorporated only in 1879, the Art Institute in 1882 purchased a site fronting 54 feet on Michigan Avenue and 171½ feet on Van Buren Street, on the southwest corner; and, with a budget of only $22,000, Root designed for the west 71½ feet a small and rather Elizabethan building, the galleries of which were opened on 13 January 1883. In the summer of 1885 the trustees acquired the 26-foot lot to the south. An old building on the corner soon was razed, and Burnham & Root were commissioned to design a new Art Institute to front 80 feet on Michigan Avenue. The foundation was laid in the spring of 1886 and the galleries were opened on 18 November 1887. From a perspective study published in the *American Architect* of 17 April 1886 (when the design already must have been under revision) it is apparent that Root abandoned an awkwardly scaled dormer on the east front and eliminated four round-arched window openings for two clusters of keenly cut, rectangular lights. He flared the southeast angle so that the Romanesque entrance arch would be better accepted, and weighted the angles with solid tourelles—"there can be no better guaranty that the house will 'stay where it was put,' " he once wrote, "than

Fig. 25. Cincinnati Chamber of Commerce competition, 1885. Early study by John Root. Art Institute of Chicago, gift of E. S. Fetcher.

50 JOHN WELLBORN ROOT

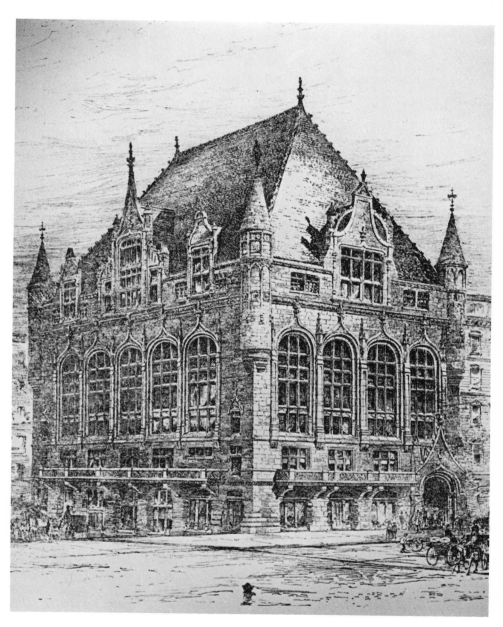

Fig. 26. Cincinnati Chamber of Commerce competition entry. From the American
Architect, *courtesy Avery Library, Columbia University.*

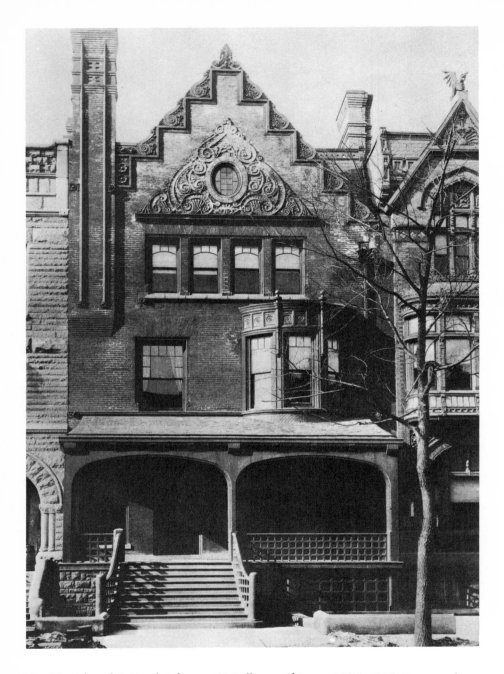

Fig. 27. Edward A. Burdett house, 60 Bellevue, Chicago, 1885–1886. Destroyed. From the Inland Architect.

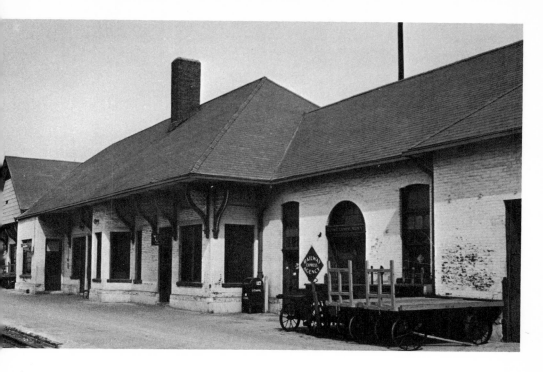

Fig. 28. Kansas City, Fort Scott & Gulf Depot, Fort Scott, Kans., 1885–1886. Tower destroyed. Photo by author.

the presence in it of masses of simple masonry at its angles."[20] His proportioning of the fenestration was impeccable, and the wall itself became a magnificent fabric in Connecticut brownstone and Denver red sandstone. The portrait heads at the least were not obtrusive. Blackall visited the building and found the interior comfortable, but the regular correspondent of the *American Architect* thought the rooms had been obliged to work themselves out for the sake of the elevations. Referring to the bizarre sculpture atop the acroterion, he also chastised the "selection of a torso to do duty as a finial," and perceptively noted that the building might be mistaken as a club house: within five years, in fact, it became the Chicago Club.[21] Yet the basic problem resided in the program presented to Burnham & Root. Much of the

[20] John W. Root, "Style," *Inland Architect*, VIII (Jan. 1887), 99.
[21] *American Architect*, XXIII (Jan. 1888), 30; Blackall's comments are in "Notes of Travel: Chicago—IV," *American Architect*, XXIII (March 1888), 142.

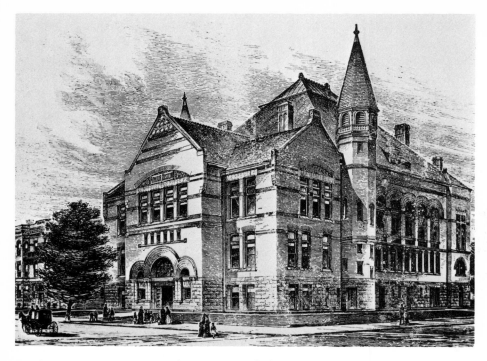

Fig. 29. Armour Mission, southeast corner of Thirty-third and Federal, Chicago, 1885–1886. Destroyed. Courtesy the Illinois Institute of Technology.

building was to be rented to clubs and to artists; and the museum itself consisted only of a dozen small galleries.

The last months of 1885 found Root at work on three office buildings, one of them of an unprecedented size and complexity. By December, excavations were under way for the Commerce Building, the Phenix Building, and the Rookery; and the foundation work was continued through the winter, the laborers under cover and heated by salamanders. Dankmar Adler was quick to see that this meant less elapsed time before a building could begin to earn returns. "In regard to Burnham & Root's construction of foundations in winter under cover," he said at a meeting of the Illinois State Association of Architects, "they deserve great credit, in the same degree as is awarded to the man who causes two blades of grass to grow where one grew before."[22]

[22]*Inland Architect*, VII (Feb. 1886), 16. During the same meeting, Root said modestly that both the winter foundations and the rail-grillage technic resulted from simple necessity.

The smallest of the three office buildings was the Commerce Building, at 319 South La Salle Street (Fig. 35).[23] The front was only 50 feet and there were only a few offices on each story (Fig. 36). Nevertheless, the building enjoyed a certain rude vigor, the stilted entrance tunneling into half the façade, the quarry-faced brownstone piers giving way at the sixth floor to drastically attenuated cluster columns, and the spandrels retreating from the piers to become simple curtains of brick across the iron beams. Root carried this kind of structural articulation even further at the shallow light court of the north wall, where the stories were merely strips of windows bounded by the massive piers—which, like great chimneys, shot straight to the parapet.

It was through Thomas R. Burch, presumably, that Burnham & Root gained the commission for the Phenix Building (Figs. 37–38); Burch was general agent for the Western offices of the Phenix Insurance Company of Brooklyn, and his house at 2637 Prairie Avenue had been designed by Root a few years earlier. The Phenix Building fronted 216½ feet on Jackson Street, stretching all the way from Clark Street to La Salle Street. Such prominence served only to magnify the idiosyncrasies of the elevations. The arcuation occurred at a meaningless height, the oriels (as Schuyler said) were too domestic in scale and too ornate for their purpose, and the knobby little projections—which Henry Van Brunt thought reminiscent of the Buddhist temples of India—were most unpleasant incidents. Finally, to crown the entrance bay, there was a yoke-like pediment, coarsely embellished with a huge terra-cotta representation of the phoenix. And yet Root's handling of the interior space was masterly. At the vestibule (Fig. 39), he reiterated the arch of the entrance and created vistas through plate glass, heightening the spatial ambiguities and the complex patterns of movement through transparencies and reflections. He enhanced this fantasy with writhing electroliers, surely a proto–Art Nouveau conceit. On the ninth floor he opened the entire space to a single room accommodating hundreds of clerical workers (Fig. 40). This space, celebrated already in 1887 as "the glory of the building," was occupied by the insurance company.[24] It presented an astonishing visual document of the dawn of the modern corporation.

[23] Burnham's diaries for 1895, now in the Burnham Library of the Art Institute of Chicago, show that he had a financial interest in the Commerce Building, as well as in the Central Market, Great Northern Hotel, Chemical Bank, Masonic Temple, and Equitable Building. Presumably, Root likewise had shares of stock in these ventures.

[24] A Week in Chicago (Chicago and New York, 1887), p. 58. The ninth floor provided 9,750 square feet, more than three times the area of the unobstructed thirteenth floor of Adler & Sullivan's Schiller Theater Building of 1891–1892, which is occasionally cited as a proto-modern space.

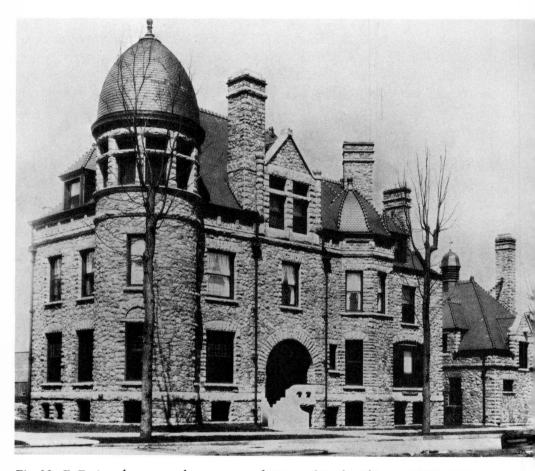

Fig. 30. E. E. Ayer house, northeast corner of State and Banks, Chicago, 1885–1886. Destroyed. From the Inland Architect.

Fig. 31. (opposite page, top) *E. E. Ayer house. Stair hall. Photo by Historic American Buildings Survey.*

Fig. 32. (opposite page, bottom) *E. E. Ayer house. Dining room. Photo by Historic American Buildings Survey.*

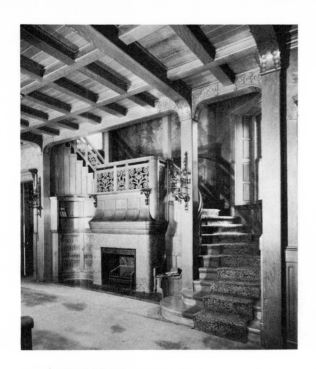

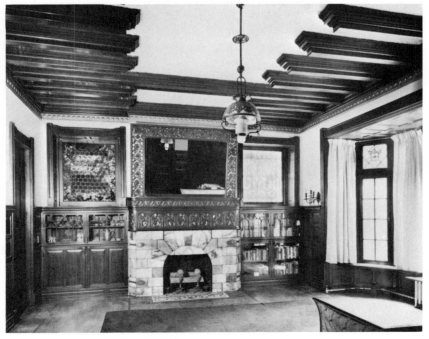

57 *A BEGINNING: 1880–1885*

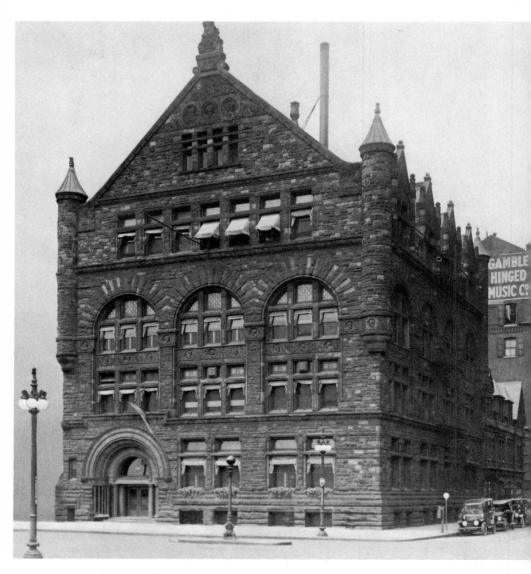

Fig. 33. Art Institute, southwest corner of Michigan and Van Buren, Chicago, 1885–1887. Destroyed. Courtesy the Chicago Historical Society.

58 JOHN WELLBORN ROOT

Fig. 34. Art Institute. Entrance hall (top) *and gallery IX. From* Harper's Weekly.

Fig. 36. Commerce Building. Plan of typical floor. Courtesy of Aldis J. Browne, Jr.

Fig. 35. Commerce Building, 319 South La Salle, Chicago, 1885–1886. Destroyed. Courtesy the Art Institute of Chicago.

Fig. 37. Phenix Building, 111 West Jackson, Chicago, 1885–1887. Destroyed. Board of Trade Building in background. From the Inland Architect.

61 *A BEGINNING: 1880–1885*

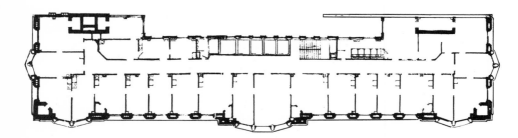

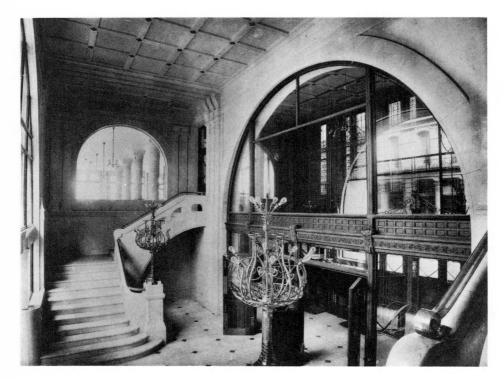

Fig. 38. (top) *Phenix Building. Plan of sixth floor. Courtesy the Art Institute of Chicago.*

Fig. 39. (bottom) *Phenix Building. Vestibule. From the* Inland Architect.

62 JOHN WELLBORN ROOT

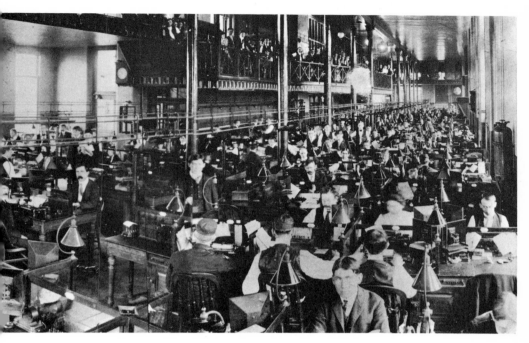

Fig. 40. Phenix Building. Ninth floor. Courtesy of C. T. Baumgart, the Western Union Telegraph Company.

P. B. Wight was perhaps the first to record how the framing of the south light-well of the Phenix Building attained skeletal structure in the purest sense:

... [Jenney's] Home Insurance Building is not an example of skeleton construction as now understood. In that building the brick piers are built entirely around the cast-iron columns except in the original upper story, where they are covered with tile on the inside. There is no separate and independent lining of hollow tile. The first building in which a complete skeleton wall was built, that I am aware of, was the Phenix Insurance Building ... in which the rear wall, or about one hundred lineal feet of it, is a complete skeleton construction, with enamelled brick on the outside, and a hollow tile wall on the inside. Each is supported on its own system of horizontal beams. This ... was the prototype of the court construction of the Rookery.[25]

[25]P. B. Wight, "Skeleton Construction," *Brickbuilder*, IV (Jan. 1895), 13. Freitag, in *Architectural Engineering*, p. 149, writes that the columns were cast, and had two sets of horizontal supports at each story: the outer I-beams, resting on brackets connected to the columns, carried a 4½-inch curtain of enameled brick, and the inner I-beams carried a 4-inch wall of hollow tile. Thus the wall was formed of two layers or "skins."

III · THE ROOKERY

Two events at the middle of the nineteenth century had seemed to conspire against John Ruskin: one was a very large building and the other was a little book with a very long title. The building, of course, was the Crystal Palace. The book was Edward Lacy Garbett's.[1] The inventor of the Doric order, wrote Garbett, possessed the greatest mind ever directed to architecture. From the Gothic system of construction a second pure style had been developed. Now, in the nineteenth century, England was claiming a national style, which, in truth, was a national shame—a modern Gothic of falsehood. Garbett argued that a true architecture remained to be discovered in the tensile or truss system of construction; and, with a much too evident delight, he asserted that the value of ornament in architecture depended not in the slightest on manual labor, but rather on the quality of mental labor. Ruskin, then, could hardly keep quiet; he was obliged to defend the traditional values of architecture, as he saw them.

At the time the issue appeared to be basic: how to resolve the opposition of the solid wall or masonry vault to the evermore obvious potentialities of glass-and-iron structure? Ruskin took refuge in the most curious notion that form, in its perfection, could be expressed only on opaque bodies without lustre; and to this he appended a syllogism:

No noble work in form can ever, therefore, be produced in transparent or lustrous glass or enamel. All noble architecture depends for its majesty on its form: therefore you can never have any noble architecture in transparent or lustrous glass or enamel.[2]

[1] E. L. Garbett, *Rudimentary Treatise on the Principles of Design in Architecture as Deducible from Nature and Exemplified in the Works of the Greek and Gothic Architects* (London, 1850). Greenough and Emerson greatly admired Garbett's book. William Le Baron Jenney also knew it.

[2] John Ruskin, *The Stones of Venice*, 3 vols. (London, 1851–1853), I, 405–406.

So much for glass. Yet iron was opaque, and Ruskin admitted that perhaps it could be rendered "lustreless" and fit to receive a noble form. Iron, however, was cast—a multiplicable thing—and thus not capable of properly receiving the muscular action of the human hand. It could not testify to human labor, it could not express moral purpose or thought.

By 1885, John Root had long since read Ruskin and Garbett (whose little book he was particularly fond of), and had also read James Fergusson and Viollet-le-Duc. He knew the issues, and he knew the construction of the first great train shed in America. In his own buildings he had seen that the apparent disparity between masonry outer walls and interior vaults of glass and iron—far from being an unfortunate contradiction—could be turned to great advantage as a kind of architectonic counterpoint. Glass in a commercial building was simply a necessity, both for storefronts and for opening the office suites to light, and he welcomed glass as perhaps "one of the most important of the building materials of the future."[3] Likewise, beyond the requirements of fireproofing, he saw no reason to disguise his employment of iron. More important, he saw that glass and iron could take on values other than structural and functional ones. Thus in the Rookery, between the obsidian outer wall and the vaulted internal court, he created passages from darkness to light; he carried one structural system into another, and a great masonry mass into a romanza of space and movement. The Rookery was his Falstaff, a rich and lusty building (Fig. 41).

The site is still owned by the city of Chicago. Burnham's old friend E. C. Waller arranged to lease it for ninety-nine years. In May 1885 the *Inland Architect* reported that "sketches" had already been made for a large building, even though the architect was not definitely appointed. Of the investors whom Waller represented, the principals were Peter Brooks and Owen Aldis; and, in a letter of 22 October 1885, Brooks proposed Burnham and Root as the architects. Waller executed a formal lease with the city on 3 December 1885 and the next day assigned it to the Central Safety Deposit Company, which had just been organized with Aldis as president; the two Brooks brothers held the controlling interest. By the end of March 1886, granite work was beginning to show above ground. Extant drawings are dated between April 1886 and October 1887. The building was finished in the early months of 1888; and, in April, Burnham and Root took their offices at the southeast corner of the eleventh floor (see Figs. 55–56).

[3] John W. Root, "Fire-Insurance and Architecture," *American Architect*, XX (Sept. 1886), 150.

Root must have known the importance of the commission quite early, for the site immediately suggested what Montgomery Schuyler was to call a Roman largeness of plan (Fig. 42). Just as soon, perhaps, there arose the problem of an unsavory name: the Rookery. After the great fire of 1871 the city for more than thirteen years occupied the southeast corner of La Salle and Adams streets with a temporary City Hall. As legend had it, a man accosted the mayor about the nuisance of pigeons, and he called the building a rookery. Because the word so pithily alluded to the crowding of the building as well as to its dilapidation, to municipal corruption as well as to the bird nuisance, the public prints had been happy to adopt it. The early drawings for the new building were tentatively labeled "Central Building," and, in a letter of 22 April 1886, Peter Brooks valiantly offered twenty-two other possible names, most of them resembling that of the Montauk Block—"I have a fancy for Indian names," he added, somewhat redundantly. How he must have worried: as late as 11 August 1887, Aldis wrote him that no name but the Rookery could stand—"it seems utterly impossible to give any name to it by which it will be called except that."

In giving the building a quadrangular plan, Root was less indebted to the precedent of the temporary City Hall (a brick structure surrounding a water tank) than to the dimensions of the site. With 177 feet 8 inches on La Salle Street and 167½ feet on Adams Street, the site could accept a large internal court and two tiers of offices on every side. However, for Root much of the spirit of the building came from its name. The rook was a handsome, gregarious kind of bird, and so was Root; and he, for one, must have been willing to wager all along that so pungent a name stood a very good chance of prevailing. The value of the name, Peter Brooks notwithstanding, resided in its wealth of associations. At the La Salle Street entrance the little rooks carved in the gray granite imposts, which surely would have satisfied Ruskin by evincing the muscular action of the human hand, were only the most literal allusion (Fig. 43). For the building was pervaded by intricacies and lush foliate intertwinings (were they not nest-like?); and the framing of the glass-and-iron vault of the court suggested countless roosts, a most fantastic aviary (see Fig. 51).

Root presumably took secret pleasure vis-à-vis Peter Brooks, who always was content to express his opinions from Boston, never traveling to Chicago to see the buildings his money was bringing into being. Brooks, indeed, was baffled by the elevation drawings, which he considered neither Richardsonian nor clearly Romanesque. "I am surprised that Messrs. Burnham & Root do

not improve in their elevations," he had written Aldis on 22 April 1886; "they might do so instead of retrograding. Plain massiveness is often most effective, as frequently and happily shown in Richardson's exteriors." It is significant that by this time Root could choose not to revise his design to suit Brooks. In fact, he asserted his hand, and while the details of plan, structure, and color might be justified rationally, the range of expression was imaginative and even perilous. Root could, if need be, conceal from Brooks this vast visual metaphor by reference to the belated wave of the "Moresque." In 1885, even the *Sanitary Engineer* published a drawing of a balcony at the palace of Agra, and in the same issue of the *Inland Architect* that reported Waller's negotiations for the site of the Rookery there was a "Design for Moresque Decoration" by a member of the new Chicago Architectural Sketch Club.[4] Root had resorted to Moorish precedents for the railroad hotel project in Guaymas and he was adopting Moorish ornamental motifs in certain rooms of the E. E. Ayer house. He could have referred readily to the *Plans and Details of the Alhambra*, which Owen Jones had published in the 1840s, or to the popular plates of *The Grammar of Ornament*, published first in 1856 and often reprinted, where details from the Alhambra again were presented as "the very summit of perfection of Moorish art."[5] A few months after the Rookery was finished, a correspondent reported from Chicago, rather drily, that "the people talk learnedly of Romanesque lines and Moresque exteriors."[6]

In the foundation of the Rookery, Root was served very well by his rail-grillage technic. The footings had to be kept out of the basement, where the Central Safety Deposit Company (in this instance, more than a convenient fiction) intended to have its vaults. At the same time, in a building with such great loads, the risk in taking the footings below the crust of blue and yellow clay was extreme. He set the basement floor 9 feet 8 inches below grade, and still carried no footing as far down as 13 feet. The cement base of each footing was only 17 inches high, and the four tiers of rails added only 19 inches (Fig. 44).

[4] *Sanitary Engineer*, XI (Feb. 1885), opp. 230; *Inland Architect*, V (May 1885).

[5] In *The Grammar of Ornament* (London, 1856), compare "Moresque No. 4," fig. 6 with the detailing of the oriel staircase; the several figures of "Moresque No. 1" with the carving at the west entrance; and "Arabian No. 2," fig. 22 with the arabesques of the west vestibule. Vincent Scully, Jr., in "Louis Sullivan's Architectural Ornament," *Perspecta*, V (1959), 78, notes that Sullivan obviously studied Islamic motifs. See also Gerald Steven Bernstein, "In Pursuit of the Exotic: Islamic Forms in Nineteenth-Century American Architecture," Ph.D. diss., University of Pennsylvania, 1968.

[6] W. H. Howard, "The New Chicago," *Harper's Weekly*, XXXII (June 1888), 451.

A nice attention was also directed to the lower stories of the south and east elevations, where the neighboring buildings cast their shadows. Root dissolved the wall into a translucent membrane of plate glass and carried the masonry above the third floor on girders supported by doubled cast columns (Fig. 45). For the lower stories of the principal elevations, he returned to the inset oriels of the Rialto Building, but changed the intermediate piers into round columns of polished and reflective red granite, the columns being somewhat thinner than the brick piers above (Fig. 46).[7] Brooks, of course, had his point about the overall elevations. On both street fronts the strong beltcourses merely stacked one arcade on top of another, and the bays were differentiated in a way which said less about sensibility than about compositional determinism. Only at the east wall, on the alley, were there ten bays of equal width. At the opposite wall, where the entrance arch surely was noticeable enough, the first five stories above it were slightly bowed, a balcony was slung between the haplessly elongated tourelles, a parapet and flag mount were thrust toward the sky, and the bay was distended to almost three times the width of the other bays. At the south wall, facing Quincy Street, again the center bay was widened; and on the north, where the entrance bay was off-axis, the symmetry was imposed by a matching bay which signified nothing else.

The outer wall of the Rookery nevertheless attained a virile and homogeneous character, standing foursquare against the daily assaults of smoke; and because the smoke of the city was visibly diminishing its daylight, a very large proportion of wall was given to window openings (see Fig. 41). Root relieved the inertness of the masonry by rounding the edges of the inner piers to a 6-inch radius, and the outer edges of the angle piers to a 4½-inch radius; this created the subtle illusion of light bending around corners. What was hardly apparent in these walls of brick and terra cotta was the amount of metal in the lintels, or the beams within the masonry, or the strands of hoop-iron girding the fabric to invest it with greater stability: a primitive technic,

[7] Root probably took this detail from the third and fourth stories of the Studebaker Brothers warehouse on Michigan Avenue, a rendering of which was published in the *Inland Architect*, VI (Nov. 1885). The commission was S. S. Beman's, but Irving K. Pond later claimed that he "designed and drew free hand" the elevations of the warehouse while he was working for Beman. The columns of the Rookery made better sense than those of Adler & Sullivan's Guaranty Building of 1894–1895, in Buffalo, which clumsily pierced the storefronts and, moreover, were at odds with the framing above. Even less pardonable were the monolithic granite columns decorating the Peoples Gas, Light & Coke Building on Michigan Avenue as late as 1911—sure evidence of the decline in Burnham's office after the death of Root in 1891 and the death of Atwood in 1895.

yet one conceptually not unlike the reinforcement of concrete. The floors were framed with wrought-iron beams on 7-foot centers reaching from the piers to the single line of interior columns, the columns being spaced on centers of about 20 feet, and joined with girders composed of two 15-inch iron beams. Most of the framing members were 15-inch beams. The flat arches of terra-cotta filling between them now were designed to protect even the lower flanges. In the plan of a typical floor the columns were absorbed by the partitions, and thus presented no additional obstruction.

But the wall of the internal court was an independent skeleton (Fig. 47). Its basic purpose was precisely defined: to admit the maximum amount of light to the inner tiers of offices. A continuous line of 12-inch iron beams and 7-inch channel irons, fireproofed on all sides, carried the floor loads and the entire weight of the enameled brick and terra-cotta facing. As in the detailing of the capitals of the McCormick Warehouse, the ornamentation of the terra cotta represented more than a conventional guilloche; it symbolically expressed the tension in the beams and the connections of beams to columns. The detailing of the oriel stair housing (see Fig. 53) was equally accurate. The court of the Rookery was its heart; and in Chicago, as Root was to remark a few years later, offices facing a large internal court were thought to be fully as desirable as offices facing the streets.

So complete was the change in structure between outer wall and inner wall that the skeleton of the court was set lower, in the expectation of greater settlements in the masonry outer piers. The change in ambience of color, light, and space was just as radical. The entrance on La Salle Street struck a darkling and mysterious note (Fig. 48), then opened to a vestibule shimmering in white marble and elegant interlaces carved against a gold ground (Fig. 49). The space at once became active and complex. Crypt-like archways led to the safety vaults while the main stairs doubled back to the entresol, the balustrade bowing inward and wedging the space toward the elevators. Below this extraordinary marble bridge, the space was compressed and channeled to the elevators again, thence to the court, where a grand stairway near the east wall ascended again to the entresol (Fig. 50). C. H. Blackall, in his "Notes of Travel," considered these rather ceremonial stairs gratuitous, arguing that they failed to connect with other stairs, and thus led nowhere. In truth, they served the suites of the entresol, where prestige tenants were expected to advertise the rest of the building. Moreover, they activated a nearly squared space that would have been much too static.

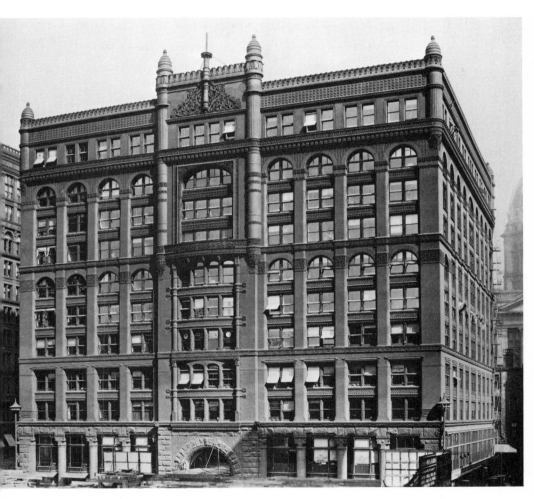

*Fig. 41. The Rookery, southeast corner of La Salle and Adams, Chicago, 1885–1888.
Ground story obscured. Photo by Chicago Architectural Photo Co.*

71 *THE ROOKERY*

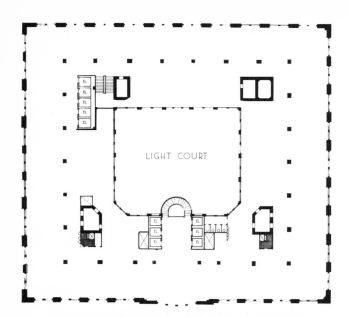

Fig. 42. The Rookery. Plan of typical floor. Courtesy of Sudler & Co.

Fig. 45. The Rookery. Detail of south wall. Photo by author.

Fig. 43. The Rookery. Granite detail at west entrance. Photo by author.

Fig. 44. The Rookery. Section of footing. From the Engineering and Building Record, *courtesy Linda Hall Library.*

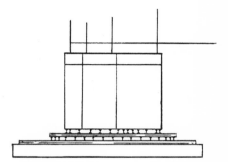

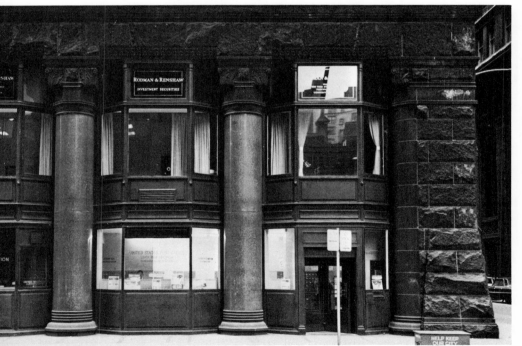

Fig. 46. The Rookery. Detail of west wall. Photo by author.

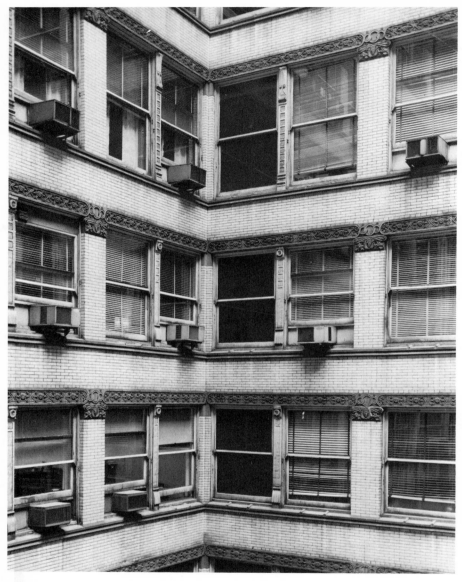

Fig. 47. The Rookery. Detail of court wall. Photo by Thomas Knudtson.

Fig. 48. (opposite page, top) *The Rookery. West entrance. From the* Inland Architect.

Fig. 49. (opposite page, bottom) *The Rookery. West vestibule. From the* Inland Architect.

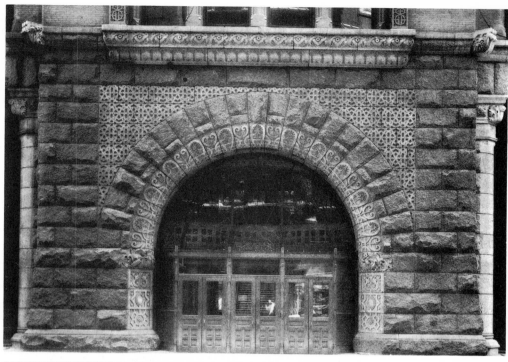

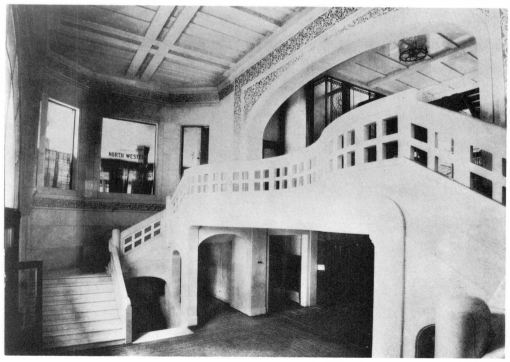

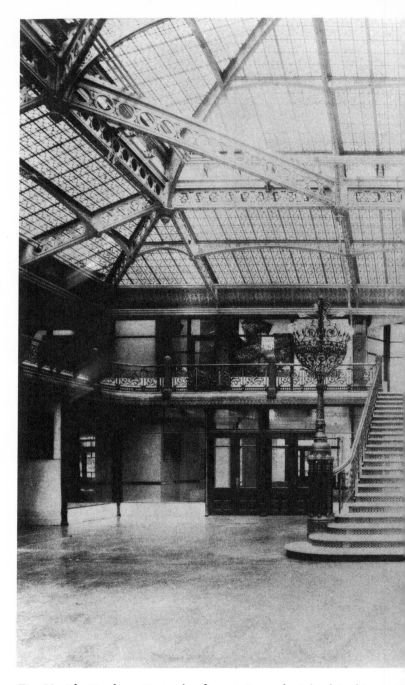

Fig. 50. The Rookery. East side of court. From the Inland Architect.

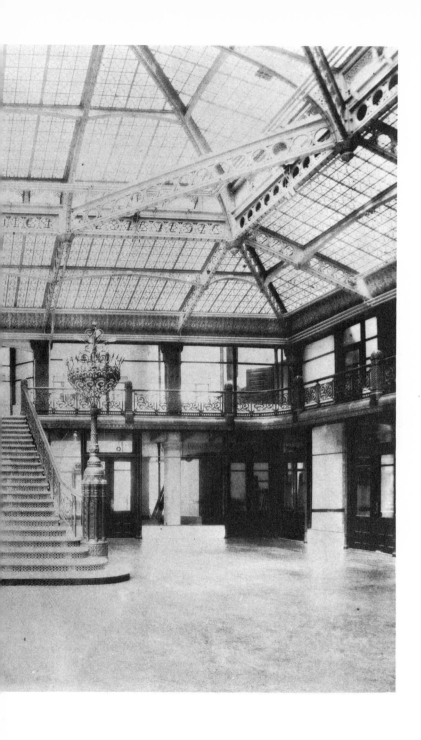

77 *THE ROOKERY*

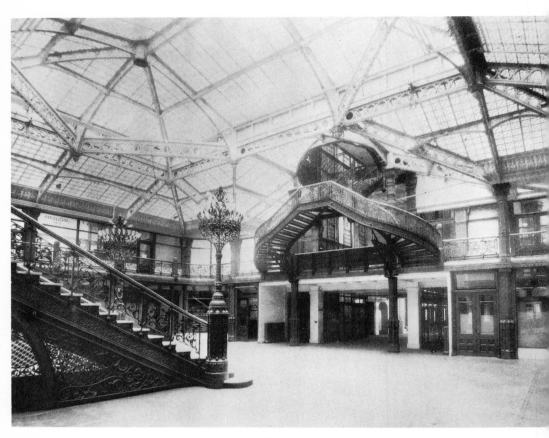

Fig. 51. The Rookery. West side of court. From the Inland Architect.

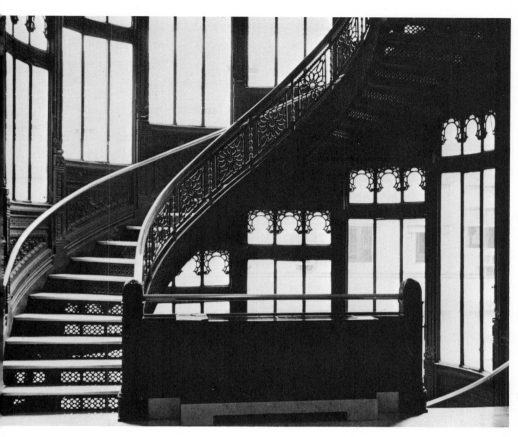

Fig. 52. The Rookery. Landing of oriel stairs. Photo by author.

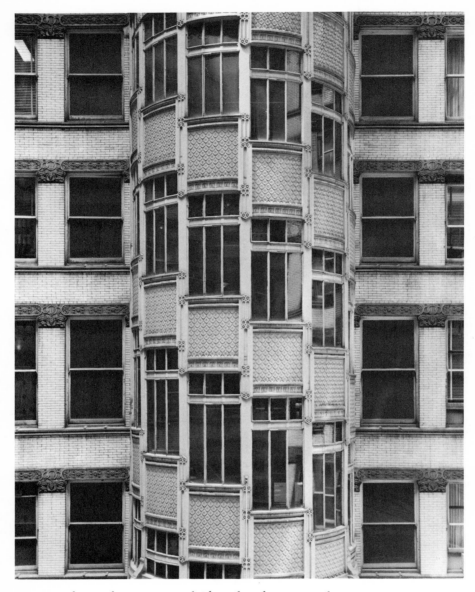

Fig. 53. The Rookery. Stair oriel. Photo by Thomas Knudtson.

Fig. 54. (opposite page, top) *The Rookery. Interior of stair oriel. Photo by author.*

Fig. 55. (opposite page, bottom) *The Rookery. Office plan for Burnham & Root. From the* Engineering and Building Record, *courtesy Linda Hall Library.*

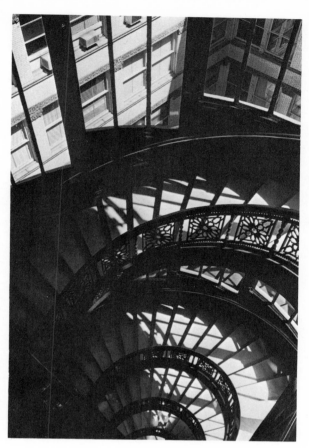

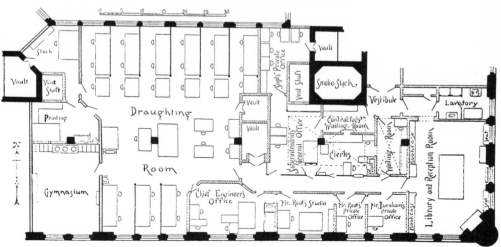

81 THE ROOKERY

Fig. 56. The Rookery. Burnham (left) *and Root in the library. From the* Inland Architect.

Root opened the staircase with lacy arabesques and perforated the risers (Fig. 51). Each electrolier flowered into twenty-eight carbon filament lamps. The colors everywhere were gold and white, even across the perforated girders of the vault. Light was of the essence. Root took the gallery back to the west wall and then exploded it into a double flight of stairs cantilevered precipitously into the space of the court. Not without reason did Van Brunt recall the visions of Piranesi.[8] A single flight of stairs leading to the third floor rose back into the mass of the building. Still the walls were transparent, for the elevators were sheathed in plate glass.[9] Finally, the stairs assumed a semi-helical route (Fig. 52) through an oriel projecting 10 feet past the wall plane (Fig. 53) and rose high above the vault of the court in a vertiginous flight of fancy, the steps glistening from the majestically attenuated lights (Fig. 54).[10]

All these points in the court were subject to enhancement by the changing light of day, all could counter the monotony of the office cubicle by enlarging the sphere of perceptual response while inviting the more casual encounters that enrich professional and social life.[11] Through the constant interplay of dualities—of solid and void, structure and space, stasis and kinesis, opacity and transparency, darkness and light—Root achieved a dynamic balance, a vital resolution.[12] And the Rookery might claim this much: that in the course of an architectural type, the finest years may well occur very soon after the requirements are first manifest.

[8]Henry Van Brunt, "John Wellborn Root," *Inland Architect*, XVI (Jan. 1891), 87. He must have read, only a year earlier, that Root's office library included "a complete set of Piranesi." See "The Organization of an Architect's Office, No. 1," *Engineering and Building Record*, XXI (Jan. 1890), 84.

[9]Ironically, in these early days the architect welcomed the new range of perceptual experiences in mechanized motion, while today the elevator is only a blind conveyance.

[10]The Rookery hardly supports the contention of Carroll Meeks, in *The Railroad Station* (New Haven, 1956), pp. 46–47, that the aesthetic lessons of the train shed went unheeded, and that elsewhere, transparent enclosures and the attenuations inherent in metal did not become acceptable until the twentieth century.

[11]The overwhelming ennui of the typical office building of today derives not only from the poverty of spatial imagination, but from the tyranny of artificial lighting and other static environmental controls.

[12]Today the aesthetic of the Rookery must be largely reconstructed. In remodeling the court after the turn of the century, Frank Lloyd Wright sacrificed much of Root's curvilinear ornament to the astringent patternings (irrelevant enough to the theme of the Rookery) of his own Prairie House years. Later, the bridge at the west vestibule disappeared, the elevators were forced to surrender their transparency, and the skylight was rendered meaningless by an opaque waterproofing.

IV · THE MILIEU OF THE CHICAGO SCHOOL

The center of Chicago remained where the city had begun; the last tall office building that John Root designed would have stood across the street from the first. Aristotle said an acropolis was suited for the stronghold of an oligarchy or monarchy, a plain for a democracy. The plain of Chicago, lying in the central lowland of North America, had been the bed of a glacial lake; in the nineteenth century, it was still a sedgy marsh. Drainage was poor and disease was common until the late 1850s, when the street grade was peremptorily raised. The river continued to serve as a sewer emptying into Lake Michigan, from which, unhappily, the city drew its water. In the early 1880s, eight enormous pumps were applied to the river to force it backward into the Illinois-Michigan Canal, and eventually the course was reversed. The lake was sometimes called an inland sea. In a storm of May 1894 more than fifty ships were wrecked, and in 1888 there had been more ships at the port of Chicago than at New York. Ships constantly tormented the river, their tugs burning soft coal and spewing smoke onto all who were waiting to cross the bridges. In 1888 there were thirty-two bridges apart from those serving steam railways only, and the traffic of the citizenry to and from the center of the city was so outrageously impeded that it was seriously proposed to demolish the approaches, cover the river, and render all the streets level and continuous. In 1889 the *Inter Ocean* (one of the most endearing flags, surely, in American journalism) complained of reckless bridge tenders, some of whom, when befuddled by whisky, would swing open their bridges with vehemence, hurling traffic into the river. Two tunnels had been built before the great fire, but by the 1880s they were hopelessly inadequate.

It is apparent that the democracy served commerce with much more zeal than it served the citizen. The railroads, twenty-five of which entered the city by 1893, only magnified the nuisance created by the ships. Paul Bourget, a French novelist, did not exaggerate when he said the incessant noise of locomotive bells seemed to be sounding in advance the knell of those who were about to be crushed; too many crossings were at grade, and the victims too often were children. Locomotives seemed to be everywhere, wrote Bourget, "crossing the streets, following the lake shore, passing over the river which rolls its leaden waters under soot-colored bridges. . . ."[1] Freight and passenger depots nearly engirded the center of the city. The center, indeed, was virtually confined (see Fig. 7). George Chambers, the real estate man who guided the Sherman house commission to Burnham & Root, in 1889 published a map to illustrate "the contractedness of the business district of Chicago." The same point was made by the Chicago *Tribune* in 1890:

Chicago's business district is probably more curiously situated than that of any other city in the country. The business district is practically but nine blocks square. General trade cannot be driven across either branch of the river, and on the south it is largely hemmed in by the railroads. The street-car lines discharge their passengers at practically a common center. The customs of the city have crystallized the tendency towards centralization to an unusual degree.[2]

Between 1880 and 1890 the population of Chicago doubled, from half a million to more than a million, but the center of the city remained only nine blocks square. Julian Ralph remarked in 1892 that the only leeway for expansion was upward. As long as the democracy chose not to regulate the aggrandizement of real estate, the center would be subjected to an unceasing transformation. The builders were rarely those corporations that, as Root said, were aware of the value of a large building as a corporate advertisement. Nor were they often institutions; in buildings like the Woman's Temple or Masonic Temple the space still was mostly speculative. Samuel Bing, when he visited America early in the 1890s, found that the huge commercial buildings had been calculated solely in terms of materialistic speculation. His com-

[1] Paul Bourget, *Outre-Mer* (New York, 1895), p. 116.

[2] "Chicago Real Estate," Chicago *Tribune*, L (16 Feb. 1890), 10. Robert Kerr, the English architect, in "On the Lofty Buildings of New York City," *Sanitary Engineer*, IX (Jan. 1884), 113, noted the constricted commercial center of New York, but also discerned that it could easily expand uptown. And of course it did.

patriot, Bourget, said he could sense in the streets of Chicago a business fever rushing along like an uncontrollable element, and, behind the windows of the skyscrapers, the quivering hot breath of speculation. According to Lincoln Steffens, there was an invisible passenger in every trip of the elevator car: the value of a parcel of real estate where the commercial fight was thickest. Charles Whitaker said the skyscraper was socially nothing more than a gambler's chip in the game of land debt and usury.

In 1892, Dankmar Adler observed that nearly every skyscraper in the city of Chicago had been erected by a stock company organized for that purpose only. Such a volume of office space would not have been profitable, of course, had not businesses and corporations grown in ways that entailed vast clerical staffs and increasingly bureaucratic organization. Typically, the Santa Fe Railway had an office force of only two men in 1868, and 235 men in 1884. Professional men continued to find it advantageous to take offices in the center of the city. What mattered most to the capitalists who built the skyscrapers of Chicago was the rate of return. In the spring of 1889, when John Root began revising his drawings for the Monadnock Block, pushing it—at the request of his client—to sixteen stories, what really excited Owen Aldis was not the quest for form, but the fact that the rentable space would be about 68 percent of the floor space, thus a gain over that in the Rookery or in Jenney's celebrated Home Insurance Building. Only a few months later, Jenney was refused steel beams and girders for the Manhattan Building; his client thought steel was too expensive. Corydon T. Purdy, an engineer, observed that the "remarkable enterprise of Chicago has made such great demands upon both architects and engineers that they have been forced to be progressive";[3] he was right, of course, but it was also true that an architect's best thinking could be negated by the narrow economic interest of his client.

That the "commercial palaces" of the 1860s and 1870s were soon dwarfed in the 1880s and early 1890s by buildings that the press in Chicago chose to describe as "monster office blocks" was no incidental fact: a change in degree, when great enough, could become a change in kind. "Buildings of ten or twelve stories are treated with a different expression from that made conventional by buildings of four or five stories," Henry Van Brunt, getting to the heart of the matter, wrote in 1889.[4] C. H. Blackall, touring Chicago

[3] Corydon T. Purdy, "The Use of Steel in Large Buildings," *Engineering Record*, XXXI (Feb. 1895), 207.

[4] Henry Van Brunt, "Architecture in the West," *Atlantic Monthly*, LXIV (Dec. 1889), 782.

two years earlier, discovered that with one or two exceptions none of the large buildings had been designed by architects from out of the city. The signal exception was of course the Field Wholesale Store; but indeed it proved the rule. Richardson built his masterwork of commercial architecture in Chicago, for a Chicago client. All the major office buildings of the city, noted Blackall, were to be ascribed to the 1880s:

> Not that such structures were unknown to the Chicago of twenty years ago, but the buildings as they now are, planned and conceived as we find them in this great Western city, are so largely original in their entire thought that, while it is easy to trace the lines of development that have led to them, no one will deny their originality in architectural treatment.[5]

Root said in 1890 that the age of steam, electricity, gas, and modern sanitation was witness to a material revolution a thousand times more radical and significant than the evolution throughout the preceding centuries; during the late nineteenth century an architect in Chicago was not asked to design a temple to embody the spiritual sentiments of the age, to design a castle, or palace, or shop with living quarters overhead. The conditions of the high office building, he said, were without precedent. It was an architectural type new in every essential element. It depended largely on entirely rational processes. Less than three weeks before he died, Root was asked to comment on the continually crumbling U.S. Post Office and Custom House. His response showed how central to modern architecture the large office building had become:

> The simple business principles which should dictate the utmost simplicity and straightforwardness of plan, so arranged as to obtain the very best ventilation and light, have been neglected in every case. . . . What the Government needs upon this magnificent lot is an entirely modern, carefully studied office building, each function of which is as frankly recognized and as carefully provided for as in any private office building yet erected.[6]

Simple business principles had made the architecture of the large office building so complex that now an architect's own office had to be expanded, rationalized, and fully articulated. Montgomery Schuyler said the one faculty absolutely indispensable to the practitioner in Chicago was the faculty of administration; a talent, he added, that was pre-eminently Daniel Burnham's.

[5] C. H. Blackall, "Notes of Travel: Chicago—II," *American Architect*, XXII (Dec. 1887), 313.

[6] "For a New Post-Office," Chicago *Tribune*, L (30 Dec. 1890), 8.

"Study the organization side of the business," Burnham advised young Paul Starrett, who had joined the office in 1888. ". . . don't you know that you can hire any number of civil engineers, mechanical engineers, and electrical engineers, who will be absolutely contented to spend their whole lives in doing routine?"[7] The first years after the great fire, as Root recalled, did not produce the educated draftsmen, the superintendents, and the builders who by the 1880s constituted the facilities of the large architectural office. At the time of the Grannis fire, Burnham & Root already occupied a suite of five rooms. In 1888, when they moved from the Montauk Block to the Rookery, they were surrounded by experts in structure and sanitation; the *Inland Architect* said they had built an organization perhaps not previously attempted in the history of the architectural office. Burnham & Root's office plan from the Rookery was the first in a series published in the *Engineering and Building Record*, a New York journal, and the plan was reprinted in the Paris journal *Semaine des Constructeurs* (see Fig. 55).[8]

Perhaps their office was not organized toward an inhuman efficiency—Paul Starrett found the spirit of the place to be delightfully free and easy—but it seemed to be headed that way. The baths near the vestibule were intended to refresh a man on a hot day or when he came in from a long trip, so he could be more productive; and when Burnham appeared occasionally in the gymnasium, at the opposite corner of the office, to offer fencing lessons, it was because he believed a certain amount of exercise could keep a man's wits sharpened. Burnham was head of the office, but he had delegated the direct supervision to John M. Ewen, who had the chief engineer's room, next to Root's drafting studio. Ewen had three other structural engineers working with him. A client or members of the building committee would be escorted into the handsomely finished library, where Root kept the Piranesi and a number of other portfolios for the stimulation of his imagination, and where either he or Burnham would make sketches to illustrate a possible starting point (see Fig. 56). P. B. Wight said that Burnham, in particular, had the great faculty of impressing a client with the abilities of the partners to solve any problem at all; he would dash off plan-sketches on sheets sometimes as small as 6 inches square, until it seemed he had discovered the best plan conceivable. After showmanship of this sort in the library, it was Root who withdrew to his studio to begin in earnest the studies for the building. He con-

[7] Paul Starrett, *Changing the Skyline* (New York, 1938), p. 43.

[8] See "The Organization of an Architect's Office, No. 1," *Engineering and Building Record*, XXI (Jan. 1890), 84.

sulted with Ewen or with Charles L. Strobel on matters of structure. William S. MacHarg gave four days a week to Burnham & Root's details of plumbing, heating, and ventilation.[9]

Ewen figured the specifications and dictated them in brief to men who would set them out in full. He had devised a use of the hectograph for making rapid copies from drawings prepared with aniline colors; the low-paid draftsmen, who previously traced drawings merely to supply enough copies to the contractors, were dismissed. Experienced draftsmen enjoyed considerable freedom only in the drawings for inexpensive residences. There were eighteen regular posts for draftsmen, with each row shielded by a partition. Sometimes as many as sixty draftsmen were put to work. Any major building was assigned a superintendent hired by the office but paid by the client. These superintendents reported systematically from out-of-town, mailing progress photographs. In Chicago, contractors were allowed to conduct business with Burnham & Root only between 11 and 1 o'clock, in rooms screened from those where clients might be.

For such an office to have existed, the city had to have attracted a large number of architects and engineers. Their talents and skills were unrivaled anywhere in the country, and for the most part they were youthful men. When, in 1897, Burnham proposed for the Harbor of Chicago a great statue as the pharos of the inland sea, the conceit was not inappropriate—the monument would have expressed the genius of the city in the figure of a young man. "None but energetic people go to Chicago," a visitor remarked in 1892. "The state of New York and the states of New England have sent to the building up of this great city the very best of their youth. . . ."[10]

Indeed, hardly anyone was a native of Chicago—not even John M. Van Osdel, who arrived as a rather wild-eyed carpenter from New York in 1837, the year the city was incorporated. S. S. Beman, another native New Yorker, had come to design a whole town for George Pullman, the manufacturer of sleeping cars. Otis Wheelock and Francis Whitehouse were from New York, and Asher Carter was from New Jersey. William Le Baron Jenney was a native of Massachusetts, and had studied at the Lawrence Scientific School, of Harvard, and at the École Centrale, in Paris. Of the men who worked at one time or another in Jenney's office, Sullivan was born in Boston, and Burnham

[9]MacHarg also worked for Adler & Sullivan where, presumably, he met young Frank Lloyd Wright. Wright surreptitiously designed a house for him. Sullivan, in dismissing Wright, may have had better cause, then, than mere moonlighting.

[10]H. L. Nelson, "The Clubs of Chicago," *Harper's Weekly*, XXXVI (Aug. 1892), 807.

in upstate New York (both, however, reached professional age after their parents had moved to Chicago). Martin Roche had left Cleveland, and William Holabird had dropped out of West Point. (The partnership of Holabird & Roche, said Schuyler after the turn of the century, had the enviable distinction of having produced more buildings devoid of intentional "architecture," in the Eastern sense, than any other office.) Irving K. Pond, originally from Ann Arbor, worked for Beman on the town of Pullman, as well as on the Pullman Building at the southwest corner of Michigan Avenue and Adams Street, which Frank Lloyd Wright remembered as the first skyscraper. William B. Mundie, a Canadian, joined Jenney in 1884 and finally became his partner in 1891. Henry Ives Cobb and Charles S. Frost resigned from the office of Peabody & Stearns, in Boston, to come to Chicago. P. B. Wight and Root, of course, had left New York simply because of the amount of work to be done after the great fire.

Once in Chicago, architects moved from office to office, founding partnerships and dissolving partnerships. There could not have been many professional secrets. To the contrary, the architects of Chicago composed a vital group and, as Blackall could see, they cherished camaraderie:

One of the most hopeful signs of Western architecture is the desire and willingness of the architects to mingle together, to show each other their work, and to exchange criticisms. Only in such ways can growth come about. There is everything to be gained by intercourse, and we fancy that Eastern architects are sometimes inclined to disregard this means of progress.[11]

The call for a Chicago School had come as early as 1879, when an anonymous and extraordinary essay commanded a full page of the Chicago *Times*:

The conditions of Chicago are so unlike those of any part of the union or of the world that what has been learned elsewhere is of no great value when applied to this city. Nowhere else is the site so low and flat, the soil so uncertain and treacherous. . . . What this city needs are architects who have been reared in what may be termed a Chicago atmosphere. An architect of this school should be permeated by the peculiar surroundings of our locality. He must be in sympathy with the soil, so to speak, for the reason that Chicago is *sui generis*, and must have a construction such as would suit no other city. Before Chicago attains a complete success in its architecture, it must have a school of its own. The architect who would succeed must be *adscriptus glebae*—must be as much a product of the soil as one of our scrub oaks, or one of our cotton woods.[12]

[11] C. H. Blackall, "Notes of Travel: Chicago—IV," *American Architect*, XXIII (March 1888), 142.

[12] "Architectural," Chicago *Times*, XIV (2 Nov. 1879), 9. The same essay proposes a high domical civic building as the focus of radial boulevards, etc.—strangely premonitory of the Plan of Chicago of 1909.

Every significant vehicle for architectural thought, every vital professional society, was established between 1883 and 1889—precisely the years in which the new architectural type first flowered. The *Inland Architect* appeared in February 1883. Robert Craik McLean, the editor, then twenty-eight, was an architectural journalist of exceptional enthusiasm and understanding. His editorial voice generated much of the scene that his journal reported. He was a friend to Root, Burnham, and Sullivan. With the second issue, he began to publish the lectures Jenney gave at the first University of Chicago, and also the reminiscences of Van Osdel, a "History of Chicago Architecture." A few months later he published Root's essay on color. The masthead by April 1885 listed Root, Burnham, Wight, Jenney, and Irving K. Pond among the special contributors. When, at a symposium, Frederick Baumann (a native of Germany, like Augustus Bauer and Dankmar Adler) quoted a sentence from Semper—"style is the coincidence of a structure with the conditions of its origin"—Root took note and, later, with help from his friend Fritz Wagner, whose career was devoted to architectural terra cotta, translated parts of Semper for publication in McLean's journal.[13] During the same years that the content of the *American Architect*, in Boston, became increasingly historicist, McLean published articles of academic or archaeological interest only to fill space until he could come up with another discussion pertinent to the issues of the day. For the Chicago architects were learning as much from each other, and probably more, as from history.

McLean took the leading role in the founding of the Western Association of Architects. It was a moment in history epitomizing the division between West and East, and the growing consciousness among the Chicago architects of a common interest. More than a hundred architects were present when McLean called the organizational convention to order on 12 November 1884; more than sixty were from Chicago, and the others represented fourteen states. "It is not to be hoped, perhaps, that the name of each shall go down to posterity," said Burnham, who was elected chairman of the convention, "but it may be hoped that the united efforts of us all will leave impressions which shall stamp a pure American spirit on the ages to follow."[14] The following night, Jenney proposed a most pointed toast to the American Insti-

[13] "Development of Architectural Style," tr. from Gottfried Semper, *Der Stil in den Technischen und Tektonischen Kunsten*, 2 vols. (Munich, 1860–1863), in the *Inland Architect*, XIV (Dec. 1889), 76–78, and XV (Feb. 1890), 5–6. Baumann is usually remembered for his 1873 pamphlet on *The Art of Preparing Foundations for All Kinds of Buildings, with Particular Illustration of the "Method of Isolated Piers" as Followed in Chicago.*

[14] "Western Association of Architects," *Sanitary Engineer*, X (Nov. 1884), 578.

tute: *its* conventions, he observed, usually were held in the East; the convention of 1882, although held in Cincinnati, attracted only one architect from farther west; the convention of 1883, in Newport and Providence, was attended by only one architect from Chicago; and at the convention of 1884, in Albany, there was no architect from any place west of Ohio.

The architect Sidney Smith, of Omaha, once said the Western Association was nurtured by a band of earnest, zealous men. In contrast, McLean recalled that at the time of the first convention the Chicago chapter of the American Institute had not met for two years. McLean said the Western Association from the beginning was vitally representative of the highest professional level in the Middle West. "It was not a Philistine movement," he said, "but grew out of the insistent and general desire for professional association, the comparison of ideals, expression of ambitions, a better practice and more gregarious professional life."[15] The second convention was held in St. Louis. Adler was elected president and Root secretary. Sullivan read his first paper, "Characteristics and Tendencies of American Architecture." At the convention of 1886, held again in Chicago, Root was elected president, and he read his ironic paper "Architectural Freedom." Sullivan read a prose poem "Inspiration," the paper he described in his last years as a sophomoric effusion to which only Root, McLean, the draftsman Paul Lautrup, and perhaps a few others seemed to respond. All such papers were published by McLean, whose journal had been designated the official organ of the association.

The Western Association clearly was becoming an embarrassment to the American Institute. At the convention of the American Institute in December 1886, in New York, Root tried to reassure the Eastern architects that the association was in no way a rival body, but by 1887, according to P. B. Wight, leaders in the East saw the hand moving across the wall and recognized an urgent need for accommodation. Later that year, when the American Institute convened, significantly, in Chicago, Root was elected a director. Burnham proposed a consolidation. Adler later commented that the conventions of the American Institute in the East ". . . could never have developed the courage for so radically progressive measures as the proposition to consolidate. . . ."[16] At the convention of 1888, in Buffalo, Adler put aside diplomacy to say that the Western Association had three times the membership of the American Institute and sufficient vitality to exist without it; even R. M.

[15] Editorial in *Western Architect*, XIX (March 1913), 24.
[16] Letter of 16 Aug. 1889, in the *Building Budget*, V (Aug. 1889), 105.

Hunt said it had taken the Institute thirty years to gather two hundred members, while the Western Association had a greater membership after only three or four years.

As chairman of the Western Association's committee on consolidation, Adler soon reported that the only real point of issue in the liaison between the two bodies was whether the reconstituted American Institute should have different categories of membership, in the European fashion, or absolutely no distinctions of rank, as in the Western Association. The reorganization was accomplished at a combined convention of November 1889, in Cincinnati; Hunt continued as president, and Root was elected secretary. "It was the new blood and vigor of the Western Association that revived the Institute at a time when it was moribund, and in that regard made it what it is today," McLean wrote in 1913.[17]

State and local chapters had been a great source of strength in the Western Association. Professional problems were regularly discussed at meetings of the Illinois State Association of Architects, founded in January 1885. Some papers, like "The Effluorescence on Brick Walls," presented later in 1885, were of narrow interest; but the symposium at which Baumann quoted Gottfried Semper was chaired by Root and directed to the question, "What are the Present Tendencies of Architectural Design in America?" and, only a month later, Sullivan chaired a symposium on "What Is the Just Subordination, in Architectural Design, of Details to Mass?" These proceedings also were published by McLean.

McLean urged the formation of still another fraternity for the very young employees of architectural offices. The preliminary meeting of the Chicago Architectural Sketch Club was held in his office in February 1885; the first regular meeting, in March, was attended by about fifty draftsmen. Root gave a great deal of time to the club—he was as close to the younger men, said Irving K. Pond, as Burnham was not. Root frequently served as a juror in the club's competitions, and it was to the club that he read "Style" and "Broad Art Criticism." These two papers were also published by McLean.

Another journal, the *Building Budget*, was founded in February 1885 by Henry Lord Gay, who had the habit of styling himself a "practical architect." Gay's journal was less lively than the *Inland Architect*, and was colored by occasional attacks on it, even though McLean in his second issue had published a High Victorian Gothic design by Gay for a residence on Dear-

[17] Editorial in *Western Architect*, XIX (May 1913), 41.

born Street. Nevertheless, Gay made his journal valuable by publishing renderings and other illustrations, as well as tidbits of construction news. He also published translations from Viollet-le-Duc's *Dictionnaire Raisonné* by N. Clifford Ricker, chairman of the department of architecture at the University of Illinois. His journal survived through December 1890, and the next month was absorbed by the *Northwestern Architect*, of Minneapolis.

Another forum was provided by the Art Institute of Chicago. For the architectural class beginning in September 1889, the lecturers included Root, Burnham, Ewen, Pond, and Jenney—the last of whom, for many years, had directed the new men in his office to the writings of Viollet-le-Duc and James Fergusson. To this class, Root read his important paper "A Great Architectural Problem." He discussed with singular objectivity the central concern of the Chicago architects.

The high office building remains the most radical and characteristic architectural type of America. The best of the Chicago architects shared a will to create what Paul Bourget called an authentic report of the profound forces in American life. Theirs was not a quest for a stylistic formula, but for freedom from the tyranny of history and the fear of an "incorrect" architecture. Their errors, as Root said, at least were on the side of vitality. P. B. Wight said after Root died that his architecture proved not that an American style was about to be born, but that the best nineteenth-century architecture was not trammeled by precedents, that America could have good and true and beautiful architecture without the disguises of style. Even in 1880, Wight had observed that certain architects who occasionally referred to the past were beginning to work from principles "uncontrolled by the traditions of previously existing styles."[18]

Sullivan said in 1885 that a national style would have to come as a growth, a gradual assimilation of nutriment, with a nurturing by those architects capable of developing elementary ideas organically. In 1886, his partner Adler remarked that Sullivan's work bore reminiscences of the École des Beaux Arts, that the Rookery was embellished with motifs drawn from the past, and that Richardson confessed in the Field Wholesale Store what he had learned from the Palazzo Strozzi; but that surely there was being born a style of the nineteenth century, a style developed by the needs, conditions, and limitations of its own civilization. H. H. Richardson had written very little, but enough to say that he found in the Romanesque "a style especially

[18]P. B. Wight, "On the Present Condition of Architectural Art in the Western States," *American Art Review*, I (1880), 138.

adapted to the requirements of civic buildings; for while it maintains its dignity together with a strong sense of solidity, it lends itself at the same time most readily to the requirements of utility."[19] (Samuel Bing at first thought it curious that Richardson should have revived the Romanesque; then he decided that the idiom of imposing mass could indeed become a perfect incarnation of the force of business in American life.)

There was yet a more important aspect of the rationale of the Romanesque revival as the Chicago architects understood it. It is significant that after the turn of the century Montgomery Schuyler still believed the Romanesque revival to have been the most promising beginning ever made in America, and perhaps anywhere, toward the evolution of a living architecture. A few days after Richardson died, in 1886, even the *American Architect* published an anonymous appreciation of his buildings in North Easton which suggested that in time the foreign origin of his style could be forgotten and his style could be known as an American style. Alfred Waterhouse, as president of the Royal Institute of British Architects, said Richardson seemed to have inspired a school of young Americans following his steps in developing the capabilities of the Romanesque, an art which did not die a normal death but which was extinguished by problems in vaulting oblong spaces and the consequent introduction of the pointed arch. Henry Van Brunt, who could never decide after having moved his family from Boston to Kansas City in 1887 whether he stood with the Chicago architects or with his older confreres of the East, and whose essays forever attained that kind of urbanity in which all that seems to be said is doomed soon enough to be gainsaid, between 1886 and 1893 wrote at least eight times that the Romanesque was a style never perfected or exhausted, and thus pregnant with suggestions for the architecture of the hour. In 1885, Root wrote that often "the study of a transitional period, as such, is much more suggestive than a study of a completed style," and in 1886 he said, again, that the fruitful periods of architecture were to be discovered in its transitions.[20] Thus the architects of the 1880s who most often took the Romanesque as a starting point chose to work under the spell of a wholly different principle from that which guided those who already had begun to look toward the classical lan-

[19] From an 1886 booklet on the Hoyt Library project; see Charles Price, "Henry Hobson Richardson: Some Unpublished Drawings," *Perspecta*, IX–X (1965), 208.

[20] J. W. Root, "Architectural Ornamentation," *Inland Architect*, V (April 1885), 55; and "Short Roofs and Half-Timbered Gables," an interview with Root, in the *Sanitary Engineer*, XIV (Oct. 1886), 517. A focus on transitional or tentative phases is characteristic of the evolutionary criticism of architecture, Geoffrey Scott observes in *The Architecture of Humanism*, 2nd ed. (New York, 1924), p. 130.

guage of the Italian Renaissance; they presumed the road to be long, the precise destination unknown.

If the Chicago architects could not accept any "perfected" historical style for the architecture of the high office building, neither could they be satisfied with a barren display of structural technic. The "revelation" of a structural system could hardly encompass a broad range of functional, aesthetic, and symbolic choices in expression. In most of the great high office buildings of the early years the structural system was indeed so improvisational that it was better *not* revealed; as late as 1895, Corydon T. Purdy said that between solid masonry and total steel skeletonization there continued to be a countless number of variations in mixed structure. Metal framing had come into being for definite practical purposes, such as rapidity of construction (so an investment could turn quick profits), savings in labor costs, less weight on the footings (thus reducing foundation work), and a thinning of the piers (for increased floor space, larger window openings, and the accommodation of plate-glass storefronts). In the early years, metal framing was not the overriding determinant of architectural expression: one may well question why it should have ever become so. When he first discussed the partial metal framing of his Home Insurance Building of 1883–1885, Jenney's words were inescapably low-key: "As it was important in the Home Insurance Building to obtain a large number of small offices provided with abundance of light, the piers between the windows were reduced to the minimum. . . . "[21]

In 1891, Jenney said that what was being called "the Chicago construction" was simply a fireproofed steel skeleton with the columns carrying all the loads, a system in which the materials were so closely calculated that the same rigid inspection was necessary as in a railway bridge. The system was sometimes called "bridge construction." A few years later, Lincoln Steffens discerned that if high buildings were to respond to the insatiable demands of the real estate market, the architect was obliged to call in the services of another expert, "some one who understands the laws of metals. The engineer was the man. The architect seeing him spinning his suspension bridge, recognized that his was the knowledge wanted, and called him down to consultations about the building of houses. . . . the architectural engineer was the result."[22] The men to whom the Chicago architects turned for expertise in

[21] W. L. B. Jenney, "The Construction of a Heavy Fire-Proof Building on a Compressible Soil," *Sanitary Engineer*, XIII (Dec. 1885), 33.

[22] J. Lincoln Steffens, "The Modern Business Building," *Scribner's Magazine*, XXII (July 1897), 47–48. J. K. Freitag, in *Architectural Engineering* (New York, 1895), p. 1, writes that architectural engineering

problems of technic were William Sooy Smith, Charles L. Strobel, and E. C. Shankland, all of whom were railroad engineers. For the railroad engineers, in adopting steel as a reliably uniform material, long since had called for the first standard steel shapes.

In detail, the work of the Chicago architects had to do with footings, fireproofing, framing, lighting, heating, and ventilating; but the basic concern was with an architectural expression of the new era. Van Brunt ventured in 1889 that the Chicago architects were "ministers of an architectural reform so potent and fruitful . . . that one may already predicate from it . . . the establishment of a school."[23] In 1890, a correspondent wrote that "we now find ourselves in the very midst of and watching the formation and growth of a school here in Chicago."[24] In 1891, Schuyler proclaimed utilitarian business blocks to be "the true and typical embodiment in building of the Chicago idea."[25]

In the few years between 1886 and 1894, the Chicago idea was carried to Kansas City, Cleveland, San Francisco, Tacoma, St. Louis, Atlanta, Salt Lake City, and Buffalo. In 1908, in introducing Frank Lloyd Wright's heroic paper "In the Cause of Architecture," the editors of the *Architectural Record* remarked that the first sentiments for an American architecture had been realized in Chicago *twenty years earlier*, in the acknowledged solution of the problem of the high office building. A month later, in describing the work of the Prairie School, the architect Thomas Tallmadge recalled the Chicago commercial architecture of the 1880s as a noble movement. It was a movement peculiarly appropriate to the American people, he said, and it fostered an untrammeled architecture capable of serving every building need.[26]

is a "recently coined term." See also W. L. B. Jenney, "Chicago Construction, or Tall Buildings on Compressible Soil," *Engineering Record*, XXIV (Nov. 1891), 389–390; M. A. Lane, "High Buildings in Chicago," *Harper's Weekly*, XXXV (Oct. 1891), 853–854; and "Tall Buildings in Chicago," *Railroad Gazette*, XXIII (Oct. 1891), 761.

[23] Van Brunt, "Architecture in the West," p. 777.

[24] "Chicago," *American Architect*, XXIX (Sept. 1890), 185.

[25] Montgomery Schuyler, "Glimpses of Western Architecture: Chicago," *Harper's Monthly Magazine*, LXXXIII (Aug. 1891), 403. In 1884, the Chicago *Tribune*'s anonymous and loquacious real estate informant said that "what is commonly known as the Chicago idea in architecture [is] a combination of all that is good of the past and the present and much that is original." See Chicago *Tribune*, XLIV (6 July 1884), 15.

[26] Cf. *Architectural Record*, XXIII (March 1908), 155, and T. E. Tallmadge, "The 'Chicago School,'" *Architectural Review*, XV (April 1908), 69–70.

V · KANSAS CITY, CLEVELAND, AND SAN FRANCISCO: 1886-1887

In 1886 and 1887, John Root could see his work surrounding him: the Rialto, the Commerce, the Phenix, and the McCormick buildings, the Art Institute, and, most important, the Rookery. Now his commissions became more various, both in type and place. Among them were apartment houses, churches, hotels, and the first high office buildings in cities both east and west of Chicago. And still there were more residences, more railroad stations. Burnham tried to shield him from administrative details and the interruptions of the day, for Root was determined to give personal attention to every commission of any moment. Burnham liked to delegate; Root did not. Root seems never to have worried whether, under the pressures of such a pace, he could long bear up. There are rather close holograph sketches that must be dated to his last months.

The Argyle Apartments and the Pickwick Flats were modest, direct buildings (Figs. 57–58). The commissions were reported in February 1886, and must have been familiar to Clinton J. Warren and Theodore Starrett. Warren left Burnham & Root that year for an independent practice. Apartment buildings became his forte. Starrett left a little later, and his Hyde Park Hotel of 1888–1889, a vanished and lamented landmark of the South Side, showed how much he had learned from working also on the Rookery. The Argyle Apartments fronted 172 feet on Jackson Street and 38 feet on Michigan Avenue, at the northwest corner. The Pickwick Flats, across the street from the Calumet Club, measured 160 feet on Twentieth Street and only 30 feet on Michigan Avenue, at the southeast corner. Both must have had long central corridors and much the same plan. The very prominent oriels were more simple and rational than the oriels of the Phenix Building; they

gave sunlight and air, and variety in plan, to domestic suites. The entrances simply were scaled down from those of an office block. The walls were left with little embellishment. In each building, Root relied on the flickering planes of the oriels to animate the mass.

St. Gabriel's Church appears to have been the first of Burnham & Root's very few church commissions; it obviously caught Root off guard. Chicago was so notoriously deficient in church architecture, Schuyler remarked in 1895, that to say of St. Gabriel's that it was architecturally the most interesting church in the city was almost to damn it with faint praise. Root's first impulse was to find recourse in Trinity Church, in Boston. His early renderings show an admirable watercolor technique but little more than a paltry reduction of Richardson's design. Harriet Monroe characteristically praised these studies. She said they were rejected only because they would have taken the building beyond its budget. But it is doubtful that Root could have rested with them anyway. In a later study he retained the square tower at the crossing, but gave it a double curb roof, incongruously rustic. By the spring of 1886, he had the final design in hand. The church was constructed at the southeast corner of Forty-fifth and Lowe streets (Fig. 59).

Root made the body of the church low and sympathetic to the prairie, a foil to the sentinel of the bell tower. "Did you know," he asked a newspaperman in 1890, "that in all Chicago there is but one church spire of masonry from the bottom to the top?" He showed his drawings for St. Gabriel's, and he described the tower as the breaking of day.[1] Root had modeled the tower with a force now more truly comparable to the brickwork of the fortress-cathedral at Albi, and had stressed the turret at the salient in a way that reflected the engagement of the tower with the church. He was not so successful in handling the corbels at the belfry as an inversion of the battered base, but he cut the openings in the wall with stern precision. To the gable over the low porch he assigned a cross, in terra cotta, and a rose which unhappily faced north and was never finished. He grouped the transept lights so they would echo the mouldings and openings of the north front. He carried the round arch through the interior and divided the hemicycle of the apse into seven bays, with an arcade springing in weightless elegance from slender granite columns.

The Midland Hotel, in Kansas City, Missouri, probably was planned earlier than the building for the Kansas City Board of Trade: the four clients

[1] "Church Spires Must Go," Chicago *Tribune*, L (30 Nov. 1890), 30.

Fig. 57. Argyle Apartments, northwest corner of Michigan and Jackson, Chicago, 1886–1887. Destroyed. From the Inland Architect.

were Chicago men, and one of them, William E. Hale, was speculating on the Board of Trade being built across the street from the hotel—which it was not. In 1886, Hale was finishing a residence Root had designed for him at 4545 Drexel Boulevard. Another of the clients for the hotel, Norman Ream, had already built one house designed by Root, at Groveland Park, and a few years later was to build a second house, at 1901 Prairie Avenue; in addition, in 1883–1884, Burnham & Root had done a warehouse for him on a site measuring 149 feet on Clark Street and 80 feet on Wacker Drive, at the southwest corner. The Midland Hotel had a slightly irregular plan with a front of 149 feet on Seventh Street and wings reaching southward 84 feet on Grand Avenue and 85 feet on Walnut Street (Figs. 60–61). The indentation of the north wall was rather too slight to express either the junctures of the wings or the presence of the masonry crosswalls. To the south, the external light court measured 43½ feet by 81 feet, its oriel stairhousing (far less impressive than that of the Rookery) projecting 6 feet past the wall, above the glass-and-iron vault at the second story. While the plan of a typical floor suggested that of

Fig. 58. Pickwick Flats, southeast corner of Twentieth and Michigan, Chicago, 1886–1887. Destroyed. From the Inland Architect.

an office block, there were billiard rooms, a bar, and a dance court beneath the skylight, a pool in the basement, and dining rooms on the sixth floor.

After the hotel was under construction it was decided to use a truss system to free the banquet hall from columns. On 29 February 1888 the trusses broke from the brick piers, the collapse killing one workman and injuring others. Burnham testified at the inquest that the drawings were "absolutely perfect," and he accused the iron contractor of slipping in thin plates. The jury held that the *surface* of the plates was only half what it should have been, and that the dimensions of the brick piers were less than had been specified. Paul Starrett recalled many years later that Burnham soon afterward retained E. C. Shankland, the bridge engineer, in the hope of averting any more such embarrassments.[2]

Notwithstanding the smooth planes of the brick wall, the street elevations of the Midland Hotel were vitiated by willful discordancies—the split

[2]The structure was peculiarly *ad hoc*: besides the masonry piers, there were circular cast columns and certain brick piers enclosing cast box-columns with rolled columns in the centers.

Fig. 59. St. Gabriel's Church, 4501 South Lowe, Chicago, 1886–1887. Courtesy the Newberry Library and the Art Institute of Chicago.

arcade of the Seventh Street front, the stunted tourelles that seemed to have slipped down both side elevations, and the curved pediment and diminutive oriel above the main entrance, both of which were recrudescences from the Phenix Building. At the same time, Root discoursed brilliantly on freedom and restraint in brick and terra cotta (Fig. 62). He found a happy middle ground between handicraft and the machine, an ornament designed by the architect, modeled at the terra-cotta works, and laid in place by masons exercising only normal skills. Concerning his expressive intent, he had already written in 1885:

Who that has seen the interlaced and tangled stems of a vigorous Virginia creeper and has tried to part them, does not know why much Romanesque and Byzantine ornament was at once so graceful and powerful?[3]

The Board of Trade Building (Fig. 63) was very likely the most powerful and most characteristic work of architecture ever erected in Kansas City. According to office legend, Root drew all the elevations, as well as alternate plans, on a Saturday, two days before he left Chicago with his wife and daughter for a summer in Europe—the kind of performance, no doubt, that led the editors of *Industrial Chicago* to describe him as "the ablest, and at the same time the most rapid designing architect the present building epoch has produced."[4] But of course the problem had been in his mind at least four years, ever since the Board of Trade competition in Chicago. Again he chose to separate the trading hall from the wing given wholly to office space, connecting them with a vaulted entrance court and a monumental elevator tower. The colossal arcade expressed the trading hall; and the tower, rising far past the height of the overhead elevator machinery, celebrated the grain trade as one of the city's principal reasons for being, which indeed it was. Had the building committee been parsimonious, the tower could have been eliminated. Burnham in fact mentioned such an alternative while Root was still in Europe; fortunately, the emasculation never occurred.

The Board of Trade competition was held under rules proposed by the Western Association of Architects. There were fifty-five entries, including those solicited from Burnham & Root, Peabody & Stearns of Boston, and George B. Post of New York. All were pseudonymously identified. William Robert Ware, who, by now, was at Columbia College, chose five entries for

[3] John W. Root, "Architectural Ornamentation," *Inland Architect*, V (April 1885), 55.
[4] *Industrial Chicago* (Chicago, 1891), I, 616.

Fig. 60. Midland Hotel, southeast corner of Seventh and Walnut, Kansas City, Mo., 1886–1888. Destroyed. Courtesy the Native Sons of Kansas City.

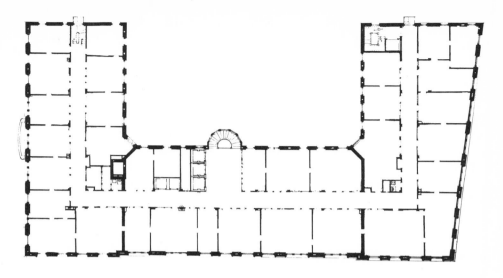

Fig. 61. (top) *Midland Hotel. Plan of typical floor. Courtesy of Maurice J. Bluhm.*

Fig. 62. (bottom) *Midland Hotel. Detail of cornice. Photo by author.*

105 *KANSAS CITY, CLEVELAND, SAN FRANCISCO: 1886–1887*

the building committee to ponder. In announcing the winner on 30 June 1886, the committee said Burnham & Root's plan was "plainly the best of all for light and ventilation of offices, gave to the halls the best positions possible, and furnished the largest number of offices for rent in the best groupings for advantageous use, and on the whole promised the largest returns of income."[5] Burnham & Root, signing their entry "Utilissimus," told how they began by weighing all the plan-forms feasible for the program and site, then chose to address the building to the south, with a large external light court; chose red brick and terra cotta as fireproof, clean, and economic materials, "bright and warm in their glowing monotone"; placed the elevator bank against the north wall, where it was convenient to the three entrances and where the light was of least value for offices; and stationed the tower "at the rear end of the great south court, where it [would] command the mass. . . ."[6]

Root somewhat improved the detailing when he returned from Europe, but made no substantive changes. The building was finished in the summer of 1888, at 210 West Eighth Street, four blocks from the Midland Hotel. The plan and section (Fig. 64) show banking floors in both wings, with double marble stairs to the mezzanine, where the gallery was floored in Hyatt lights (Fig. 65). The corridors were walled mostly in white marble, and the balusters (cast by the Winslow Brothers Company) were of a springing, light-footed rhythm (Fig. 66). By suspending the curved and coffered ceiling of the trading hall from scissors trusses at the roof, Root kept the space of about 59 feet by 115 feet clear. With the ornate chandeliers and manorial fireplace, he made the hall almost convivial (Fig. 67). He gave the outer walls an extraordinary plasticity (Figs. 68–69), at every point moulding the boundaries of the interior spaces. In the tower—where transverse hip roofs rose steeply in slopes consummately quarter-rounded, and the turrets were poised like brick lances—he etched a splendid silhouette; while at the north wall he curved two huge stacks, the one for smoke and the other for ventilation, and stood them to the sky as if they were the trumpets of the Industrial Revolution (Fig. 70).

His summer in Europe was the first time Root had been abroad since his school days near Liverpool. Harriet Monroe tells very little about his trip except that he admired the medieval cathedrals, did not admire the Gothic re-

[5] Kansas City *Star*, XII (2 July 1886), 1. It is noteworthy that even a representational building had to be presented in stringent economic terms.

[6] *Inland Architect*, VIII (Aug. 1886), 7. Echoes of the tower appeared in Root's houses in Chicago for Lot Smith, at 32 Bellevue Place, and for A. H. Dainty, at 1528 North Dearborn Street.

vival, discovered that Viollet-le-Duc was justified in denouncing the French for a slavishness to tradition, and found he was more at home in France than in England—all of which one would have guessed. In "Fire-Insurance and Architecture," a speech that he gave in September 1886, he mentioned the European practice of using plaster of Paris for fireproofing. In Kansas City, it was said that he visited hotels in Europe before designing the interiors of the Midland Hotel. In Cleveland, the staircase detailing in the Society for Savings Building was soon to betray his visit to the Cathedral of Rouen.

When the American National Bank in Kansas City first opened its doors, on 9 August 1886, the president announced that a new and substantial building was already being contemplated. Root must have designed it soon after he returned from Europe (Fig. 71). The building was finished in 1888 at the northwest corner of Eighth and Delaware streets, an intersection which formed acute angles and gave to the plan a wedge shape (Fig. 72). Root welcomed the salient, enhancing it with a slim engaged column which flowered at the seventh floor into a richly ornamented corbel destined to support a colossal flag staff.[7] The lone oriel on the east front (which measured only 1½ feet longer than the south front) heralded the main entrance, an oddly residual Romanesque porch like that of the Traders Building. On both fronts the window openings were paired, but the centers and widths of the piers were varied in order to establish different axial rhythms. Ornamentation was discreet, the mullions nicely attenuated, the spandrels withdrawn to emphasize the reveals: the building under construction could have looked little different from the finished building. Here was an office block of great and simple dignity, proving how far Root had gone even by 1886.

In Chicago, the Lake Shore Drive was widened and assigned to the park and boulevard system, thereby creating a fashionable residential area on the near North Side. Burnham & Root reported the house for V. C. Turner, a street railway magnate, in October 1886 (Fig. 73). The site was on the drive between Schiller Street and Burton Place, only a few doors north of the house Richardson's office had in construction for Franklin MacVeagh. The MacVeagh house, so strangely embryonic, stood, in turn, only seven blocks north of the suavely pictorial Francis I house which R. M. Hunt had designed for William Borden. Of the three, there was an affinity between those for Turner and MacVeagh. In both, the granite walls were punctured by clusters

[7]This ornamental detail was thus rather more purposeful than, say, the brooch-like flowering of the piers of Sullivan's Gage Building façade of 1898-1899.

Fig. 63. Board of Trade Building, 210 West Eighth, Kansas City, Mo., 1886–1888. Destroyed. Photo by Richard Nickel.

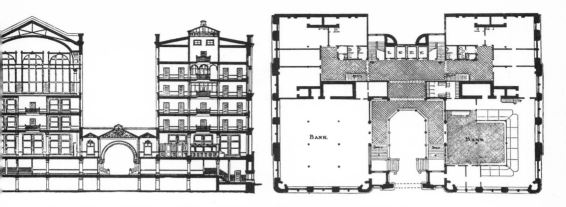

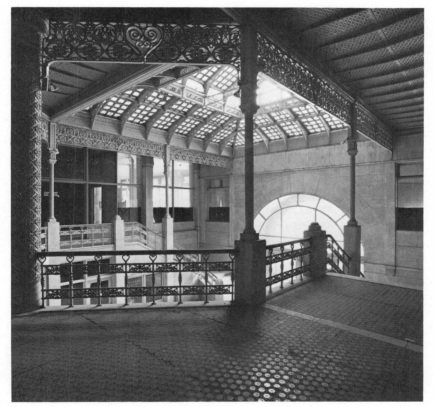

Fig. 64. (top) *Board of Trade Building. Section and plan of mezzanine. From the* Inland Architect.

Fig. 65. (bottom) *Board of Trade Building. Mezzanine gallery. Photo by Richard Nickel.*

109 *KANSAS CITY, CLEVELAND, SAN FRANCISCO: 1886–1887*

*Fig. 66. Board of Trade
Building. Detail of stairs.
Photo by Richard Nickel.*

*Fig. 67. Board of Trade
Building. Grain trading hall.
From* Views of Kansas City.

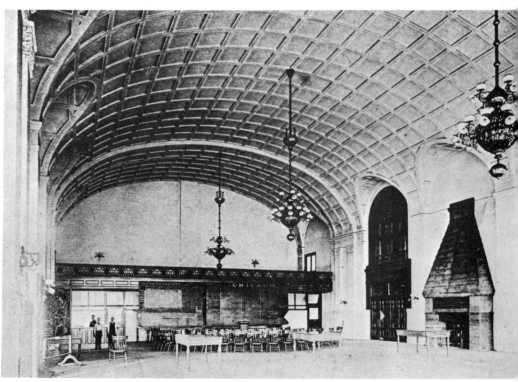

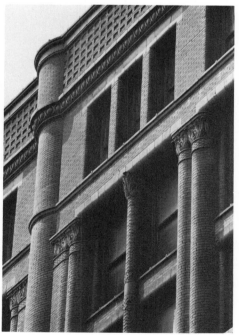

Fig. 68. Board of Trade Building. Detail of west wing and tower. Photo by Richard Nickel.

Fig. 69. Board of Trade Building. Detail of east wing. Photo by Richard Nickel.

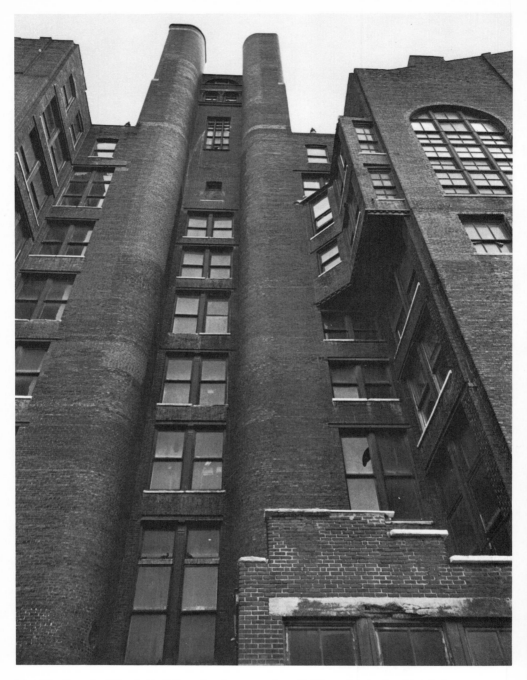

Fig. 70. Board of Trade Building. Stacks at north wall. Photo by Richard Nickel.

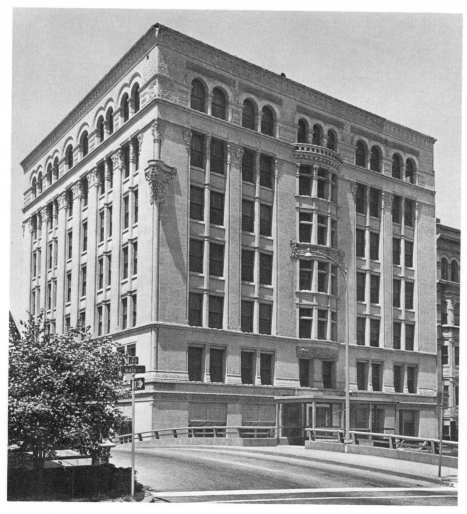

Fig. 71. *American National Bank Building, northwest corner of Eighth and Delaware, Kansas City, Mo., 1886–1888. Ground story obscured. Destroyed. Photo by author.*

Fig. 72. *American National Bank Building. Plan of eighth floor. Courtesy of W. K. Stapp, Commerce Trust Co.*

113 *KANSAS CITY, CLEVELAND, SAN FRANCISCO: 1886–1887*

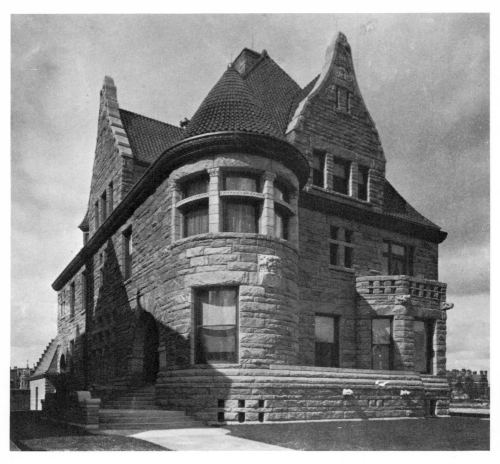

Fig. 73. V. C. Turner house, Lake Shore Drive near Burton, Chicago, 1886–1887. Destroyed. Courtesy the Art Institute of Chicago.

of tiny square openings, the entrances shadowed by cavernous arches, and the turrets engaged with a rude directness. The masonry of the Turner house, in itself, was superb. Some of the windows, particularly those overlooking the inland sea, must have been of startling dimensions.[8] Yet the design was incoherent to the extent that Root diminished both the intrinsic gravity of the mass and the unifying force of the moulded cornice by scattering the window openings without any rhythm and by torturing the tiled roof with giant wall dormers, shaped almost like a rabbit's ears.

[8] A holograph drawing by Root for the front of the Charles Needham house, at 3647 Michigan Avenue, shows the panes of one window at 5 feet 4 inches wide.

Two shingled buildings must be ranked among Root's best designs of 1887. The Lake View Presbyterian Church was built on a suburban site at the northwest corner of Addison Street and North Broadway (Fig. 74). The first service was held on 1 April 1888. The cost of the structure and furnishings had come to only $13,057, and it was probably because of the budget that Root—in searching for a key to spare surfaces and elementary forms—looked back to a Colonial type. He carried the motif of the high-pitched gable (the roof timbering rested on hammerbeams) into nearly every detail, even to the turning of the balusters. The little church became a tour de force in shingling and sharp edges.

An even smaller building, the station in Kewanee, Illinois, for the Chicago, Burlington & Quincy Railroad, was little more than windows and roof (Fig. 75). Root gave his attention to the broad eaves and contoured the brackets as an inversion of the supple rooflines.

The commission for another Presbyterian church on the North Side of Chicago evidently had come to Burnham & Root earlier than the commission for the Lake View Presbyterian Church. The congregation was known as the Church of the Covenant, and the site was at the southeast corner of Belden Avenue and Halsted Street. Because the program exceeded that of St. Gabriel's Church, the construction was deliberately phased. By the time Root was ready to announce the entire scheme—a rendering was published in March 1887 (Fig. 76)—the chapel and Sunday school, at the south end of the site, were already finished and in use. The picturesque tower never was realized, but the auditorium, designed to accommodate 1,500 persons, became a most handsome space, rhythmically defined by an arcaded balcony and warmly lighted by two levels of arcaded window openings (Fig. 77). Without the tower (which, indeed, the congregation may have sensed to be gratuitously over-scaled), the massing assumed a mysterious, almost sphinx-like aspect, commanding the site with great haunches of battered masonry (Fig. 78).[9]

In June 1887, Burnham & Root reported a commission for four party-wall houses in the 1300 block of Astor Street (Fig. 79) for James F. Houghteling, whose business was a building and loan company, and who was a brother of Owen Aldis's first wife. The street fronts of the houses were of red sandstone and a tawny brick, and the Elizabethan feeling of their wide

[9]The tower would have been more palatable than Sullivan's somewhat similar tower for the Seattle Opera House project of 1890. The massing of the auditorium very likely was an antecedent of Adler & Sullivan's Anshe Ma'ariv Synagogue of 1890–1891, and the interior disposition and lighting of Root's auditorium seem superior.

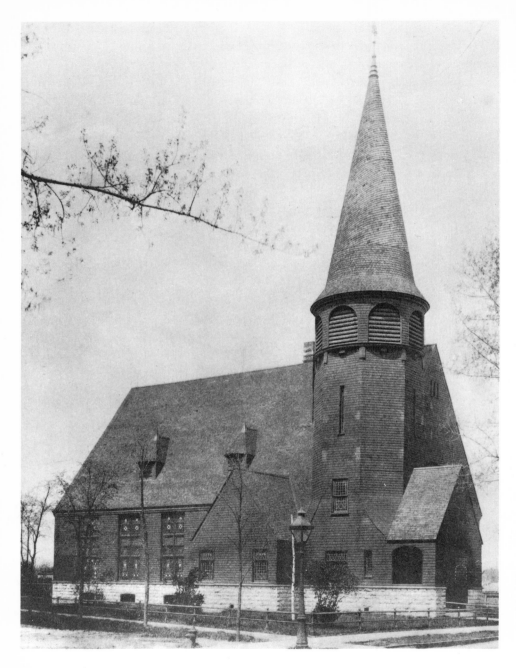

Fig. 74. Lake View Presbyterian Church, northwest corner of Addison and Broadway, Chicago, 1887–1888. From the Inland Architect.

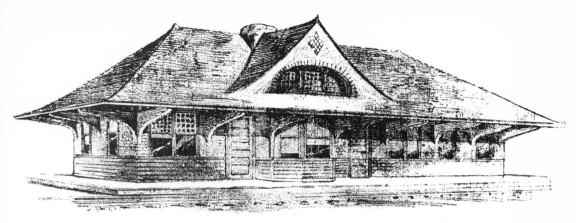

Fig. 75. Chicago, Burlington & Quincy Station, Kewanee, Ill., 1887. Destroyed. From the Inland Architect.

transomed windows and picturesque rooflines was clearly more appropriate, in fronts of only 18 feet 9 inches, than the Romanesque would have been. The plans typically called for an entrance hall and kitchen on the ground story, living room and dining room on the story above, and bedrooms on the upper stories. The house with the suppressed oriel, at 1310 Astor Street, Root soon chose for his own family. It was his last home.

Much of the work in Burnham & Root's office during the summer of 1887—with the exception of the house for James L. Lombard, at 1805 Jefferson Street in Kansas City, Missouri, where the wall was of Roman brick, in strict planes and with hard-edged boundaries (Fig. 80)—can be dismissed as disappointingly routine. The building for the First National Bank of Peru, Indiana, at the northwest corner of Main Street and Broadway, perhaps was indebted to Richardson's Cheney Block in Hartford, Connecticut, and in any event was a tired design. The high, octagonally domed memorial designed as their entry in the competition for the Indiana Soldiers' and Sailors' Monument, in Indianapolis, was not premiated and was not very fortunate. Likewise academic was their six-story addition to the St. Louis Hotel, in Duluth, Minnesota. In Kansas City, a meager budget resulted in a building of very little note for the Young Men's Christian Association.

But by the fall of 1887 Root was planning a large building for the Society for Savings, a mutual savings association founded in 1849 by Samuel H. Mather, in Cleveland. The society was rather more than a mere bank; by the summer of 1890, when it occupied its new home at the northeast corner

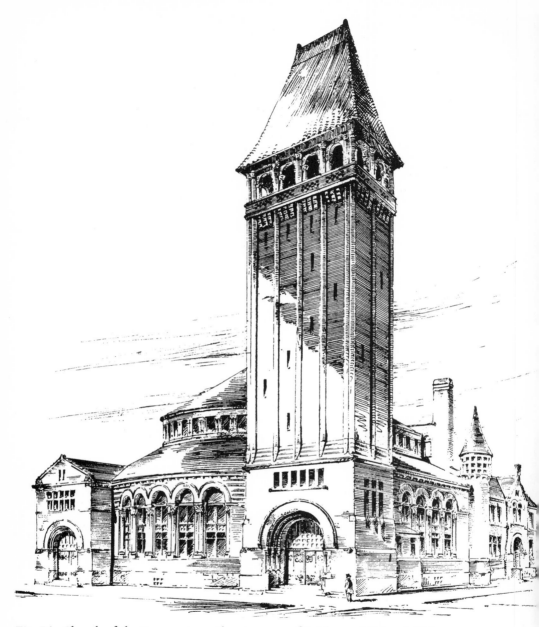

Fig. 76. Church of the Covenant, southeast corner of Belden and Halsted, Chicago. Rendering of 1887. Destroyed. From the Building Budget.

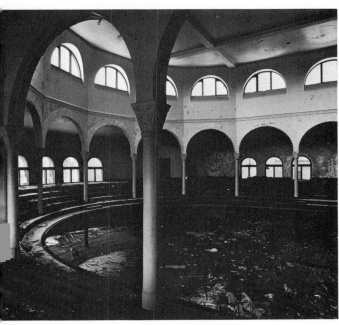

Fig. 77. Church of the Covenant. Auditorium, prior to demolition. Photo by Richard Nickel.

Fig. 78. Church of the Covenant. Photo by Richard Nickel.

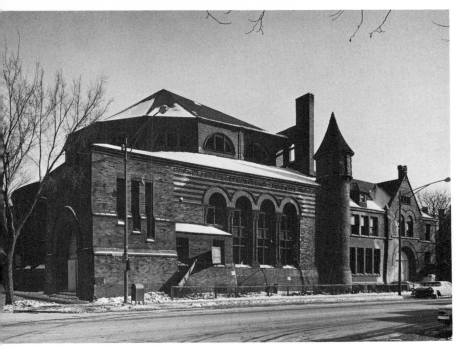

119 *KANSAS CITY, CLEVELAND, SAN FRANCISCO: 1886–1887*

Fig. 79. J. F. Houghteling houses, 1300 block of Astor, Chicago, 1887–1888. Photo by author.

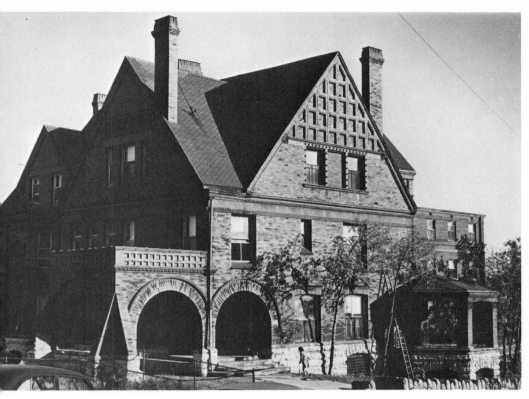

Fig. 80. James L. Lombard house, 1805 Jefferson, Kansas City, Mo., 1887–1888. Destroyed. Photo by author.

of Public Square, there were more than 40,000 depositors. The outer walls of the building (Fig. 81) were as thick as 5 feet: as a deliberately monumental expression of a financial citadel, they were plainly self-sustaining.[10] In contrast, the interior structure was advanced—the odd-numbered floors diagonally windbraced and the columns built-up from Z-bars, a technic pioneered only in 1886 by Charles L. Strobel, in the Chicago, Milwaukee & St. Paul Railroad bridge at Kansas City.[11]

The plan (Fig. 82) measured 110 feet on the south and 132 feet on the west, taking its form from a central light court 34 feet by 56 feet and sur-

[10] A photograph showing the building in construction appears in *Engineering Magazine*, IV (Nov. 1892), 180.

[11] The Z-bar column was also called the Strobel column. Its apparent advantage was that the girders could be brought up to the web member, and the load close to the center of gravity of the column. See "Tall Buildings in Chicago," *Railroad Gazette*, XXIII (Oct. 1891), 761.

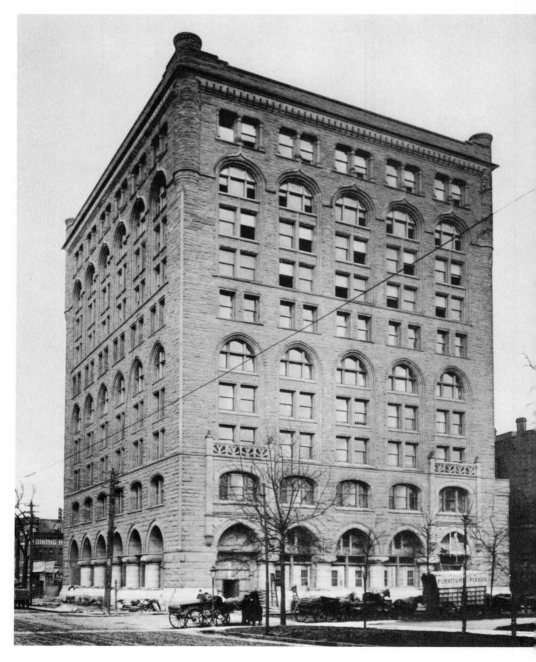

Fig. 81. Society for Savings Building, 127 Public Square, Cleveland, 1887–1890. Courtesy the Western Reserve Historical Society.

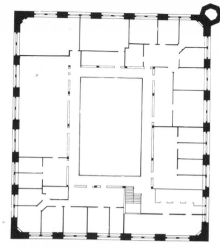

Fig. 82. *Society for Savings Building. Plan of eighth floor. Courtesy the Society National Bank.*

Fig. 83. *Society for Savings Building. Light court. Courtesy the Society National Bank.*

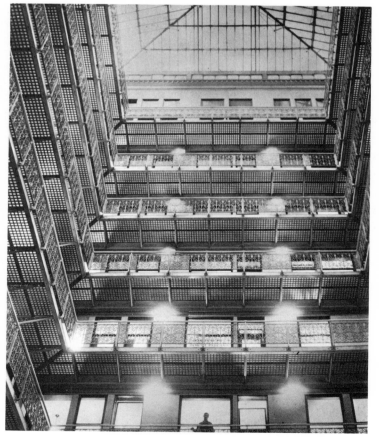

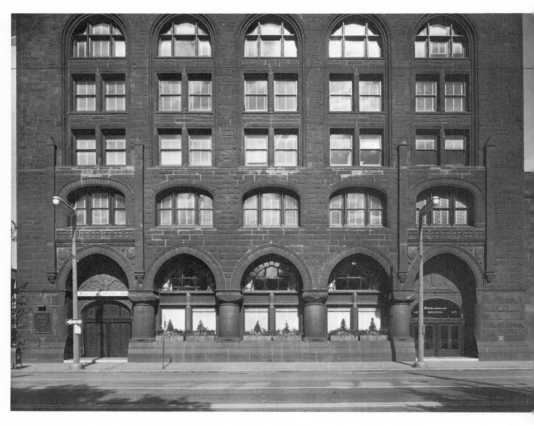

Fig. 84. Society for Savings Building. Detail of south front. Photo by Historic American Buildings Survey.

Fig. 85. Society for Savings Building. Lamp standard. Photo by Historic American Buildings Survey.

125 *KANSAS CITY, CLEVELAND, SAN FRANCISCO: 1886–1887*

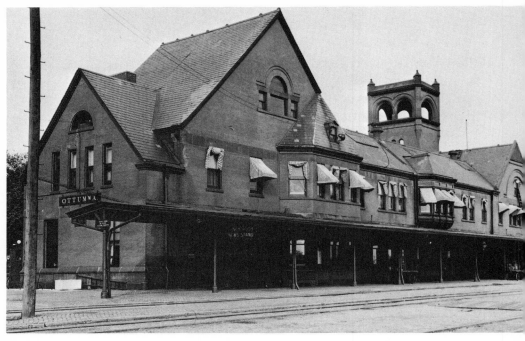

Fig. 86. Chicago, Burlington & Quincy Depot, Ottumwa, Ia., 1887–1889. Roof of tower destroyed. Courtesy of A. M. Rung.

rounded by galleried corridors and a single tier of offices. Light was Root's controlling motive. Nearly every surface—the white marble facing of the walls, the gilt guardrails, or the little lights of the gallery floor—was either reflective or translucent (Fig. 83). The court was vaulted at the roof and again above the banking chamber, where an inner ceiling, 26 feet above the ground floor, was coffered and colored with leaded-glass lights. Great round columns with gilt capitals of a strange vegetative design articulated the space of the chamber. The artist William Pretyman, a friend of Root's, executed murals as well as stenciled patterns across the spandrels and the wood fasciae of the beams. Root expressed the chamber in the street elevations by a deep arcade which sprung from cyclopean rock-faced capitals on short granite columns (Fig. 84). His evident caprice in varying the arcades of the upper stories was largely overcome by the uniform texture of the red sandstone wall, a kind of allover masonry grid. A short polygonal tower at the southeast corner communicated with the offices immediately above the banking chamber; while, at the southwest corner, Root planted a lamppost which

Fig. 87. San Francisco Chronicle Building, northeast corner of Market and Kearny, San Francisco, 1887–1890. Courtesy the Bancroft Library, University of California.

Fig. 88. San Francisco Chronicle Building. Bracing scheme. Diagram by author.

127 *KANSAS CITY, CLEVELAND, SAN FRANCISCO: 1886–1887*

clasped the stone with coiling vines of iron (Fig. 85)—a very personal fantasy that hardly could have occurred except in those few years between the death of Viollet-le-Duc and the advent of the Art Nouveau.

The station for the Chicago, Burlington & Quincy Railroad in Ottumwa, Iowa, was commissioned late in 1887 and finished in 1889. In later years it was dispossessed of the steep hipped roof of its stair tower and observation deck (Fig. 86). The ground plan measured 36½ feet by 212 feet 5 inches and was the same, essentially, as the plan of the Union Depot in Burlington, Iowa.[12] Nearly all the window openings were now rectangular. The edges of the wall were sharp, the surfaces smooth and flat.

In 1887, Michael de Young introduced Burnham & Root to the West Coast by commissioning them to design a new house for the San Francisco *Chronicle*. Construction was begun a year later, in November 1888, and the building became the first high office block in the city, rising at the northeast corner of the intersection of Kearny, Geary, and Market streets, on a mis-shapen lot which sloped down Market Street toward the bay (Fig. 87). The plan-form surely must be ranked among the most eccentric in the history of the high office building (Fig. 88). The mixed structural system—masonry outer walls bearing their own weight, with the framing of cast columns and steel girders and beams braced to the masonry for mutual support—was intended as protection against earthquakes. Horizontal steel straps, running diagonally from the columns and bolted to the beams at each crossing, were introduced "to prevent the lateral racking and dislocation which an earthquake of great force might bring about."[13]

The program, partly institutional but mostly speculative, called for two presses in the basement, the paper's business offices on the ground floor and entresol, editorial offices on the ninth floor, and the stereotyping department and composing room on the tenth; the rest of the space was for rent. Thus, although Root handled the speculative middle stories in a straightforward and clean-cut way, he overpowered them with a monumental base and a gigantic clock-tower reaching 208 feet high. The tower, as Schuyler remarked, was rather more than required to mark the juncture of the two unequal wings

[12] The plans appear in the *Engineering and Building Record*, XXI (May 1890), 372.

[13] San Francisco *Chronicle*, LI (22 June 1890), 2. See also San Francisco *Chronicle*, LI (17 June 1890), 1, 3; *San Francisco News Letter* (25 Dec. 1889), 83–84; and *Sixty Years a Builder: The Autobiography of Henry Ericsson* (Chicago, 1942), pp. 289–290. The building suffered major damage in the earthquake of 1906. In the 1960s it was altered so grossly that it might as well have been destroyed.

(measuring 59 feet on Geary Street, and 85 feet 10½ inches on Market Street); indeed, it said far less about the newspaper than about how obsessive a tower could become in the picturesque architecture of the nineteenth century. The quasi-Palladian motif, which had appeared in St. Gabriel's Church and in two of the railroad stations, was not an effective transition from the building mass to the sandstone base of the tower. The corbels were inanely repetitive and profiled as if cut with a scroll-saw. The tourelles were sheathed in cold-rolled copper, ringed as though turned on a monstrous lathe, and capped with most curious spools. The *Chronicle* nevertheless took great pride in the clocks, boasting that they deviated only two seconds a month from Lick Observatory time. A helical staircase behind the clocks climbed to the loggias of the fourteenth story. There, perhaps, with the enchanted hills of the bay spreading out in every direction, the tower was redeemed.

VI· CHICAGO AND ELSEWHERE: 1888-1889

Apart from the lack of government commissions (which, as P. B. Wight said, never seemed to go to architects of high caliber), the most conspicuous lacuna in the work of Burnham & Root was the architecture of theaters.[1] Their only building of this type was the Davidson Theater, at 621 North Third Street in Milwaukee, where, in a program probably inspired by the Auditorium in Chicago, the theater was hidden within a hotel building and flanked on the north side by a low annex of shops and offices. The commission was reported in January 1888. The clients were Alexander Davidson and John A. Davidson, Chicago contractors in marble: the easy source of stone evidently turned Root's thoughts to the Gothic palaces of Venice.[2] Yet the budget was puny, somewhere between $250,000 and $300,000. The marble facing of the building stained badly over the years, but early views show that it never had any strength or variety in color and thus acquiesced to a city of crushing grayness. The marquee was an elephantine excrescence of stubby columns and depressed arches below an arcaded stone parapet. Similar columns defined the ground-story bays, where the windows folded out-

[1] Probably the reason for Burnham & Root's lack of theater commissions was that Adler & Sullivan (through Adler's growing reputation for acoustical genius, in combination with Sullivan's decorative bent) had gained a dozen commissions for theaters and theater remodelings during the same years in which Burnham & Root were working. Sullivan makes it clear that William E. Hale was unhappy when Ferdinand Peck did not choose to give the Auditorium commission to Burnham & Root. See his *Autobiography of an Idea* (New York, 1924), p. 294.

[2] Harriet Monroe illustrates a detail (*John Wellborn Root* [Boston and New York, 1896], p. 110) that she identifies only as a "Tower for a Venetian Theater." Whether it represents a study for the Davidson Theater or an exotic motif for the Fair of 1893, is uncertain. Views of the theater are in *Milwaukee, 100 Photogravures* (Milwaukee, 1892), p. 66, and *History of Milwaukee*, ed. William George Bruce, 2 vols. (Milwaukee, 1922), I, 702.

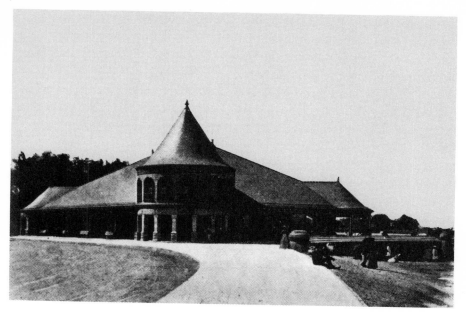

Fig. 89. Jackson Park Pavilion, Fifty-sixth and the lake shore, Chicago, 1888. Destroyed. From Picturesque Chicago and Guide to the World's Fair, *courtesy Chicago Public Library.*

ward at an obtuse angle.[3] Narrow beltcourses confused most of the wall, while at the attic the mullions advanced from the wall plane, rose into blind flowing tracery, and pierced the cornice—where they flowered into twenty lily pinnacles. This rude detailing and lethargic massing renounced at every turn the evident historical sources. In the theater, thin cast columns like those in the Church of the Covenant supported the two balconies. After a fire on 9 April 1894 very little of Root's interior was left. It was rebuilt from plans by Charles B. Atwood, the decoration becoming classicistic.[4]

Two lesser commissions, both reported in March 1888, resulted in much happier designs. For the Jackson Park Pavilion, on the lake shore just south of Fifty-sixth Street in Chicago, the program was ideal: a simple shelter from sun and rain, for picnics and other pursuits of leisure (Fig. 89). In 1886, Root had remarked that "in all inclement climates the most vital element of exter-

[3] Similar detailing appears in the five oriels on the east wall of the Society for Savings Building, and later in certain oriels of the Manhattan Building by Jenney with Mundie.

[4] The fire started in the hotel kitchens, which, for better ventilation, were at the top of the building. Beneath the kitchens were the wooden Howe trusses from which the theater ceiling was suspended. Two trusses caught fire and the ceiling collapsed.

nal expression is the roof."[5] Here the roof was almost the only element among the requirements, and a more beautiful roof scarcely is conceivable. It fanned over the gentle ridges to surround the conical turrets. Its slate was like the feathering of some giant gray gull. The wall was arcaded and nearly nonexistent. The great bollards along the promenade perhaps harked back to Root's days along the docks of Liverpool. For only a few years, the pavilion stood as one of the more inspired essays in the seaside architecture of America.[6]

In Kansas City, the Grand Avenue Station (Fig. 90) invited comparison with H. H. Richardson's last building of this type, the Union Station of 1885-1887 in New London.[7] Commissioned by the Kansas City Belt Railway as a switch point and stopover for passengers on three roads, the station unfortunately was sited in a ravine known quaintly enough as O. K. Creek. Basic to the simple plan, which measured 37 feet 2 inches by 150 feet, was a double staircase from the waiting rooms to the third floor, where a boardwalk communicated with the street. Like the station in New London, the building was long and low, its clean walls of brick rising to softly curled rooflines. With the flutter of the window openings and the extension of the eaves, Root spoke of travel. By contrast, Richardson's station had heavy shoulders, a massing too monumental and even leaden-hearted. It was the end of the line.

The site for the Rand-McNally Building, at 165 West Adams Street in Chicago, was leased from Marshall Field in October 1888. Root was already planning a metal-framed structure, each street elevation resulting from a studied adjustment of window openings to the sheathed frame (Fig. 91).[8] There was much indecision about the height: would the building be ten, twelve, fourteen, or sixteen stories? Paul Starrett recalled the constant revision of the interior framing, as well as of the floor plans. A permit was issued in June 1889 for a fourteen-story building but only ten stories were built. The 125-foot building was finished in the fall of 1890.

[5] "Short Roofs and Half-Timbered Gables," *Sanitary Engineer*, XIV (Oct. 1886), 517.

[6] The pavilion unfortunately stood at the northeast corner of the World's Columbian Exposition; the South Park Commission allowed it to be altered and enlarged to serve as the Iowa State Building. It was later destroyed.

[7] Cf. H. R. Hitchcock, *The Architecture of H. H. Richardson and His Times*, 2nd rev. ed. (Hamden, Conn., 1961), fig. 114. Hitchcock judged this to be an excellent design.

[8] The framing was not exclusively of steel. The mullions of the court wall were cast iron. Cf. "Building Construction Details, No. 50," *Engineering Record*, XXV (Jan. 1892), 94.

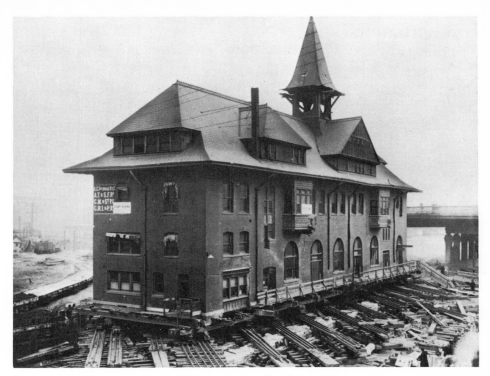

Fig. 90. Grand Avenue Station, Twenty-second and Grand, Kansas City, Mo., 1888–1889. Destroyed. Courtesy of William Sims.

The interior lot presented another problem. It seemed large, about 158 feet on the north and about 171 feet along the blind west wall, but nevertheless it denied the plan (Fig. 92) the wholeness that was characteristic of the Rookery. The sectional drawing (Fig. 93) shows the rational framing (the columns were built-up from Z-bars, with horizontal tie-rods for windbracing), and how the internal court, about 60 feet by 67½ feet, funneled daylight to the inner quadrangle of offices. But it is also apparent that the court was not animated by vital patterns of communication. The vault did not span a semi-public space, but merely the corporation's accounting department; the building suffered from the fact that the client was his own best tenant. With entrances at every corner, and stairs and elevators scattered along the east and west walls, there was indeed very little spatial organization.

At the east wall, where a small external court keyed with the court of the abutting structure (Burnham & Root's own Insurance Exchange Building), Root once more appealed to his structural intuition. For the wall

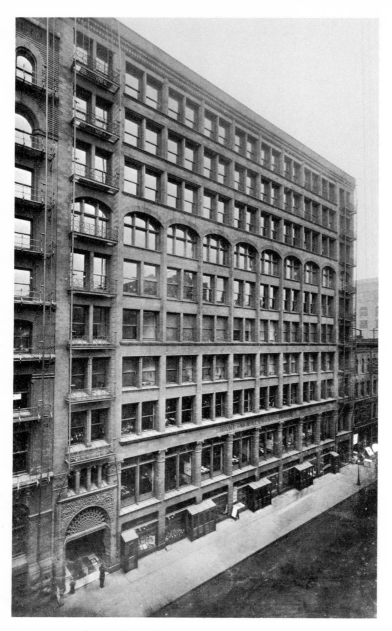

Fig. 91. Rand-McNally Building, 165 West Adams, Chicago, 1888–1890. Destroyed. Courtesy of Rand McNally & Co.

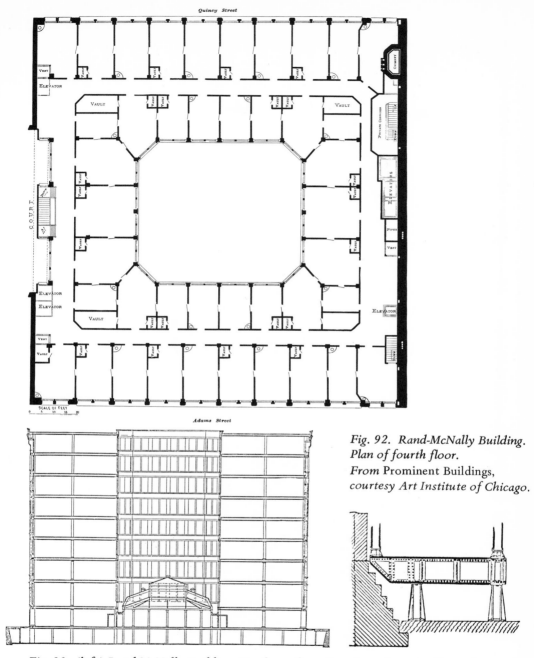

Fig. 92. Rand-McNally Building.
Plan of fourth floor.
From Prominent Buildings,
courtesy Art Institute of Chicago.

Fig. 93. (left) *Rand-McNally Building. North-south section through center. From the*
Engineering Record.
Fig. 94. (right) *Rand-McNally Building. Elevation of cantilever at foundation. From the*
Engineering Record.

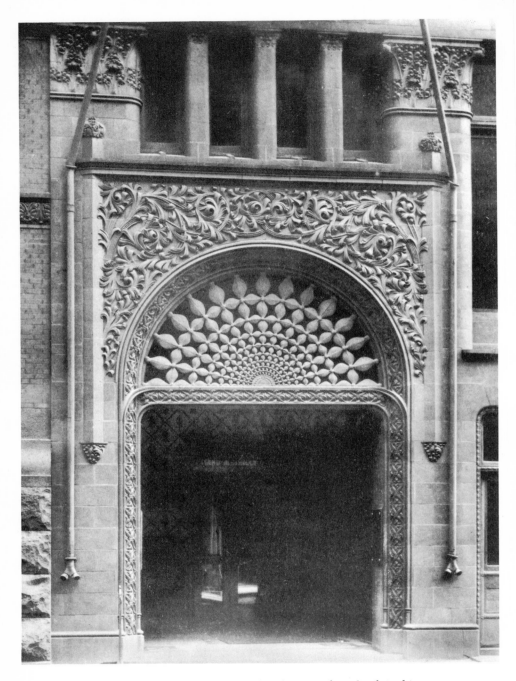

Fig. 95. Rand-McNally Building. Entrance detail. From the Inland Architect.

136 JOHN WELLBORN ROOT

was to reach well over the stone footings of the older building, thus threatening to cause damaging settlements. Seeing not enough room for underpinning, Root thought of the cantilever, "one of the architect's best friends." By treating the new wall as a curtain carried on beams—the plan indicates that the east wall was much lighter than the blind west wall—he could, in turn, carry the columns on cantilevers formed of double box-girders, which were poised on heavy cast-iron pedestals as fulcrums (Fig. 94). "Thus we carry our own new wall from within," he explained, "and in no way disturb the neighboring building."[9] The cantilever foundation represented Root's second great contribution to foundation engineering.[10]

The street fronts of the Rand-McNally Building were faced in an allover terra cotta, still another innovation. Terra cotta promised the advantages of economy, light weight, excellent fireproofing, and easy modeling. If the elevations at first blush seemed as rigorous as those of the second Leiter Building, which was designed in Jenney's office only a few months later, Root nevertheless thought the walls of the latter were diminished by a cold and unimaginative Puritan spirit.[11] Although he was just as explicit in "expressing" the metal frame (even the segmental arches at the seventh story, a polite salute to the arcuation of the Insurance Exchange Building and of the Field Wholesale Store, were at the same time a sly, if wayward, allusion to a structural fact, for the flat ceilings of the Rand-McNally Building were hung from segmental floor arches), he always sought plasticity. He rounded the piers or compounded their edges, and he enriched the four small entrances with a terra-cotta foliation particularly exquisite at the capitals, where the forms seemed in the very process of bubbling forth from the material (Fig. 95).[12]

[9] John W. Root, "A Great Architectural Problem," *Inland Architect*, XV (June 1890), 70.

[10] Cf. the obituary in the *Economist*, V (Jan. 1891), 121. The cantilever, said Dankmar Adler, played a minor role under the Auditorium and under the Edison Building on Adams Street (a front of 45 feet, the next door east from Jenney's Home Insurance Building), and was first used on "a grand scale" in the Rand-McNally, Chemical Bank, and Herald buildings; see *Industrial Chicago* (Chicago, 1891), I, 476. The Manhattan Building, where it was Mundie, apparently, who suggested cantilevered party walls and a withdrawal of the stories above the ninth (thus inadvertently creating the first setback skyscraper), is dated 1889–1891, or slightly later than the Rand-McNally Building. The origins of the setback are discussed in my note, "The Setback Skyscraper City of 1891: An Unknown Essay by Louis H. Sullivan," *JSAH*, XXIX (1970), 181–187.

[11] John W. Root, "Architects of Chicago," *Inland Architect*, XVI (Jan. 1891), 92. The second Leiter Building has survived into the 1970s, while the Rand-McNally Building was destroyed in 1911. But the comparative lack of attention paid to Root's building is inexcusable.

[12] Root's ornament rarely became as idiosyncratic as Sullivan's, which matured near the end of the decade. Root did not commit the solecism of combining foliate forms with a geometric or crystalline

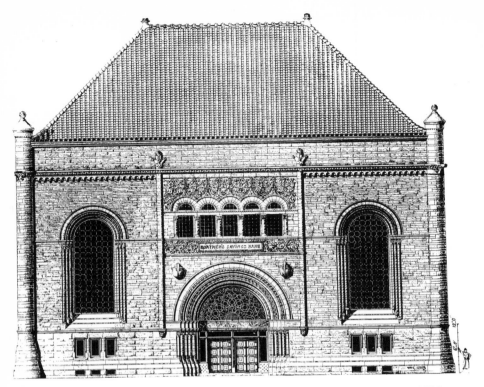

Fig. 96. Boatmen's Savings Bank Building, St. Louis, competition project, 1888. From the Inland Architect.

In the competition of 1888 for the Boatmen's Savings Bank Building in St. Louis, Root entered an astonishing image (Fig. 96), carrying the spirit of the Romanesque as close as he could to the Renaissance. The elevation, drawn in the manner of Viollet-le-Duc, with a little hooded figure conveniently holding a scale rule, was very different from the spare axiality of his west front for the Santa Fe Building. It was, at once, more Romantic and more calculated. The parts were ordered into threes or fives, and most of the measurements were set at multiples of a 3-foot module (Fig. 97). The rock-faced wall, the tiling of the steep roof, the sculptured angle turrets were still characteristic; but such compulsive proportioning makes one suspicious that Root had paid close attention to the publication of McKim, Mead & White's

space-lattice. Root and Wright both discerned in Sullivan's ornament a basic indifference to the materials in which it was realized.

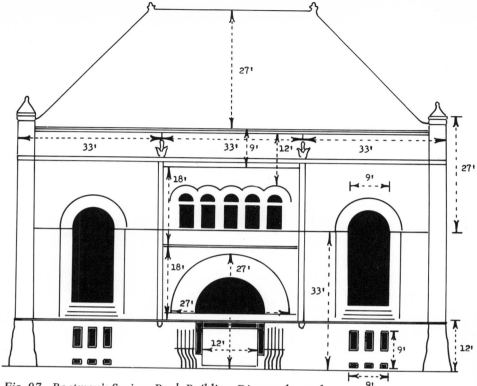

Fig. 97. Boatmen's Savings Bank Building. Diagram by author.

plans for the Boston Public Library.[13] Root's design was not premiated, and at some point the program was changed so that it entailed five stories of speculative office space.[14]

The First Regiment Armory (Fig. 98) was conceived as an engine of defense in a day when civil disorder was a source of great anxiety. (A perspective drawing is dated March 1889; two months later, the Haymarket Monu-

[13] Plans, elevations, and perspectives were first exhibited in April 1888, and were published in the *American Architect*, XXIII, on 26 May and 9 June 1888. William H. Jordy thoroughly discusses the library in his Vol. III of *American Buildings and Their Architects* (Garden City, N. Y., 1972), pp. 314–344. Early views of the library, and of the model for it, can be found in *Back Bay Boston: The City as a Work of Art* (Boston, 1969), pp. 59–61, 65, 117.

[14] In 1890-1891, the bank built a seven-story block at the northwest corner of Fourth and Washington, from plans by Thomas B. Annan & Sons of St. Louis. The building, shown in *Commercial and Architectural St. Louis* (St. Louis, 1891), p. 85, was destroyed by fire in 1914. The records of the competition were lost at the same time.

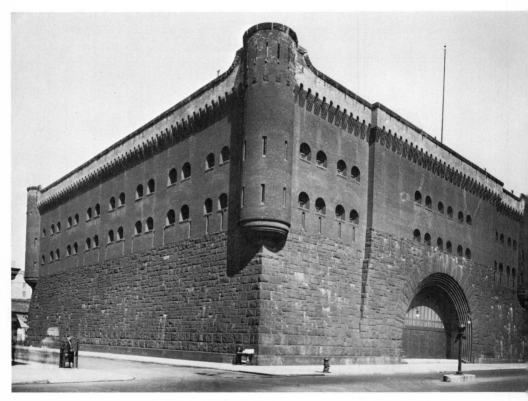

Fig. 98. First Regiment Armory, northwest corner of Sixteenth and Michigan, Chicago, 1889–1891. Destroyed. Photo by Kaufmann & Fabry.

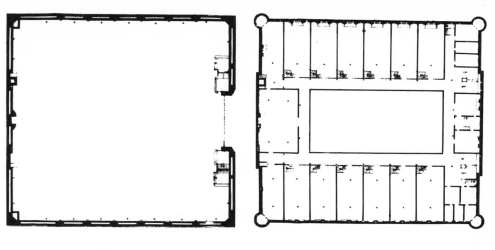

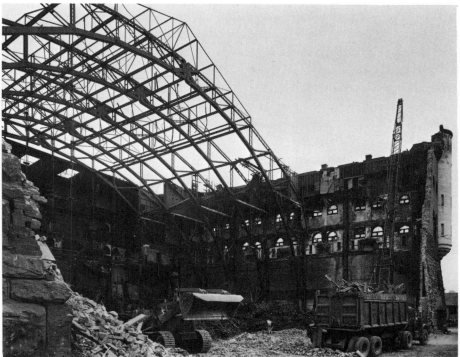

Fig. 99. (top) *First Regiment Armory. Plans of first (left) and second floors. Courtesy the Art Institute of Chicago.*

Fig. 100. (bottom) *First Regiment Armory. Under demolition. Photo by Richard Nickel.*

ment, commemorating the policemen who died in the riot of 4 May 1886, was formally unveiled. The sculpture was by Johannes Gelert, a friend of Root's, and the pedestal was designed by Root himself.) The rifle slots and machicolated parapet were hardly ornamental. The plans noted such details as the set of a gatling gun to the southeast. The slits in the bartizans were intended for enfilading, to "command both Sixteenth Street and Michigan Avenue in case of riots or in times of disturbance."[15] The site of the armory, significantly, was close to the South Side houses of the very wealthy.[16]

Montgomery Schuyler thought an old armory in Philadelphia possibly had furnished the prototype. He must have been referring to the armory of the First Troop, Philadelphia City Cavalry, a building designed by Frank Furness in 1873 and built at Twenty-first and Barker streets in 1874. The elevations, which one might call Victorian Assyrian, did not really suggest Root's armory except for the fact that the high base of battered stone gave way to an upper wall of red pressed brick; but the plan was distinguished by a suspended gallery overlooking the ground-floor drill space.[17] Root's elevations found their source in French medieval architecture, in structures such as the fourteenth-century keep at Vincennes.

The cornerstone was dedicated on 12 July 1890 and the armory was substantially finished by the end of 1891, after Root had died. The walls stood about 75 feet high, in an east front of 163 feet 4 inches and a south front of 172 feet 2 inches. Root quite logically designed the fabric from the outside in. The drawings show the span of the sallyport, scaled to accept sixteen men marching abreast, to have been more than 40 feet. The voussoirs measured 10 feet and the depth of the reveal 11 feet. The iron portcullis weighed more than 6 tons. The sandstone masonry was magnificent, especially where the wall returned at the surrounds of the sallyport, a detail reminiscent of the granite angles at the base of the Rookery. In the brickwork, the first register of stilted window openings was beautifully ordered by the relieving arches above and the rifle slots below. Such impenetrability of course meant a drastic reduction of light to the interior; thus the plan was generated from an internal light court of about 50 feet by 105 feet, the up-

[15] "Chicago," *American Architect*, XLVI (Nov. 1894), 60.

[16] The reputation of the National Guard as an elitist and antilabor force is discussed by Renata Adler in "The Guard," *New Yorker*, 3 Oct. 1970, 40–64.

[17] Cf. Montgomery Schuyler, "D. H. Burnham & Co.," *Architectural Record*, V (Dec. 1895) p. 64. See also *History of the First Troop, Philadelphia City Cavalry 1774–1874* (Philadelphia, 1875), pp. 88–89; and James C. Massey, "Frank Furness in the 1870s," *Charette*, Jan. 1963.

Fig. 101. (top) *E. H. Valentine house, northeast corner of State and Goethe, Chicago, 1889–1890. Destroyed. From the* Inland Architect.

Fig. 102. (bottom) *E. H. Valentine house. Plan of first floor. From* Scribner's Magazine.

per floors suspended from huge roof trusses (Figs. 99–100).[18] Twelve company rooms took the north and south walls of the second floor. Each had a fireplace and a corner staircase to the locker room above. A kitchen, banquet hall, and library were at the west wall, and the rooms for the officers, quartermaster, and surgeon at the east. The drill floor was kept highly polished. It served also as a dance court.

Of the two houses which Root had ready for bids by March 1889, that for Edward H. Valentine was more important (Fig. 101). It was built at the northeast corner of State and Goethe streets, only a block south of the Ayer house and with the same orientation. The site of the Valentine house was only three blocks from where the James Charnley house was to be built in 1891–1892. Frank Lloyd Wright claimed for the Charnley house not only that it was the first modern building, but that it was the first instance in which the plain wall was decoratively enhanced by a careful assignment of single window openings. Yet it is evident that the Valentine house, both in plan (Fig. 102) and elevation, set a definite precedent.[19] Root had written in 1887 that one could hardly overestimate the value of plain surfaces. "Strive for them," he said, "and when the fates place at your disposal a good, generous sweep of masonry, accept it frankly and thank God."[20] The house for Valentine indeed had much the same spirit as Wright's early "dress reform" houses. Root himself thought it enjoyed "a very strong Colonial feeling, without in any way servilely following the Colonial type."[21] The wall was of dark brown brick streaked with red, the terra-cotta sillcourses and window surrounds in similar hues—"a singular bloom of color," Root called it. The porch and the broad beltcourse above the basement were in red sandstone, the roof of purple slate. It was Root's finest residential design, a house of profound simplicity and repose.

The townhouse for Reginald de Koven, the composer and critic, might be faulted as excessively Tudor in detail (Fig. 103). Nevertheless, such picturesque historicism did not detract from the felicitous plan (Fig. 104). The house was built at 104 Bellevue Place. The front measured only 24 feet

[18] The trusses probably were designed by E. C. Shankland, whose trusses for George Post's Manufactures and Liberal Arts Building, at the World's Columbian Exposition, likewise lacked grace.

[19] Each house was characterized by sharp wall planes in Roman brick, a clearly demarcated basement, and a frontality emphasized by the round columns and the projections and recessions of the entrance bay. The very simple first-floor plan of the Charnley house was nearly identical to the plan of the Valentine house, with a prominent center stair hall and large alcoves flanking the entrance.

[20] John W. Root, "Style," *Inland Architect*, VIII (Jan. 1887), 99.

[21] John W. Root, "The City House in the West," *Scribner's Magazine*, VIII (Oct. 1890), 431.

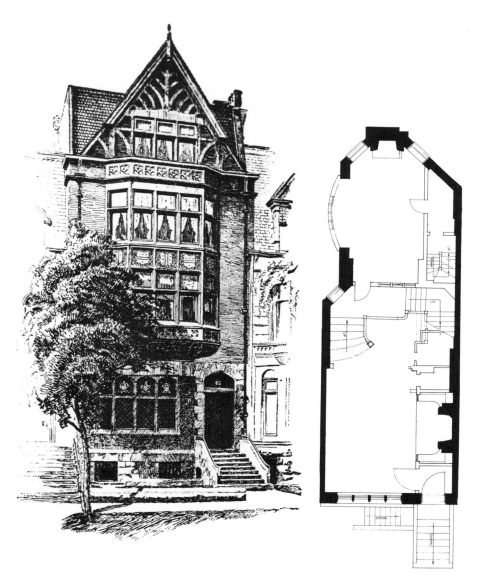

Fig. 103. Reginald de Koven house, 104 Bellevue Place, Chicago, 1889–1890. Destroyed. From Harriet Monroe, John Wellborn Root.

Fig. 104. Reginald de Koven house. Plan of first floor. Historic American Buildings Survey.

145 *CHICAGO AND ELSEWHERE: 1888–1889*

4 inches, but the depth was 71 feet. The raised first story afforded a living room about 23 feet square, with a broad fireplace and inglenooks, and a dining room more than 25 feet long, with another fireplace and with a segmental bay to the west. An open, skylighted stairwell enhanced the space between these principal rooms.

The eight-story speculative office building named eventually after the Chemical Bank was announced in March 1889 and was constructed rapidly at 115–121 North Dearborn Street (Fig. 105). Wilson K. Nixon had organized what he called the Abstract Safety Vault Company to build the block, and a major tenant was not secured until 1890. The front measured 60 feet on Dearborn, the north wall about 80 feet on an alley so aspiring that it was named Court Place. The framing throughout was of metal, and Root carried both the south wall and the east wall on cantilever girders. But the façade was a confusion of varied window enframements, superfluous sillcourses, trivial decorations of the spandrels, and scribbly interlaces surrounding the attic oculi.

Root had recovered, however, by the fall of 1889, when he designed two buildings for banks in Tacoma, Washington, a boom town founded in 1873 as the western terminus of the Northern Pacific Railroad. Soon after the Fidelity Trust Company was incorporated in September 1889, Burnham traveled to Tacoma to study the site: it measured 90 feet by 100 feet on the northeast corner of Broadway and Eleventh Street, sloping down to Commerce Street on the east. The grade gave the west elevation five stories and the east elevation six (Fig. 106). Storefronts, a large restaurant, and the offices of the trust company occupied the base, while each of the upper stories, on an H-plan, afforded twenty-six offices. Above the ground story the elevations were almost entirely of Roman brick and had almost no ornamentation. The window openings seemed chiseled through the wall. The middle stories were integrated by the withdrawal of the spandrels and mullions and by the arcading of the fifth story. At the sixth story the piers and mullions were gently corbeled into a machicolated cornice.

There were obvious affinities between the Fidelity Trust Building and the warehouse Adler & Sullivan had designed for Martin Ryerson, published in the *Inland Architect* of April 1889. Yet, in a more basic sense, Root drew the remarkable simplicity and dignity of his building from the level of discipline he had attained in the spring and summer of 1889, when he was at work on two of his greatest office blocks, the Monadnock Block and the fifteen-story tower for W. E. Hale.

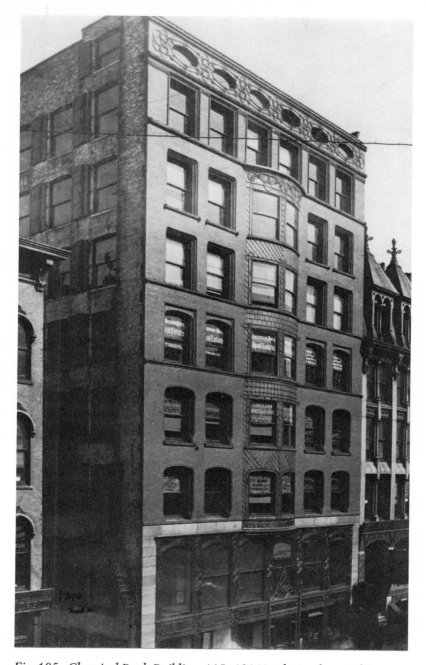

Fig. 105. Chemical Bank Building, 115–121 North Dearborn, Chicago, 1889. Destroyed. Courtesy the Chicago Historical Society.

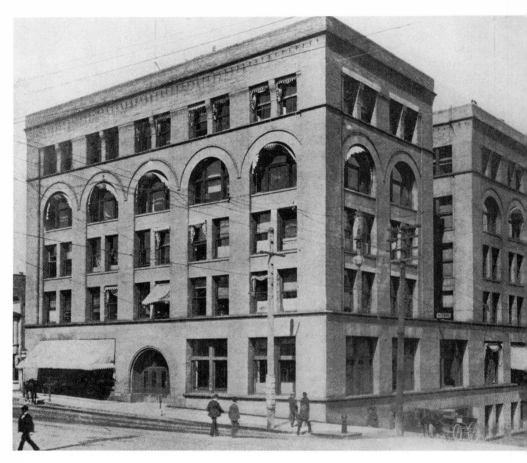

Fig. 106. Fidelity Trust Building, northeast corner of Broadway and Eleventh, Tacoma, Wash., 1889–1891. Courtesy the Tacoma Public Library.

The second commission in Tacoma seems to have come simultaneously, and it is probably significant that the same man, Thomas B. Wallace, was president of the Fidelity Trust Company and first vice-president of the Pacific National Bank. The building for the latter represented an investment of less than a third of that of the former; the construction was of timbers, not even fireproof. It stood on the south side of Thirteenth Street, between Commerce Street and Pacific Avenue, and again, because of the grade, had five stories on the west and six on the east. Over the years, remodelings were so ruthless that all that remained, really, to suggest the work of Burnham &

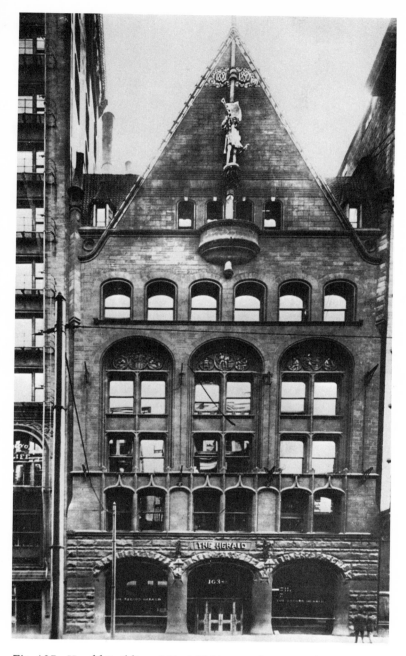

Fig. 107. Herald Building, 161–165 West Washington, Chicago, 1889–1891. Destroyed. Courtesy of Chicago's American.

149 *CHICAGO AND ELSEWHERE: 1888–1889*

Root were ten small blocks of terra-cotta foliation at the entrance arch on Commerce Street.

As a comparatively small block with a definite representational intent, the Herald Building in Chicago not surprisingly became picturesque (Fig. 107). The editors of *Industrial Chicago* strained to describe its relaxed medievalism as Romanesque below and almost Flemish above. The site was chosen in 1889. It had a 61-foot front at 161–165 West Washington Street, running south almost 180 feet to the alley called Calhoun Place. With an external light court at the east wall, the plan became a backward C. In five full stories and two more floors in the gabled attic, the building rose 125 feet 11 inches to the roof ridge. The ground story, where the newspaper had its business offices, was lavishly enriched with mosaic floors, Italian marble columns and wainscoting, and a vaulted ceiling decorated in ivory and gold patterns. A gallery gave visitors a view of the presses. Root's organization of the façade in three bays was essentially a variation of his front for the Art Institute, although the details were different. At the ground story he nicely contrasted the rock-faced red granite ashlar with the smoothly rounded columns, and played both of them against the recessed reflections of the plate glass. He dressed the stories above in terra cotta, like the Rand-McNally fronts. From his friend Gelert, a native of Denmark who had arrived in Chicago by 1887, he commissioned the bas-reliefs and the bronze sculpture of the herald.

In November 1889, Eugene Pike approached Burnham & Root with a proposal to develop a site measuring 165 feet on Dearborn Street and 100 feet on Jackson Street, at the northeast corner. Some months earlier, Pike had entertained the notion of a sixteen-story office building; now, with the brisk competition for the Columbian celebration, he proposed a large hotel that could be finished in time for the Fair. Burnham himself organized the building company; he and Root became partners in the venture with Norman Ream, the building contractor George Fuller, and, of course, Pike. The leases for the older buildings on the site expired on 1 May, the customary time, and site preparation began immediately. The hotel was finished by the summer of 1891. It was originally named the Chicago Hotel, but more often remembered as the Great Northern Hotel (Fig. 108).

The structure was metal, with diagonal tie-rods for windbracing. The plan (Fig. 109) was as completely rationalized as the plan of any of Burnham & Root's office buildings. The best guest rooms were obviously those enjoying the oriel windows, especially at the wide polygonal bay on Dearborn Street and in the two ample hemicycle bays of the angles. Because of the var-

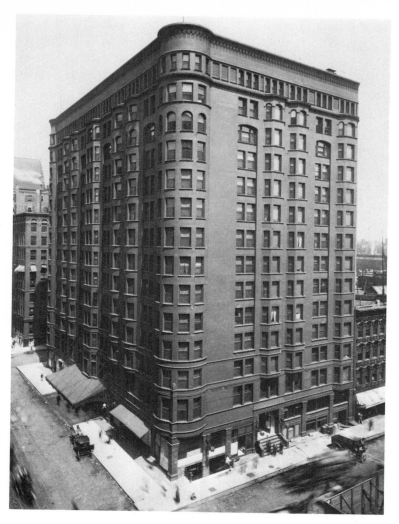

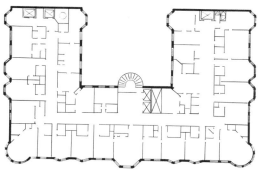

Fig. 108. Chicago (Great Northern) Hotel, northeast corner of Dearborn and Jackson, Chicago, 1889–1891. Destroyed. Courtesy the Chicago Historical Society.

Fig. 109. Chicago Hotel. Plan of fifth floor after remodelings. Courtesy the Graham Foundation.

151 *CHICAGO AND ELSEWHERE: 1888–1889*

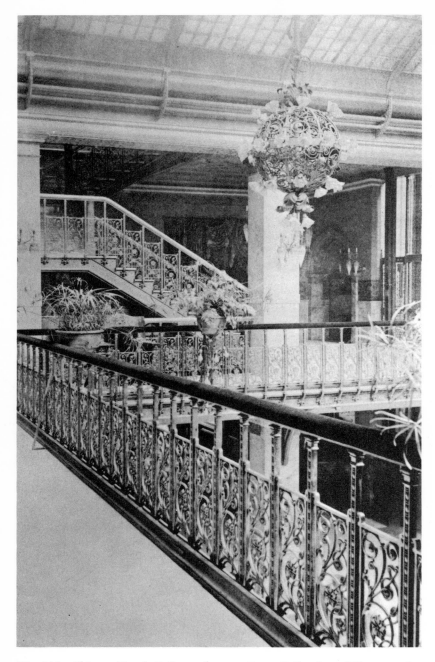

Fig. 110. Chicago Hotel. Gallery of court. From Collection of Photographs of "Ornamental Iron," *courtesy the Art Institute of Chicago.*

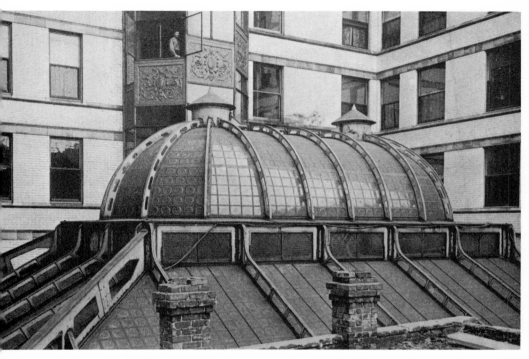

Fig. 111. Chicago Hotel. Court vault and stair oriel. From Collection of Photographs of "Ornamental Iron," *courtesy the Art Institute of Chicago.*

ious entrances, the elevator banks were dispersed; but the main corridors of the first floor converged at the hotel counters and offices, beneath the glass-and-iron vault of the court (Fig. 110). The detailing of the outer walls of the court and of the oriel windows was particularly straightforward and handsome (Fig. 111). In the street elevations, the piers at the base seemed as unrelated to the wall above as *pilotis*; the pier near the salient, because of the awkward requirements of a basement shop, gained a peculiarly barren appearance, as if some sort of makeshift underpinning. An entresol crowded part of the base. The design of the main entrance canopy and of the spiky lanterns seemed not responsive to the sober surfaces of the stories above, where the wall became a smooth skin of pressed brick, flickering over the serpentine trail of the projecting bays. It was a splendid performance, and the hotel had the good fortune to stand diagonally across from the incomparable Monadnock Block.

VII · THE MONADNOCK BLOCK

By 1884, John Root had come to regard the Monadnock Block as a challenge to the basis of his life work. There can be little doubt that he gave more time to it than to any other building. He had the design in his mind for more than five years. He died when the building was under construction; and, for a time, nearly everyone insisted on seeing the building as largely Burnham's work. To identify Root with both the Monadnock Block (Fig. 112) and another building finished at the same time, the Woman's Temple (see Fig. 135), was not easy. In 1892, when the correspondent of the *American Architect* contrasted the two buildings, he found the Monadnock Block to be not beautiful, not graceful, not appropriate, but simply big.[1] In 1893, another writer called the Monadnock Block a pure expression of business, a building which told its story in the plainest and strongest words, and then stopped talking.[2] In 1894, the critic Barr Ferree called its fenestration monotonous, but nevertheless concluded that it was a bold and simple building of dignity and power.[3] Finally, in 1895, Montgomery Schuyler was exalted to a seemingly Transcendental response: "This, one cannot help seeing, is the thing itself."[4]

[1] "Chicago," *American Architect,* XXXVI (May 1892), 134.

[2] Robert D. Andrews, "The Broadest Use of Precedent," *Architectural Review,* II (May 1893), 34–35. Andrews held the Monadnock Block to be without precedent in architecture.

[3] Barr Ferree, "The High Building and Its Art," *Scribner's Magazine,* XV (March 1894), 312.

[4] Montgomery Schuyler, "D. H. Burnham & Co.," *Architectural Record,* V (Dec. 1895), 56. Schuyler, alas, bore the usual cross of the journalist: only four years later, in appraising the Bayard Building (which was Sullivan's own favorite, even though, as Lewis Mumford observes, it was only a façade), Schuyler wrote: "This is the thing itself. Nobody who sees the building can help seeing that"; and in 1907, of the New York Evening Post Building, he wrote: "This, one may fairly say, is 'the thing itself.' . . . "

155

Once more the client was Peter Brooks. On 2 December 1881, Owen Aldis wrote Brooks that he had bought a lot 100 feet square, at a cost of $118,000. The problem was that the lot was dangerously isolated, if only by a few blocks, from the concentration of office space. No plans were begun. After the city council adopted an ordinance in 1882 for the opening of Dearborn Street south from Jackson Street, the lot was reduced to about 68 feet by 100 feet. Brooks knew that the narrowed site suggested an extremely tall building; he stood firm in his belief that Chicago was destined to become the second city, if not the first, in the nation. In 1884, he was beginning to think of perhaps fourteen to sixteen stories. In the meantime, Aldis heard rumors of an ordinance to restrict building heights and of a proposal to require complete fireproofing of all high buildings. Only by securing a building permit in advance could he protect Brooks's investment.[5] In a letter of 31 March 1884, he asked of Burnham & Root:

For what price will you make such carefully prepared and studied plans for a 12-story and basement building 68 X 100, S. W. corner Jackson and Dearborn. . . . I mean all plans essential and necessary to get out [a] permit to build . . . ?

Brooks evidently had approached Burnham & Root on his own; in a note of 5 April, they advised Aldis that Brooks was definitely planning a building. Brooks called the project the "Quamquisset." On 15 April, he wrote Aldis to complain that he had not yet seen elevation studies and added: "I would request an avoidance of ornamentation . . . rely upon the effect of solidity and strength, or a design that will produce that effect, rather than ornament for a notable appearance."[6] Root soon obliged, and on 29 April, in another letter to Aldis, Brooks wrote that he had received a front elevation: "I do not by any means think badly of this elevation and prefer it to the Counselman Building [published in the *Inland Architect* of April 1884]. The square windows are handsomer than the arched windows of [the] Montauk Block. . . . I dare say of course Mr. Root can improve on this but I am not

[5] An editorial in the *Sanitary Engineer*, IX (March 1884), 399, reports a rush for building permits in Chicago. In January 1884, in the same journal, Robert Kerr discussed legal limitations of building heights, with references to New York, Paris, and London. W. L. B. Jenney took out a building permit for the Home Insurance Building on 1 March 1884—rather prematurely, he said, because of a proposed ordinance to limit building heights at 100 feet.

[6] Thus the question of ornamentation was raised more than five years before the time that Harriet Monroe thought the building was first planned. Her anecdote of the Monadnock design, often quoted and all too familiar, is vitiated by such grievous errors that it will not be repeated here.

disappointed in it." In a letter of 6 May, Brooks made it clear that he was *not* demanding a building with no ornamentation whatsoever:

My notion is to have no projecting surfaces or indentations, but to have everything flush, or flat and smooth with the walls with the exception of bosses, and ornamentation of that nature in low relief, on the red terra cotta. . . . So tall and narrow a building must have some ornament in so conspicuous a situation . . . [but] projections mean dirt, nor do they add strength to the building . . . one great nuisance [is] the lodgment of pigeons and sparrows. . . .[7]

Brooks wrote on 31 July to assure Aldis he was happy to have Burnham & Root working on the plans. Aldis, on the contrary, was not so happy. On 16 September he wrote Brooks:

I have suggested to Mr. Root that Mr. Richardson, Mr. Root and some other architects have given up in despair the problem of architectural beauty and effect, under the conditions of the modern office building, *viz.*, great height, straight thrusts and bearings, flat surfaces, all the light attainable, low stories, and economy.

Mr. Root, however, refuses to give up the problem and vows that he is back on the right track with the sketch sent you some time ago. His head is now deep in Egyptian like effects, and he declares that if he fails to make a harmonious and massive and artistic building this time, he will never build another Office Building.

Brooks responded on 22 September by suggesting another solution—a square tower at the front of the lot, reaching about 200 feet high and shaped like an Italian campanile, "with a frieze around it on top with figures in terra cotta of large size." He seems to have had in mind something like the tower of Richardson's Brattle Square Church in Boston. But he abandoned the notion as soon as he had perversely enough broached it. "Mr. Root will have a hard nut to crack," he wrote, "but I think he is really on the right track with his sketch and that the Egyptian Style is the thing if not too pronounced."

By 1884, the concentration of office space had shifted to the area immediately north of the site of the new Board of Trade Building. The lot at Dearborn and Jackson streets, only two blocks to the east, still seemed estranged. On 20 October, Aldis wrote Brooks that the plans could wait until 1 May 1887; and Brooks was not anxious. "Chicago is yet in its infancy,"

[7]Brooks may have read the paper "On the Present Condition of Architectural Art in the Western States," *American Art Review*, I (1880), 141, where P. B. Wight said the best business buildings of the Middle West were characterized by an "absence of all projections." The journal was published in Boston.

wrote Brooks. He continued rather crankily: "Fifty and one hundred years will see it an enormous place unless communism and utter folly of the kind brings it and all the rest to grief and destruction. Universal suffrage and an elective judiciary are to be our curse."

Root, however, was not waiting. He had refused "to give up the problem." On 13 December, Aldis wrote Brooks that Root was "devoting much time and study to a pet plan for Quamquisset." It was not surprising that he was working with an ancient Egyptian theme.[8] Egyptian motifs had appeared in American architecture for some years; Root must have known such monuments as the old Croton Reservoir in New York. In 1879, for the Ames Monument in Sherman, Wyoming, Richardson designed a great granite pyramid. Irving K. Pond recalled that in 1880 the enigmatic John Edelmann, whose influence on Louis Sullivan has yet to be understood, was sketching ornamental conventions which he lightly described as "the Lotus of the Calumet."[9] In 1881, a draftsman in Chicago wrote the architect George Mason of Detroit that Dankmar Adler had introduced a new style with "features belonging to the ancient Egyptian"; indeed, between 1880 and 1884, at least five buildings from Adler & Sullivan were decorated by pilasters with bud-shaped Egyptian plant forms.[10]

Brooks decided early in 1885 to name the building after Mt. Monadnock in New Hampshire. Fortunately, elevation studies of that year have survived: the drawing for the Jackson Street front (Fig. 113) shows a narrow block, 166 feet high, in a "not too pronounced" ancient Egyptian spirit. The ground story is stone rather than pressed brick, and still has the appearance of a raised basement. Although framed by engaged columns beneath an entablature, the entrance is severe. It is also somewhat awkward in relation to the lower stories. Significantly, the batter of the wall does not occur in the ashlar of the ground story, but in the two stories above; and already the attic story responds with a shallow cove cornice. There are no projecting bays. The

[8]The common belief that the building represented "Richardsonian Romanesque" is of course false. In *Pioneers of Modern Design*, rev. ed. (Harmondsworth, England, 1960), p. 142, Nikolaus Pevsner rightly observes that here Root made no use of Richardsonian forms.

[9]Irving K. Pond, review of Sullivan's *Autobiography of an Idea*, *Western Architect*, XXXIII (1924), 68. Edelmann proclaimed the essence of architecture to be "emotional expression."

[10]The letter, dated 22 May 1881, appears in the *Illinois Society of Architects Bulletin*, XVII (1933), 7-8. Cf. the Rothschild Store, S. Bloomenfeld house, Ryerson Building on Randolph Street, row houses for Mrs. N. Halsted, and, far the finest, the Troescher Building, a rendering of which appeared in the *Inland Architect*, IV (Dec. 1884). Hugh Morrison, in *Louis Sullivan* (New York, 1935), p. 59, suggests that Sullivan acquired the Egyptian motifs from the exotic flavor of Edelmann's interests.

angles are not chamfered, but between the fourth and tenth stories the inner arrises of the piers are. Three heavy sillcourses impede the rise of the piers. At the tenth story the piers are embellished rather coarsely with terra-cotta representations of the lotus, the ancient emblem of Upper Egypt. At the attic story there is a decorative row of curious upright shafts. The germinal ideas of the final design are already present in this 1885 study.

In a letter of 28 April 1885, Brooks asked Aldis whether plans were still being made for the Monadnock Block. His fascination with the project was becoming not unlike Root's. On 29 June, he instructed Aldis to make sure the corridors were kept clear so that the plan could be extended southward, for now Shepherd Brooks owned the adjacent lots. "It may yet be some time before Monadnock should be built," Peter Brooks mused in a letter of 13 July; yet the very next day he urged Aldis to spare no pains or expense "in testing the iron work which enters into the construction of the building, [for] it is a very important matter in supporting so great a weight." On 23 July, Brooks commented: "Mr. Root has carried out the Egyptian style well, the entrance is plain it is true but that is in accordance with the style."

Burnham & Root advised Aldis on 31 August that the ground floor would have to be raised slightly to get the boilers into the basement. On 26 September, they reported that ½-inch scale diagrams were complete, with the plans above the first floor understood as tentative. At that time, the Monadnock Block would have been the highest office building in the city (Jenney's Home Insurance Building was 159 feet), and that alone was sufficient to excite Burnham. On 15 October, he invited Aldis to dinner at his office, to be followed by a night meeting to review the plans, "as the Monadnock is much the most important building ever done here. . . ." Yet even though there still was talk of a limit on building heights, the plans languished.[11] Peter Brooks pinpointed each new office block on a map and studied the pattern of speculative space. "There is little chance of the Monadnock Block being begun before three years," he wrote Aldis on 16 March 1886.[12]

[11] The *Sanitary Engineer*, XII (Sept. 1885), 328-329, published the new law regulating heights in Paris; and in April 1885, p. 398, it discussed a proposal to limit heights of apartment houses in New York. Late in 1884, Root had made drawings for a twelve-story office block, 158 feet high, on a site owned by Peter Brooks at the southwest corner of Clark and Van Buren streets. The plan entailed a central light court. A permit was issued in January 1885, but Brooks never built on the site.

[12] There is no evidence to support Sullivan's anecdote about the Monadnock being delayed to see whether the tower of the Auditorium would "go down to China." Cf. his *Autobiography of an Idea* (New York, 1924), p. 309, and his "Development of Building—II," *Economist*, LVI (July 1916), 40, the latter of which, in fact, shows how far out of touch Sullivan was with the structural developments of the 1880s.

Three years passed. In May 1889, an ordinance was drawn to restrict the height of any commercial building to the width of the street it faced.[13] Aldis became anxious, but Brooks still pondered the location. "If this building can be put up so that it will pay a good income *with no others near it*," he wrote Aldis on 17 May, "another Monadnock will raise its head in Illinois as well as in New Hampshire." On 18 May, Aldis wrote Brooks a long letter, urging him to build sixteen stories, and to extend the site 275 feet along Dearborn Street by adding 175 feet of land owned by Shepherd Brooks. He continued:

The plans . . . well under way, contemplate a building of steel columns and girders and beams with all floors laterally trussed 16 stories high with some bays. All steel protected with brick or hollow terra cotta. Cross walls of masonry every 40 to 50 feet, and an immensely strong and valuable building. Numerous bays for extra floor space, built of iron and brick. Galleries of iron with prismatic lights in the center, lighted by windows from offices and a large long skylight. This would make the halls cheerful. . . . The actual renting space is 68 per cent of floor space, as against 50 to 55 in the Rookery and 45 per cent in Home Insurance! . . . Outside all steel except at ends of cross walls where massive granite rock-hewn for a story to take away from the feeling of lightness. . . . I am satisfied that such a building built in the plainest and simplest manner, without one round arch or any ornament, would be of greater value than the Rookery. . . .

Thus, two months before Root left the city for a few weeks at the seashore, the Monadnock Block was to be without any ornamentation and to be shaped strictly in terms of line and mass.[14] There were to be projecting bays, and Aldis welcomed them as a source of additional rentable space.[15] In addition, there were to be steel columns in the outer walls. A year earlier, in a letter of 12 May 1888, Aldis had written Brooks in a general way about "iron framework construction." The reversion at some point to piers of solid masonry was evidently due to Shepherd Brooks, who must have been in the dark about the structure of the court wall of the Rookery, and who, even as late as 9 April 1892, when Holabird & Roche were planning the addition to the Monadnock Block, wrote Aldis: "As to erecting a tall building entirely of

[13]The *Inter Ocean*, XVIII (19 May 1889), 18, immediately denounced the proposal as "absurd."

[14]A letter from Aldis to Burnham on 18 July 1889 mentions that Root is away on vacation.

[15]Andrews, "The Broadest Use," p. 34, thought the oriels were for diagonal rays of light and for views down the street. If the oriels were smaller and less insistent they might have supported such a notion of Queen Anne domesticity. Dankmar Adler's comments in "Light in Tall Office Buildings," *Engineering Magazine*, IV (Nov. 1892), 186, show that projecting bays were intended to add space and could, in truth, work against adequate lighting. Wright, in his review of Morrison's *Louis Sullivan* in the *Saturday Review*, XIII (Dec. 1935), 6, refers to the projecting bays of the Stock Exchange Building and declares: "Calculate the floor space stolen, by ordinance, from the street and see 'why' they were there!"

steel, for a permanent investment, I should not think of such a thing. It would no doubt pay well for many years but there is so much risk and uncertainty in regard to its lasting strength."

Peter Brooks had warned Aldis about telegrams, which he detested, but on 22 May 1889, Aldis was so emboldened as to wire: "MONADNOCK BETTER BE SIXTEEN." On 31 May, he wrote to Brooks that the building commissioner "was staggered by the sixteen story plan, and wanted time to consider. . . . " The permit was issued on 3 June and site clearance began immediately. On 8 June, the Chicago *Tribune* reported the Monadnock Block would be of unornamented brick and granite, and would take three years to construct. The same day, the *Economist* provided a more thorough description:

The walls will be of steel covered with brown brick. At the corners for two stories will stand heavy red granite columns and for the upper fourteen stories solid masonry columns of brown brick. Between these columns there will be three-foot bay windows. . . . The four corners of the structure will each be in the form of a tower rising a short distance above the top of the building. . . . the framework of the floors will be of steel in the form of bridge construction. There will be steel columns surmounted by steel girders and between these girders will be lateral trusses. . . . This construction was used in the famous ten-story building recently constructed for Michael De Young in San Francisco by Burnham & Root, which passed through the recent earthquake uninjured. . . . The structure will have no ornamentation whatever, depending for its effect on its massiveness and the correct relation of its lines.[16]

The design was still in a transitional phase, Root intent on weighting the angle piers; he was seeking an appropriate expression of stability, particularly because of Shepherd Brooks's fear of the height. "I do not think it a fixed fact yet," Shepherd Brooks wrote Aldis on 15 June, "that buildings as high as 16 stories are altogether desirable. . . . " Meanwhile, the proposed ordinance limiting heights had met the not unexpected opposition of many interests. Even the *Inland Architect* defended unlimited height on the basis of the extraordinarily compacted business district. On 7 July, the Chicago *Tribune* said the agitation for the ordinance had died down, the proponents having decided that the city enjoyed no such police power.

In a letter to Shepherd Brooks on 1 July, Aldis carefully avoided any mention of the height and discussed how the floor plans would be designed so the units of the building (measuring about 100 feet, 75 feet, and 100 feet,

[16]*Economist*, II (8 June 1889), 477.

in correspondence with the three tracts of real estate) could be continuously connected. Aldis also promised to send "a rather ugly elevation." Root had now returned to his original intentions, and what Aldis considered an ugly elevation probably was very close to the final design; in a letter of 9 July, Peter Brooks objected: "The bell shaped cornice I do not like, neither does my brother." The cornice detail had appeared as early as the elevation study of 1885. Root held fast; nor did he defer to Aldis, who, in writing to Brooks on 30 July, complained that the granite in the base would be too expensive and suggested that only brick be used. Aldis also mentioned a request from Shepherd Brooks to make his part of the building a different color. Everyone in Chicago, Aldis said, was against the idea.

On 7 August, Aldis directed the contractor, George Fuller, to buy all the steel necessary for the footings. Ten days later a description in the *Economist* made it clear that the design was virtually perfected:

All "ornament" as ordinarily understood, was at once abandoned. All horizontal string courses are omitted, the sills having only sufficient projection to give perfect "drip," and stopping with the windows. A uniform material is everywhere employed, brick. . . . no two parts of the building will have the same color value. . . . There is no cornice to the building only a bell-shaped coping. There is no base, the entire building swelling outward at the bottom, to insure the expression of perfect stability.[17]

The color scheme now was Root's. It called for brick graded from dark at the bottom to light at the top. For many years the emotional value of color had intrigued him.[18] Moreover, his early years were spent in the milieu of the Ruskinian Gothic, in which flamboyant polychromy was characteristic, and he had worked with P. B. Wight, one of its leading exponents in America. Finally, he may well have had in mind an observation by Owen Jones: "The architecture of the Egyptians is thoroughly polychromatic. . . . "[19]

In November 1889, the *Inland Architect* published a rendering of the Monadnock Block (Fig. 114). Only negligible changes occurred before construction. The publication was crucial; it was a year later that Adler & Sullivan set to work planning the ten-story office block for Ellis Wainwright, in St. Louis.[20] In plan, mass, and expression, the two buildings clearly were very

[17]*Economist*, II (17 Aug. 1889), 717.
[18]Cf. his paper "Art of Pure Color," *Inland Architect*, I (June and July 1883), 66–67. 80, 82; and II (Aug. and Sept. 1883), 89, 106.
[19]Owen Jones, "Egyptian Ornament," in *The Grammar of Ornament* (London, 1856), p. 5.
[20]See Chicago *Tribune*, L (30 Nov. 1890), 29. A rendering of the Wainwright Building appeared in the *Inland Architect*, XVI (Jan. 1891), after Root died. Sullivan's drawings for ornamental detail are dated even later.

different. But it is astounding that the insistent acclaim for the Wainwright Building as the first poetic and vertical expression of the modern office building has been so rarely challenged.[21] Sullivan, as well as Wright, admired the Monadnock Block. They conceded that it possessed an aesthetic unity. Thus they could only raise the objection, trivial enough, that its piers were of solid masonry. In truth, the Monadnock Block enjoyed a propulsion at once more complete and less forced than that of the Wainwright Building. The design of the Wainwright Building, observed Irving K. Pond, was comparable to a classical plinth, colonnade, and entablature, with "a frieze and cornice out of all proportion to the columns on which they rest—a horizontal, a vertical, and a horizontal, absolutely at variance with the movement within the frame." Pond also pointed out that the design was not necessarily "democratic" and that Sullivan, while given to effusions on democracy, customarily regarded the masses as nonentities. Wright finally admitted almost as much in his curious book on Sullivan (entitled, significantly, *Genius and the Mobocracy*), where he wrote that the frontal divisions of the Wainwright Building were artificial and that the noble Monadnock Block had gone further.[22]

On 8 January 1890, Aldis wrote Shepherd Brooks, who still seemed in need of reassurance, that the Monadnock Block would be "by far the best office building ever constructed." Near the end of the month Shepherd Brooks decided to build on only 100 feet of his property; thus two bays were eliminated from the plans. The brothers executed a party-wall contract intended to avert disputes among their respective heirs, and the entrances and circulatory services were planned so the building, if need be, could be operated as two units. Shepherd Brooks chose to call his half of the building the "Kearsarge."

The Chicago *Tribune*, in reporting on 3 April that the plans had been accepted in Boston, the contracts let, and construction set to begin in May, ventured that "Chicago real estate has no firmer friend than the managers of the Brooks estate of Boston. . . . "[23] On 14 May, Peter Brooks began to question the color scheme: "Black brick, then brown grading up to bright yellow

[21] The exceptions are Pond, review of Sullivan's *Autobiography of an Idea*, p. 69, and Philip Johnson, "Is Sullivan the Father of Functionalism?" *Art News*, LV (Dec. 1956), 45.

[22] Frank Lloyd Wright, *Genius and the Mobocracy* (New York, 1949), p. 59. Sullivan's stance became increasingly and poignantly messianic; in 1901, he called for "a complete and world-wide regeneration of the architectural art," and, in 1903, he wrote Claude Bragdon that he thought of architecture as a religion—a religion that was part of democracy. The late Barry Byrne recalled Wright saying that Root, had he lived to continue in his later course, could have been "the greatest of them all." Byrne assumed that Wright was not, at the time, considering his own career.

[23] Chicago *Tribune*, L (3 April 1890), 1.

is novel, but I am unable to say whether it will be good in effect. . . . Would it look as if the rain had begun at the top and washed the soot down?!" In a few days he decided the walls should be in what he described as an obsidian brown pressed brick like that of the Rookery. The basis of his decision was evidently aesthetic and not concerned with any problem in manufacturing the colors. (Today, the walls change with the light—from a dusty reddish-brown to a dark and grave violet.)

Foundation work was well under way by July. The extant drawings show footings with as many as seven tiers of rails on pads of concrete which were now fortified, at the suggestion of the engineer William Sooy Smith, by steel beams. Root considered the technic essentially the same as the one he had used under the Rookery. The corner piers were 8 feet wide at basement level and 6 feet 4 inches wide at sidewalk level on Jackson Street. The interior columns again were of Z-bar members, the girders resting on cap plates. The projecting bays, which the *Inter Ocean* described as similar to those of Holabird & Roche's Tacoma Building, were framed with 7-inch spandrel beams connected to brackets cantilevered from plate girders, with cast struts in the mullions.[24] There were three kinds of windbracing. The masonry cross walls were as much as 4 feet 2 inches thick. Portal struts, in the form of 18-inch steel girders, spanned 17 feet 3 inches from the interior columns to the outer brick piers, where the connections ran 4 inches deeper. Finally, in alternating patterns on even and odd numbered floors, 4 inch by 5/16 inch tension straps were extended from the columns to within 4½ inches of the outer face of the masonry wall, where the ends were turned 8 inches up into the brick. (In a storm on 12 February 1894, the winds reached velocities of more than 80 miles an hour, and Aldis had an engineer drop a plumb-bob in each stairwell; the original building moved only ¼ inch, while the addition moved a little less than ½ inch, according to his letter of 13 February to Peter Brooks.)[25] By February 1892, when office space was being leased, the correspondence between Chicago and Boston was concerned with the need for more money to finish the building. Aldis blamed Burnham & Root for the

[24]*Inter Ocean*, XVIII (9 June 1889), 18. Wright, in *The Future of Architecture* (New York, 1953), p. 151, protests the presence of steel behind the brickwork of the Monadnock Block, and asserts that the use of specially moulded brick for the "flowing contours" is a forcing of the material. Yet in his own Johnson Administration Building, of 1936–1939, he called for more than two hundred shapes of brick.

[25]The tests were reported in *Engineering News*, XXXI (March 1894), 169. A document entitled "The Monadnock Building," prepared by Aldis & Company and dated 3 Dec. 1947, argues that the cord of the plumb-bob could have been deflected by drafts. Such a latter day apology was hardly called for: high buildings are expected to sway, within reasonable limits.

overruns, and he soon recommended Holabird & Roche for the south addition. They had already designed the Pontiac Building for Peter Brooks.

From the very narrowed site, the Monadnock Block gained a convenient plan in which every office had windows to the street, and all paths of communication were disposed along the center of the building (Fig. 115). There was, of course, no internal court sufficient for an aesthetic unfolding of space; the skylights were only 8 feet wide. The ornamental iron and cast aluminum details were executed handsomely by Winslow Brothers, but the designs were adapted from the Rookery and were irrelevant to the sources of the Monadnock Block. The drawings for the staircase (Fig. 116) are dated August 1891, seven months after Root died. They demonstrate the unfortunate tendency of the Burnham office to parrot earlier work with no regard for meaning.

The site, at the whim of Shepherd Brooks, had expanded and contracted. At last the building gained a definite proportioning. The site was surveyed at 198.4 feet on Dearborn Street and 66.15 feet on Jackson Street, and the building rose to 202.67 feet; thus the dimensions were resolved into very nearly three-to-one ratios. Root carefully adjusted the size of the projecting bays. Along the Dearborn and Federal street fronts the first four were 20 feet wide and the last was less than 19 feet, with a widening of the last window opening within the wall plane. The two projecting bays on Jackson Street were reduced to 15 feet and each was composed of only three window openings to a floor.

What were the other subtle refinements which, in the eyes of Montgomery Schuyler, made the Monadnock Block "precisely the most effective and successful of commercial structures to which the elevator has literally 'given rise' "?[26] Through a sparing but forceful use of granite ashlar (the stonework Aldis had wished to eliminate, merely because of cost) at the three entrances and as surrounds for the store fronts on Jackson Street, Root conveyed the feeling of a substantial and stable base. The principal entrance, on Jackson Street, was only 9 feet wide and the two entrances on Dearborn Street only 7 feet wide; yet the three granite lintels on Jackson Street spanned almost 44 feet.[27]

The Monadnock Block became the apotheosis of the brick wall in American urban architecture. Its contouring was achieved entirely with bricks laid

[26] Schuyler, "D. H. Burnham & Co.," p. 56.

[27] In a remodeling, the granite of the Jackson Street front was displaced in order to accommodate wider store fronts, and the bricks at the base were painted black.

in horizontal beds: thousands of bricks were shaped in special moulds by the Anderson Pressed Brick Company. The profiling of the Jackson Street elevation was quintessential (Fig. 117). The batter began at the sill level of the second story, and through a 10-foot rise of wall swept inward 15 inches (*a* to *b*). To better receive and to weight the beginnings of the projecting bays (*b*), the second and third stories were each 12 inches higher than the first. As the eye moved upward it could readily detect that the cove of the cornice (*d*), which was carried through 6 feet 8 inches of wall and which flared 2 feet from the plane, represented an inversion of the curved second story.[28] The projecting bays were halted 19½ feet below the coping by smaller cove cornices (*c*) which flared 4 feet from the plane in responding to the convex shape at the base of each bay (*b*). Shaped as a quarter-ellipse, the celebrated chamfer of the angles imperceptibly began at the third-floor level, gradually cutting the pier ever more broadly until attaining a width of 3 feet at the coping (*e*). Once again calculated to express stability, it was a stunning detail.

Root paid unrelenting attention to detail. The arrises everywhere were exquisitely rounded. The upper framing members of the sash windows were rounded at the ends, and the broad frames of the second-story windows were gently bowed to echo in the vertical plane the bowing of the bays above (Figs. 118–119). Root succeeded in making the bays appear to have *grown* from the wall. The feeling was mysteriously organic, and most pronounced in the Jackson Street elevation (Fig. 120). Hardly should the Monadnock Block have been considered the sum of various negations by the clients. Peter Brooks was inconsistent in his attitude toward ornamentation. What was important was not that Root was forced to abandon all ornament, but that he contoured the block by absorbing ornament: the ornament, although latent, thus informed the entity itself. In that way he achieved an absolute unity.[29]

The ornament of the 1885 elevation study already was comparatively restrained. It embraced two distinct motifs in the upper stories (see Fig. 113). The panels on the piers at the tenth story plainly represented lotus blooms, the ancient symbol of Upper Egypt. At the twelfth story, the curious upright shafts were rather more than an idle pattern across the attic. They represented ranked papyrus stems, the corresponding symbol of Lower Egypt. In his il-

[28] So simple was the cornice that the artist who retouched the view in the *Architectural Record*, V (Dec. 1895) could not accept it; he painted in heavy beltcourses at the top and bottom of the attic.

[29] Sullivan may have had the Monadnock in mind when he began his paper on "Ornament in Architecture" (*Engineering Magazine*, III [Aug. 1892], 633) with these words: "I take it as self-evident that a building, quite devoid of ornament, may convey a noble and dignified sentiment by virtue of mass and proportion."

lustrations of Egyptian ornament, Owen Jones showed an abstract representation of the Nile: lotus buds and blooms in the lower register and papyrus plants rising in ranks across the upper register.[30] The ancient Egyptians attached profound meaning to both plants. In the words of Henri Frankfort: "The Egyptian religious landscape was a vast expanse of marsh. . . . the decay of the individual plants was a meaningless incident in comparison with the perennial presence of the species in the scenery from which the universe had gone forth. . . ."[31]

As a water lily of full and languorous form, seductive in its beauty, the lotus had also been associated with indolence. Its broad flowering was not particularly eligible even in the 1885 study, when the building was projected at only twelve stories. Papyrus, in contrast, is a tall sedge characterized by the thrust of its slender stem and the burst of rays, like fireworks, from its compound umbel (Fig. 121). The stem, in section, tends toward an equilateral triangle, although the angles are softly rounded. It is épée-like in its upward tapering; the roots of the word "sedge" indeed mean "sword" and "to cut." These properties of form are analogous to the lean profile of the Monadnock Block, to its austere stance, to the elliptical slice of the angles, and to that strange tension in the window openings between the ruthless incision of the wall and the sensuous rounding of the arrises (Fig. 122).

The art of ancient Egypt was eminently an art of profiling; and the Jackson Street profile of the Monadnock Block (see Fig. 117) came very close to the kind of bell-shaped column the Egyptians had derived from the papyrus stem and bud and had realized at the north court of Saqqara as early as 2650 B.C. (Fig. 123). Not only was the cornice of the Monadnock Block bell-shaped. The same motif was even more explicit in the projecting bays—their bases being rounded when seen in profile at both sides of the block (see Fig. 117), or in elevation (see Fig. 120). The form was much attenuated, but through this very attenuation the bays, in marching down the broader elevations, suggested a field of ranked papyrus stalks (Fig. 124).

Why, on the streets of downtown Chicago, should Root have deployed these allusions to an exotic plant form? He was not simply anticipating the Art Nouveau.[32] Even before he and Burnham formed their partnership he

[30] Jones, "Egyptian Ornament," in *Grammar of Ornament*, pl. IV, fig. 17.

[31] H. Frankfort, *Ancient Egyptian Religion* (New York, 1948), p. 154.

[32] Robert Schmutzler, *Art Nouveau* (New York, 1964), pp. 228–229, asserts that the Monadnock "is very close to Art Nouveau." But the superficial resemblance of the profiling of the building to that, say, of a Tiffany goblet of a few years later is due to the fact that the chalice-like goblet always was related to the stem-and-calyx form, or flower cup. Art Nouveau decorative motifs typically relied on the Egyptian water lily or convolvulus, James Laver writes in *Victoriana* (London, 1966), p. 187.

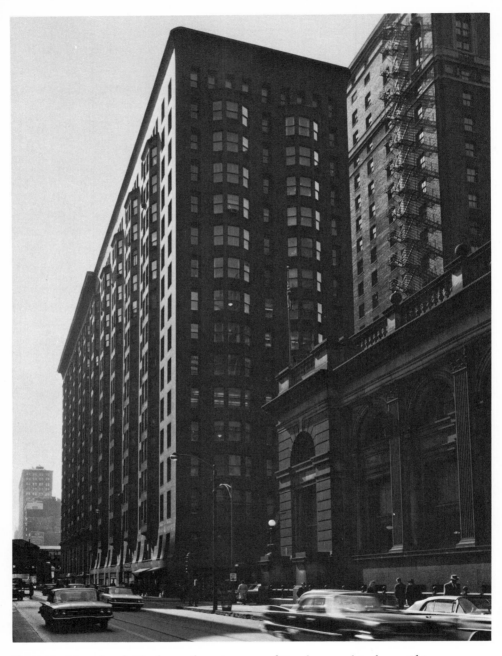

Fig. 112. *Monadnock Block, southwest corner of Dearborn and Jackson, Chicago, 1889–1892. Photo by Richard Nickel.*

Fig. 113. Monadnock Block. Study of Jackson Street elevation, 1885. Courtesy the Art Institute of Chicago.

Fig. 114. Monadnock Block. Rendering, 1889. From the Inland Architect.

Fig. 115. Monadnock Block. Plans of fourteenth (top) and second stories. Historic American Buildings Survey.

Fig. 116. Monadnock Block. Stair detail. Historic American Buildings Survey.

Fig. 117. Monadnock Block. Jackson Street profile. Diagram by author.

Fig. 118. Monadnock Block. Detail at base of projecting bay. Photo by Richard Nickel.

172 JOHN WELLBORN ROOT

Fig. 120. Monadnock Block. Jackson Street elevation. Photo by Richard Nickel.

Fig. 119. Monadnock Block. Detail of projecting bay. Photo by Richard Nickel.

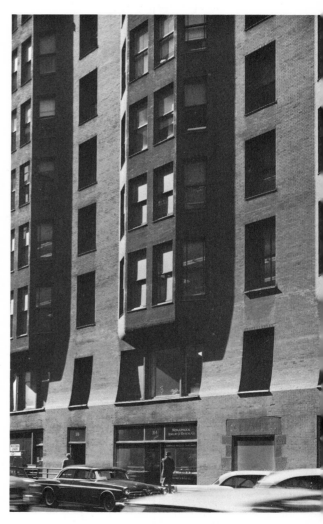

*Fig. 121. Papyrus plant.
Diagram by author.*

*Fig. 123. Papyrus
column at Saqqara.
Diagram by author.*

*Fig. 122. Monadnock Block. Detail of wall. Photo by
Richard Nickel.*

174 JOHN WELLBORN ROOT

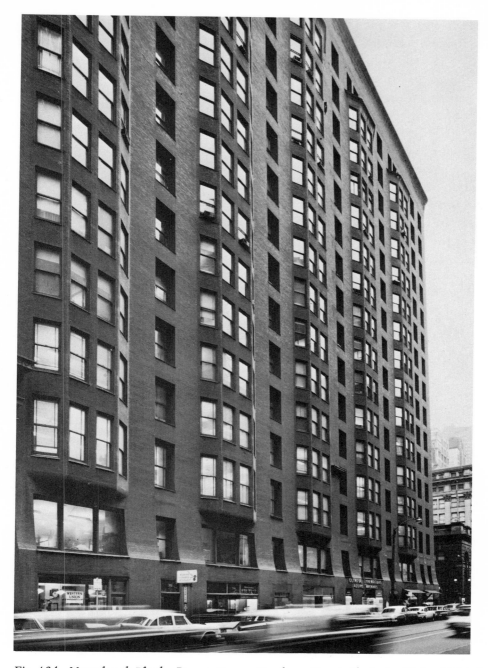

Fig. 124. Monadnock Block. Perspective on Dearborn Street. Photo by Richard Nickel.

was fully aware of the soil conditions of Chicago.[33] The soil was no casual fact: the city had grown from a sedgy wasteland, and every high and heavy building became in that sense a heroic act. Even in 1884 the narrowed lot and great height of the projected building had turned his mind to ancient Egyptian sources. When, a few years later, he translated Gottfried Semper, who wrote of architecture as a vivid expression of environment, of "the conditions," it must have occurred to him that Chicago was a place astonishingly like Lower Egypt. A river ran into a large body of water, and, in the marshy soil, the common type of plant life was the wild onion. The Ojibwa word for "wild onion place" gave the city its name. The wild onion was a typical compound-umbel plant, like papyrus.

In its refinement and nobility the Monadnock Block remains without peer in the history of the high office building. In Chicago, it was the perfect gesture—the exact visual metaphor of the vitality of the city. Root made it rise from the soil as if it were a springtime plant. "The best solution will always be the simplest," he said, "and its full growth will follow with a directness and ease which suggest the budding of a flower. . . ."[34]

[33]Cf. the letter of 17 March 1873 quoted by Harriet Monroe in *John Wellborn Root* (Boston and New York, 1896), p. 30.

[34]John W. Root, "Style," *Inland Architect*, VIII (Jan. 1887), 100.

VIII · THE RELIANCE BUILDING: A METAMORPHOSIS

By the time Owen Aldis became anxious to get the Monadnock Block under way, he had learned of plans for another high office building on another narrow site. "Mr. Hale is having plans made for a 16 story building, corner of Washington and State streets," Aldis wrote Peter Brooks on 6 April 1889. "He will build one year from May 1st." Aldis did not say that the architects were Burnham & Root, or that Hale intended to begin only two stories in 1890. Nor did he say how he happened to learn of the plans more than a year in advance of construction. One suspects that Burnham told him.

William Ellery Hale was the other man Louis Sullivan remembered as being "responsible for the modern office building." William Rainey Harper, the first president of the University of Chicago, said that a broad and philanthropic motive seemed to underlie Hale's life and that he was "one of the splendid men of Chicago."[1] At first, Hale's principal business was the manufacture of hydraulic elevators, which he furnished for many of Burnham & Root's buildings.[2] But even before the great fire he had begun to invest in speculative office space. When the First National Bank moved to the northwest corner of Dearborn and Monroe streets in 1882, he bought the old bank building on the southwest corner of State and Washington for $225,000. Originally it stood five stories high on a raised basement, but after the fire it was rebuilt with one less story.[3] Hale in 1885 commissioned Ackerman & Smith,

[1] Letter of 18 Nov. 1898 from William Rainey Harper to George Ellery Hale, in the *George Ellery Hale Papers*, mic. ed. (Pasadena, Calif., 1968). Quoted by permission.

[2] His elevators in the Burlington Office Building were described as "the most elaborately finished elevators in any Chicago building," in the New York *Daily Graphic* of 26 Feb. 1883, 813.

[3] This has caused confusion about how many stories of the old building were above Root's base for the skyscraper.

177

an obscure partnership, to make plans for remodeling the building at a cost of $20,000.[4] It was probably at this time that the corner entrance was eliminated—the bay being carried out to form a right angle. Hale had previously commissioned Burnham & Root to design a house at 4545 Drexel Boulevard (distinguished primarily because it had an elevator), and had moved his offices to their Calumet Building, of which he became the proprietor.[5] At one time or another, he held shares in the Rialto Building, the Rookery, the Insurance Exchange Building, and the Midland Hotel in Kansas City. He became an intimate of Burnham's. In 1886, on Burnham's advice, he sent his son George to the Massachusetts Institute of Technology.[6] A year and a half later, near his stable, Hale built a brick structure styled the Kenwood Physical Laboratory. There his son verified the presence of carbon in the spectrum of the sun. In 1890–1891, at a cost of $90,000, Hale had Burnham & Root build the Kenwood Physical Observatory for his son. George Ellery Hale went on to become the principal figure in the design and financing of the Yerkes, Mount Wilson, and Palomar observatories. When he wrote to Burnham in 1909 about building the tower for the new telescope on Mount Wilson, he fondly recalled how Burnham & Root had built his first observatory.[7]

The property Hale bought from the bank measured only 55 feet 11½ inches on State Street and 85 feet on Washington Street, but Hale knew that his remodeled building was far from an adventurous use of the site. The leap from a building of four stories to plans for a building of perhaps sixteen stories in fact epitomized the economic forces at work in Chicago during the 1880s. Hale, like Aldis, must have been worried by the talk of limiting heights.[8] On the day his son reached his majority, 29 June 1889, Hale gave him stock in the building company and named him a director.

Hale was quiet about his plans, though word of the project soon was abroad. On 7 July 1889, the Chicago *Tribune* reported that a sixteen-story

[4]*Building Budget*, I (July 1885), 45.

[5]The detail Monroe identifies as from the Hale house (*John Wellborn Root* [Boston and New York, 1896], p. 149) is in fact from the J. V. Farwell house on Pearson Street, published in the *Sanitary Engineer*, XII (June 1885), opp. 15. A photograph of the Hale house appears in *Pictorial Chicago* (Chicago, 1893), n.p. Both houses were similar to the Union Club by Cobb & Frost, although which of the three was the earliest is uncertain.

[6]Helen Wright, *Explorer of the Universe* (New York, 1966), p. 48.

[7]Letter of 27 Jan. 1909, in the *Hale Papers*. Quoted by permission.

[8]The permits are no longer on file with the commissioner of buildings, but in "Chicago," *American Architect*, XLVII (Jan. 1895), 43, the Reliance Building is identified as one of the high buildings constructed with permits issued before a height restriction was adopted.

building "will some day stand at the southwest corner of State and Washington and will be built by W. E. Hale when the leases of his present tenants have expired."[9] The same day, the *Inter Ocean* described the plans as an innovation, in the sense that they would create high office space in the heart of the retail trade center.[10] But the important fact was that the leases in the raised basement and first story expired on 1 May 1890, while leases in the upper stories ran until 1 May 1894. Hale planned to build new retail space *beneath* the three upper stories—a substructure which could serve four years later as the base of an office tower. He contemplated two distinct campaigns. What he did not foresee was that the building would be twice conceived, by two distinct architects (Figs. 125–126).

Hale executed a lease for the lower part of the building with Chas. Gossage & Co., effective 1 May 1890. It was agreed that the space would be transformed immediately. Evidently, the Gossage Store, a dry goods house, was willing to put up with almost anything in order to occupy the corner. Before the fire, the store had done business in the first building south of the corner lot, under the name of Ross & Gossage; the fire destroyed the building, but the store reappeared as a tenant of the new Potter Palmer Building, a mansarded block on the same site. Under the desperate pressures of retail competition, the store extended its premises around the corner lot to seize a second front, on West Washington Street.

In reporting the first campaign of what was now described more accurately as a fifteen-story building of steel framing, the *Economist* said the basement, first floor, and entresol would be constructed while the tenants continued to "do business as usual."[11] The *Inter Ocean* reported that Hale was to "improve" his building in a novel manner, that the first floor and entresol "will be decorated handsomely, while foundations will be put in to sustain the numerous stories that will be added when other leases expire."[12] In truth, the plans called for new piers, not even in line with those of the old building.

Among the surviving plans labeled "Building for W. E. Hale" is an undated diagram of soil borings supervised by William Sooy Smith.[13] The plan

[9] Chicago *Tribune*, XLIX (7 July 1889), 9.

[10] *Inter Ocean*, XVIII (7 July 1889), 18. There is some indication in this account that Hale was reluctant to discuss his plans.

[11] *Economist*, III (1 March 1890), 229. The stories consist of the first, the entresol, the second through twelfth, and the fourteenth and fifteenth; the thirteenth is "omitted" because of common superstition.

[12] *Inter Ocean*, XVIII (2 March 1890), 10.

[13] The plans have been conserved in the vault of Graham, Anderson, Probst & White, and have been recorded in the joint microfilm project of the Art Institute of Chicago and the University of Illinois.

of the footings, initialed by E. C. Shankland, is dated 2 April 1890. A revised basement plan, dated 9 July 1890, shows how the space was kept free of the footings and how, through assiduous planning, it was to be put into full commercial use (Fig. 127). The loss of the west bays to the boiler room was compensated by the extension of the retail floor more than 20 feet past the east lot line and under the sidewalk. At the south wall, the basement was to be served by three elevators and adjacent stairs, the openings in the wall apparently communicating with retail areas of the older Gossage Store. The columns were to be faced in marble and fitted with brackets for gas. The space was pushed 13 feet past the north lot line, adding floor area and accommodating a long row of water closets and a narrow light well. The plate glass of three bays was to be carried down into the well to light the sales floor. In two other details this thirst for light was manifest: the sidewalks were to be paved with prismatic lights, and the walls of the light well, as well as those beneath the sidewalk on State Street, were to be faced with white enameled brick.

The other surviving plans from the spring and summer of 1890 are peculiarly incomplete. The framing plans for the ground story and entresol show steel Z-bar columns, certain cast columns, and a special channel column. The interiors are indeed to be decorated handsomely, in mahogany millwork, walls of English alabaster with glass and gold inlay, flooring in marble mosaic, and ceiling paintings by William Pretyman, whose studio (according to the Chicago *Tribune*) was adorned by a Rembrandt portrait. Yet there are no elevations, either for the first two stories or for the rest of the tower.[14] It is inconceivable that by this time Root had made no drawings for the entire building. The loads had to be calculated. More important, he characteristically designed from the whole to the part; his mind was not so disengaged that he could have conceived the base and then rested without any clear idea of the whole building, even if the plans were understood as tentative. Why was it that his drawings evidently were not published in 1890 or 1891? There were several reasons. Hale had no need to interest other investors; he was funding the project himself. He sold an old office block across State Street, and, before the second campaign, sold the ground under the Reliance Building for $480,000, then immediately leased it back at $24,000 a year. In 1890, he had already leased the retail space for ten years and had nothing to gain from publicity five years before the office floors could be ready for lease.

[14] A search of more than forty possible sources has yielded not so much as a thumbnail sketch of what Root intended in the upper stories.

Finally, the "novel manner" of constructing a base for a skyscraper beneath an older building was, in Chicago, not a procedure so extraordinary as to cry for thorough reportage.[15]

Thus the "Building for W. E. Hale" received only the most cursory attention, as in a report of September 1890 in the *Real Estate and Building Journal*: "Work has been under way for some time on the massive sixteen [*sic*] story fire-proof structure that Mr. Hale is building there. The ground floor of this building has been rented to Carson, Pirie & Co. . . . "[16] (Carson's was at the northeast corner of Wabash and Adams streets, in Adler & Sullivan's Revell Building; it had acquired the Gossage Store as a future outlet.) The first campaign of the Reliance Building must have been carried on with little delicacy. An attorney for F. E. Morse & Son, diamond merchants, whose rooms on the second story of the old bank building were resting on jackscrews, on 17 December 1890 wrote Hale to warn him of a liability for damages "by reason of the obstructions to the entrance to their premises and, what is especially noticeable just now, the unhealthful and almost unendurable effect produced by the use of salamanders." The Gossage Store, on 22 June 1891, disputed a gas bill and complained that the workmen had tapped excessive amounts of gas during the winter, misusing "streaming flames of gas of great length," the burners going all night in the new basement.[17]

Through the spring of 1891, Carson's continually advertised final closing sales at the Revell Building and announced they were soon to consolidate with the Gossage Store. The final closing occurred on 30 June, the store opening the next day in Hale's new floors, under the name of Carson, Pirie, Scott & Co. The precise extent of the construction undertaken while Root was alive is revealed in a faint photograph published in 1892 as an illustration of the "Gossage Building" (Fig. 128).[18] The storefronts south and west of Hale's building were renovated with expanses of plate glass because they also were taken by Carson's. But the entrance bay to the old bank building was left intact, serving those obstinate tenants who lingered in the upper stories.

[15]Warehouses were raised as much as 7 feet to accord with the approaches to a new Jackson Street bridge. A five-story building was raised on jackscrews and rolled nearly 100 feet along State Street. The Chamber of Commerce Building was placed on jackscrews and "remodeled" from five stories into thirteen stories. See *American Architect*, XXIV (1888), 40; and XXVI (1889), 136, 243.

[16]*Real Estate and Building Journal*, XXXII (13 Sept. 1890), 806.

[17]*Hale Papers*. Quoted by permission.

[18]See *Chicago and Its Resources Twenty Years After: 1871-1891* (Chicago, 1892), p. 113.

The most significant of the extant drawings for the Reliance Building is that labeled "Granite Diagrams," approved on 6 June 1894 by Ernest R. Graham (Fig. 129). It shows in outline the piers existing by 1891, and bears several notations:

All columns on Washington St. and three north columns on State St. are in place. All other work to be furnished by contractor.

All bronze and granite work on sides and soffit of entrance to be the same as front.

All granite to run behind bronze and bronze to be fitted to same. All joints in granite on columns to be behind bronze.

In the campaign of 1894–1895, the Burnham office chose to follow Root's intentions only at the entrance of the office tower, where it replicated his bronze and granite detail: perhaps that is why Harriet Monroe wrote not a word about the building.[19] In 1891, after Root died, Burnham searched for another designing partner. "During the winter and early spring," he wrote a few years later, "I was casting about for an assistant to take Root's place. . . . I received two letters, one from Professor Ware and one from Mr. Bruce Price, of New York, both of them calling my attention to Atwood and claiming for him the highest rank as an architect."[20] Charles B. Atwood joined Burnham's staff on 21 April 1891. Early in 1894 (with the leases due to expire on 1 May), he redesigned the upper thirteen stories of the Reliance Building. The second-floor plan is dated 26 February 1894 (Fig. 130). A plan of a typical floor followed (Fig. 131). The new elevations are dated 28 March. Again the old stories were put on jackscrews. Carson's was temporarily roofed, and the old parts of the building demolished.

The frame was topped-out on 1 August 1894, at exactly 200 feet. Even in structure the Burnham office chose not to follow the original plans:

[19]On 1 March 1894 the office was reorganized with four partners: Burnham, Ernest R. Graham, Charles B. Atwood, and E. C. Shankland. Atwood, in charge of design, was given 27 percent of the earnings. Graham was office superintendent and Shankland was in charge of plans and construction; each was given 10 percent. Atwood was retired on 10 Dec. 1895, and Shankland withdrew several years later. In January 1910, Burnham admitted as partners two of his sons, Daniel H. Burnham, Jr., and Hubert Burnham. Burnham died on 30 June 1912. On 4 May 1914, the firm became Graham, Burnham & Company, with three additional partners, Pierce Anderson, Edward Probst, and Howard J. White. Later, the Burnham brothers withdrew, and on 4 Aug. 1917 the office became known as Graham, Anderson, Probst & White.

[20]D. H. Burnham, "Charles Bowler Atwood," *Inland Architect*, XXVI (Jan. 1896), 56. For other profiles and obituaries of Atwood see Chicago *Tribune*, LIV (21 Dec. 1895), 12, 14; *American Architect*, L (28 Dec. 1895), 143; *Engineering Record*, XXXIII (28 Dec. 1895), 57; and *Western Architect*, XXXIII (1924), 89–94.

Shankland assigned the steelwork to J. H. Gray, who substituted his own "Gray column"—a kind composed from eight angles and four tie-plates—in two-story heights, spliced alternately at each story. The advantages were taken to be simplicity of design, with consequent economy in shop drawings; economy in steel; economy through the rapidity of construction; and continuous pipe space inside the column.[21] Gray saw the frame rise at an unprecedented speed: the last eight stories and attic went up in only two weeks.

The new column, however, was of rather less interest than the facing: "The front is of enameled terra cotta. This is an innovation. It is indestructible and as hard and smooth as any porcelain ware. It will be washed by every rainstorm and may if necessary be scrubbed like a dinner plate."[22] In whatever manner such a "revision" was put to Hale, the change from the red Scotch granite facing of the base to a white enameled terra cotta must have represented a flagrant deviation from Root's intentions.[23] The immediate precedent was Holabird & Roche's Champlain Building, only a few doors south, at the northwest corner of State and Madison streets. Under roof by January 1894, it was a narrow block of fourteen stories and attic, on a plan much like that of the Reliance Building, with a two-story base dressed in brownish-red terra cotta, and the stories above in a dead-white terra cotta—evidently unglazed, but nevertheless publicized as being easy to wash.[24]

Such a strange advent of a virginal absence of color in Chicago cannot be understood apart from the White City, the centerpiece of the World's Columbian Exposition, a popular triumph in which Burnham and Atwood

[21] D. E. Waid, "Terra-Cotta in Skeleton Construction," *Brickbuilder*, III (Oct. 1894), 206. J. K. Freitag, in *Architectural Engineering*, 2nd ed. (New York, 1901), pp. 209, 214, asserts on the other hand that the Gray column involved excessive punching operations (for the large number of rivets), added expenses for the specially shaped tie-plates, and eccentric loads. Details and specifications for the Reliance Building appear in Freitag, pp. 34, 157, 168, 182–184, 221–222, 279; in *Engineering* of London, LVIII (Nov. 1894), 576; *Engineering News*, XXXIV (Oct. 1895), 250; and C. E. Jenkins, "A White Enameled Building," *Architectural Record*, IV (1895), 299–306. Jenkins errs on the number of old stories removed. More important, he fails to illustrate or even describe Root's elevation drawings.

[22] *Economist*, XII (25 Aug. 1894), 206. Montgomery Schuyler, in "D. H. Burnham & Co.," *Architectural Record*, V (Dec. 1895), p. 59, drily comments: "A monument that 'will wash' is already pretty nearly a contradiction in terms."

[23] Burnham could deal easily enough with Hale in person, rather than by correspondence; in the twenty-one volumes of letters in the Burnham Library, there seem to be only two brief notes to Hale— a letter of 1891 vaguely related to the Fair, and a letter of 1894 in which Burnham urgently requests a loan of $1,000 to cover his rent and payroll.

[24] "Chicago," *American Architect*, XLIII (20 Jan. 1894), 31. The color scheme was revised sometime after the wash rendering that appeared in the *Inland Architect*, XXII (Nov. 1893). A plan appears in Freitag, *Architectural Engineering*, 2nd ed., p. 63. See also D. E. Waid, "Recent Brick and Terra-Cotta Work in American Cities," *Brickbuilder*, IV (June 1895), 132.

shared (see Fig. 160). Burnham was ready to embrace any antidote to what he had decided were the errant 1880s, when the pioneer high office buildings from his own partnership with Root were characterized by warm hues in sandstone, granite, pressed brick, and terra cotta. Charles Jenkins, in writing of the Reliance Building before it was finished, asserted there was no reason to surrender to "the monotony of the dull greys, browns and reds of the present material used in building."[25] But the Reliance Building did not wash in every rainstorm, and no one bothered to scrub it like a dinner plate. Root had reasoned that in a city under the pall of coal smoke, cold colors were hardly eligible. He had specified white enameled brick for a limited and definite function—to reflect light onto the basement sales floor.

It was apparent soon enough that the original plans were discarded. "In the early spring of the year just closed [1894] new plans were drawn," the Chicago *Times* reported, without elaboration.[26] The correspondent of the *American Architect* was obviously disturbed:

A very curious building is that known as the Reliance, inasmuch as its two façades are composed of white vitrified terra-cotta. . . . It is the last building on which the late John W. Root left the stamp of his own individuality. The lower stories of Scotch granite are noticeable, and considering the amount of plate-glass required in them, are a most successful solving of a difficult problem, but it scarcely seems possible that the upper stories as they now stand were not materially changed from any design Mr. Root may have made for them. . . . [27]

On 15 March 1895, Hale held a housewarming in the Reliance Building and invited a large number of prominent citizens. The affair resulted in several press notices, and although one described in great detail the phasing of the construction, there was no mention of the redesigning.[28]

Two months later, a trade journal succinctly described the building as a "glazed terra-cotta tower in which plate glass figures conspicuously."[29] The wall planes of the Reliance Building were bewildered by a dodging musculature, the mass was overwhelmed by the windows. The precedent again resided in an office building by Holabird & Roche: for all the barbarism of its detail, the Tacoma Building, at the northeast corner of La Salle and Madison streets, presented a vibrant skeleton of rippling bays enclosed with glass—a

[25] Jenkins, "White Enameled Building," p. 302.
[26] Chicago *Times*, 1 Jan. 1895 (clipping in the Burnham scrapbooks).
[27] "Chicago," *American Architect*, XLVII (26 Jan. 1895), 43.
[28] See Chicago *Tribune*, LIV (16 March 1895), 8, and *Economist*, XIII (16 March 1895), 301.
[29] *Ornamental Iron*, II (May 1895), 91.

radical effort, said Dankmar Adler, to see "how much within the limits of safety the walls of a tall building might be reduced in weight, and the load upon the soil thus reduced to a minimum."[30]

Root knew the Tacoma Building before Atwood did. It was published in 1888 and opened on 1 May 1889, and was much in the public eye at the very time when he set to work on Hale's building. "Holabird & Roche stand very high among their competitors," he wrote in his last paper, "the Tacoma Building and many others bearing witness to their skill."[31] Thus the articulation of the upper stories of the Reliance Building may have been essentially Root's—although it is doubtful that he would have doubled each projecting bay, leaving a pier only 3 feet behind each glazed center panel. Yet it was Atwood who indulged in an academic and superfluous "French Gothic" décor, cluster columns appliquéd to the piers, and quatrefoil tracery impressed across nearly every foot of the enameled terra cotta. He accepted Root's detail only at the entrance (Fig. 132). Root called for a vestige of tracery only to conceal the joints, so the granite could appear to be precisely what it was—not load-bearing masonry, but a uniform facing (Fig. 133). Atwood and Burnham, shortly before they were to deviate from his plans, designed for Root's gravestone a Celtic cross, and had it carved in red Scotch granite.[32] What a poignantly hypocritical memorial.

Henry Van Brunt noted in 1889 that the requirements of modern shopfronts and the invention of great sheets of plate glass were conditions defying nearly all the precepts of the academies—conditions which, if accepted, perhaps could lead to "the flower of a new art."[33] The base of Hale's building had complications. Two entrances were required on State Street, one for the offices and the other for the store. In order to light the basement, a well broke through the sidewalk on Washington Street (Fig. 134). Yet the rhythm of the thin piers and the narrow transom marking the entresol rushed the imagination far into the future. Only the horse-drawn carriages and costumes of the citizenry betrayed the era, and thus seemed incredible.

[30]Dankmar Adler, "Engineering Supervision of Building Operations," *American Architect*, XXXIII (July 1891), 11. H. R. Hitchcock, in *Architecture: Nineteenth and Twentieth Centuries*, 2nd ed. (Baltimore, 1963), p. 245, notes the similarity of the two buildings. A rendering of the Tacoma appears in the *Building Budget* of 30 Sept. 1888; incisive commentary in "Chicago," *American Architect*, XXV (June 1889), 294.

[31]John W. Root, "Architects of Chicago," *Inland Architect*, XVI (Jan. 1891), 92.

[32]See *Inland Architect*, XXV (April 1895), 27, with photo. Late in 1893, the drawings were sent to Scotland for the carving.

[33]Henry Van Brunt, "Architecture in the West," *Atlantic Monthly*, LXIV (Dec. 1889), 782.

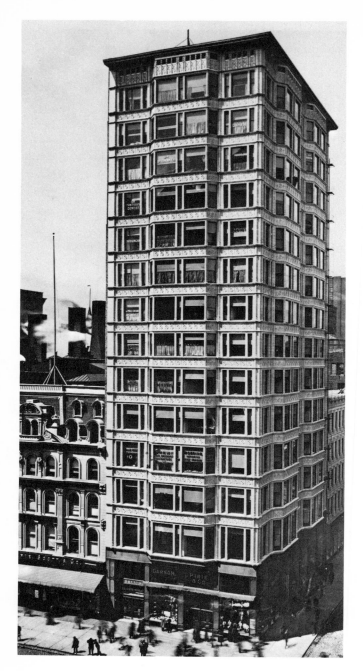

Fig. 125. Reliance Building, southwest corner of State and Washington, Chicago, 1889–1891 and 1894–1895. Photo by Chicago Architectural Photo Co.

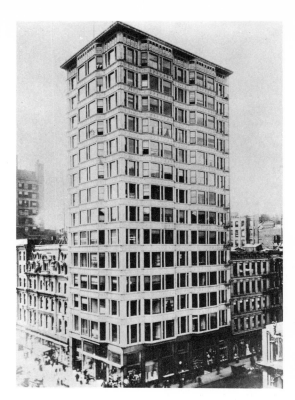

Fig. 126. Reliance Building.
Courtesy Carson Pirie Scott & Co.

Fig. 127. Reliance Building.
Basement plan, 1890. Courtesy
the Art Institute of Chicago.

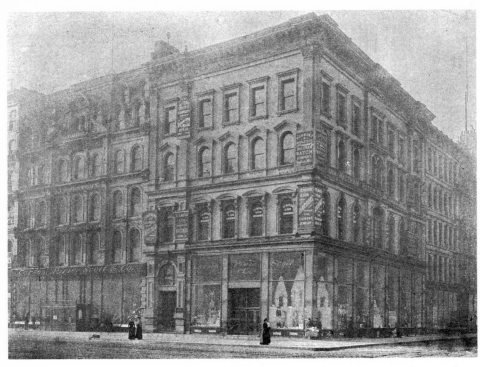

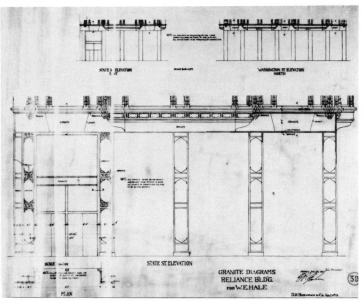

Fig. 128. Reliance Building, Extent of construction in 1890–1891. Courtesy the Chicago Public Library.

Fig. 129. Reliance Building, Granite diagrams, 1894. Courtesy the Art Institute of Chicago.

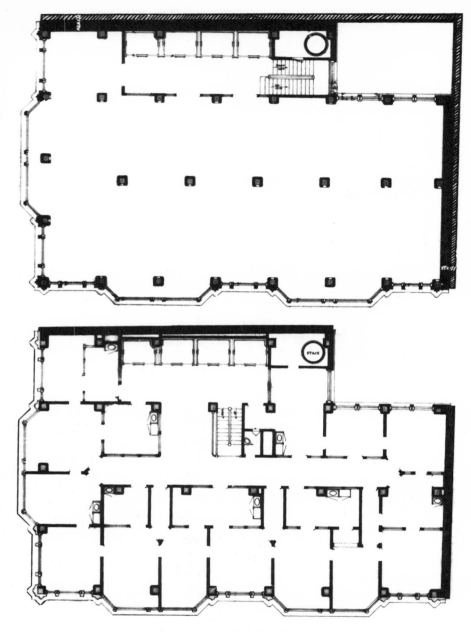

Fig. 130. (top) *Reliance Building. Plan of second floor, 1894. Courtesy the Art Institute of Chicago.*

Fig. 131. (bottom) *Reliance Building. Plan of typical partitioned floor, 1894. Courtesy the Art Institute of Chicago.*

189 THE RELIANCE BUILDING

Fig. 132. Reliance Building. Entrance. From Ornamental Iron, *courtesy the Art Institute of Chicago.*

Fig. 133. Reliance Building. Detail of base. Courtesy the Chicago Historical Society.

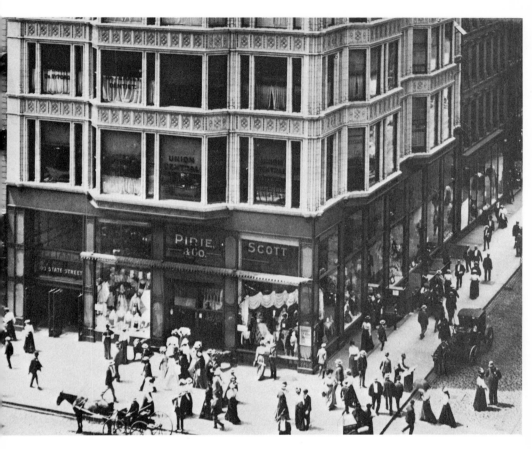

Fig. 134. Reliance Building. View of base. Courtesy the Chicago Historical Society.

191 *THE RELIANCE BUILDING*

IX · THE LAST YEAR: 1890

In his forty-first year, John Root drove himself to the final limit of exhaustion. His responsibilities had become enormous. If it was true, several years earlier, that Burnham warned him that the "only way to handle a big business is to *delegate, delegate, delegate*," then it was also true that he paid no heed.[1] In 1890, the commissions seemed more momentous than ever. He could not easily pass them along; the very few holograph drawings that have survived are still lovingly executed. At the same time, he was burdened by his duties as secretary of the American Institute—when that office, according to R. C. McLean, was rather more important than the office of president. He was also burdened by the World's Columbian Exposition: "People forget that the plan of the Exposition sprang from the brains of Mr. Root and Mr. Olmsted," Owen Aldis, who had served on the committee on grounds and buildings, wrote Peter Brooks in April 1893, two days before the Fair was opened. He engaged, moreover, in all sorts of peripheral activities, such as serving as a judge for a "Water Tower and Pumping Station Design Competition."[2] He read his paper "A Great Architectural Problem" in June. Two months later, Harriet Monroe reported his conversation on a new spirit of beauty.[3] Another paper, "The City House in the West," was published in the October issue of *Scribner's Magazine*, excerpts having appeared in the Chicago *Tribune* of 28 September. His comments in judging essays on "Ex-

[1] Louis H. Sullivan, *The Autobiography of an Idea* (New York, 1924), p. 291.

[2] See *Engineering and Building Record*, XXI (March 1890), 225–226.

[3] Chicago *Tribune*, L (10 Aug. 1890), 32. The art column was anonymous, and Root was quoted without being identified.

pression in Form" also were published in October, in the *Inland Architect*. Finally, his benign chronicle entitled "Architects of Chicago" appeared in December.

In the years immediately after Root's death, the most admired of his buildings was the Woman's Temple, headquarters of the Woman's Christian Temperance Union, at the southwest corner of La Salle and Monroe streets (Fig. 135). The plans can be assigned to the early months of 1890 (they were formally adopted in April, and construction was begun in July), although the building association had been incorporated in July 1887. Among the directors were W. E. Hale, Norman Ream, and even Burnham: there must have been little discussion about the choice of architects. The earliest studies, according to Harriet Monroe, were judged too utilitarian, and Burnham and other intimates urged Root to attempt a more "spiritual" expression.[4] The president of the building association, Mrs. Matilda Carse, contemplated "an edifice which should be memorial in its character and yet eminently suitable for a fine office building":

... where the rum-cursed victims of the legalized liquor traffic could find a refuge. ... a building that should adequately express its purpose, and also be a source of large revenue. ... [From the immense Gothic roof would spring] a flèche of gold bronze seventy feet high, surmounted by the beautiful form of a woman, with face upturned and hands outstretched to heaven in prayer ... as she protests against laws and customs of the nation ... and appeals unto God for help to save her home, children, and land from its destroying power.[5]

The organ of the W.C.T.U., the *Union Signal*, described the building as a sermon in mystic correspondences, its rounded corners expressing an attitude of Christian aggressiveness and its turrets thrusting heavenward to express the aspirations of the woman's union.

One must be charitable to an architect who is asked to design an office building capable of producing "large revenue" while symbolically preaching salvation from alcohol. Whether or not Root "entered almost with a spirit of divination into the work intrusted to him," as Mrs. Carse believed, the consensus that he had solved the problem very well must still seem just—more

[4] Harriet Monroe, *John Wellborn Root* (Boston and New York, 1896), pp. 124–125. An early study appears in the *Inland Architect*, XII (Dec. 1888). It bears resemblances to the Society for Savings Building.

[5] Matilda B. Carse, "The Temperance Temple," and "History of the Temple Enterprise," in the national archives of the Frances E. Willard Memorial Library for Alcohol Research, Evanston, Ill.

just, surely, than a faulting of the building for not fitting into a presumed evolution of the modern office building or for belying a steel frame by clothing it in ponderous masonry. (The piers of the building, except at special points, *were* masonry; they measured as large as 4 feet 2 inches by 7 feet 1 inch even at the third floor, and the cornerstone weighed 10 tons.)[6]

The site was leased at $40,000 a year from Marshall Field. It measured 189 feet 1 inch on La Salle Street and 96 feet 1 inch on Monroe Street. Root repeatedly revised the plan until he had a stunted H (Fig. 136), compact and articulate, and improved over the plan of the Kansas City Board of Trade Building in that the entrance court was much broader—the skylight over the vestibule was doubled—and addressed directly by a row of offices. Once again there were stairs to the mezzanine, the space of the ground floor moving quickly to the bank of elevators, which formed the closure at the west. Part of the ground story was taken by Willard Hall, the scene of noontime prayer meetings. (Mrs. Carse declared that no one would be turned away for lack of respectability; yet the entrance to the hall was assigned, very discreetly, to the northwest corner of the building, as far as possible from the main entrance.) The corridor to Willard Hall was fitted with a fountain and sculpture group, a maiden poised benevolently with two horses which all too apparently found water sufficient for their thirst. The hall seated seven hundred persons and was decorated with thirteen stained-glass lights and two rostral paintings commissioned from Walter Crane. Root called Miss Willard's attention to the theme of Christ turning water into wine. Crane's subjects, however, became Temperance, Purity, Mercy, and Justice—all of which he represented by elongated female figures rather in the style of Burne-Jones.

In elevation, the spirit of the Woman's Temple was that of a colossal château, the aspiring elements rising to an ethereal termination in crested skylights. In almost 200 feet, there were only twelve stories of rentable space. The picturesque was controlled by a majestic symmetry, as in the haunting elevation study for the Boatmen's Bank project. The openings in the wall were closely studied and tightly grouped, and, when they became almost too insistent, the wall broke into a rich fantasy in foliate terra cotta.

[6]Cf. Corydon T. Purdy, "The Steel Skeleton Type of High Buildings," *Engineering News*, XXVI (Dec. 1891), 535, and XXVII (Jan. 1892), 3-4. Nearly everything Hugh Morrison writes (*Louis Sullivan* [New York, 1935], pp. 144–145) about the Woman's Temple, in arguing that the Wainwright Building was like "an Athena sprung full-fledged from the brow of Zeus," is not valid. See Chicago *Tribune*, L (2 Nov. 1890) for a report of the cornerstone ceremony. A children's chorus sang "The Saloons Must Go." Root, as the proceedings wore on, is said to have suggested to his colleagues that they go and have a drink.

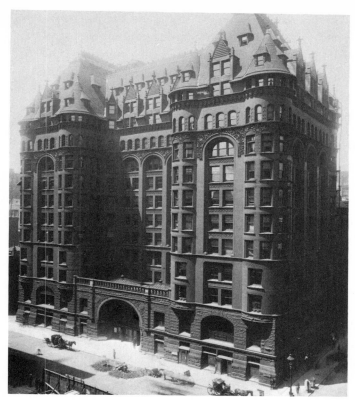

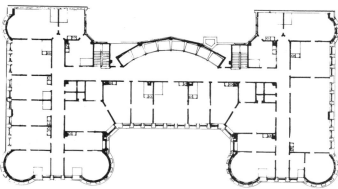

Fig. 135. (top) *Woman's Temple, southwest corner of La Salle and Monroe, Chicago, 1890–1892. Destroyed. Courtesy the Chicago Historical Society.*

Fig. 136. (bottom) *Woman's Temple. Plan of ninth floor. Courtesy the Art Institute of Chicago.*

The second huge commercial "temple" of 1890, and the largest of all of Burnham & Root's buildings, entailed complexities perhaps even greater. For the Masonic Temple (Fig. 137) was nearly a vertically organized microcosm of the city's center. It was an awesome volume in an unprecedented height of twenty stories, 273 feet 4 inches to the coping and 302 feet 1 inch to the top of the skylight. In February 1890, Norman T. Gassette began to promote a scheme for a building 190 feet high, or about fifteen stories. By the end of March, when as many as eighteen stories were contemplated, Amos Grannis had been elected vice-president of the stockholding association. Having built their first office block, Grannis perhaps guided the commission to Burnham & Root. Their appointment was not announced until June, but by then they had the plans in good order: two immense gables and various Masonic emblems already characterized the State Street front, and more than half of the commercial stories were to be shopping floors "with great plate-glass show windows, similar to the most attractive of street façades."[7]

The main front measured 169 feet 10 inches, the front on Randolph Street 113 feet 3 inches. Alleys bounded the north and east: the building could be finished on all sides. The site was reported to have cost $830,000, a fair explanation for the continuing enlargement of the building volume. By the time of the cornerstone ceremony, on 6 November 1890, the temple had grown to twenty stories. Burnham took credit for the ground plan, a squared C closed at the east by fourteen passenger elevators in an arc curiously like the apse of St. Gabriel's Church. About half the basement was given to a large restaurant, while stores and prestige offices were to occupy the first three stories. In a bold experiment—and one which was to fail within three years—floors four through ten were conceived as shopping lanes in the sky (Fig. 138). There must have been some doubt at the beginning. These floors, as well as the floors even higher, were to be named rather than numbered, "allowing Mrs. Browne to be shot up to Smith Street, instead of starting with the idea of going up to the nineteenth story."[8] However, because the floors were obstructed only by a few large columns and by the narrow passages of transverse windbracing, the partitioning could be adjusted in the same way as on the office floors (originally, the eleventh through sixteenth), where

[7]*Economist*, III (June 1890), 807.

[8]"Chicago," *American Architect*, XXX (Nov. 1890), 120. Plans, sections, and details appear in *Engineering* of London, LII (Aug. 1891), 143, 146–147, 150–152; and *Engineering Record*, XXVII (Jan. 1893), 160–161; (May 1893), 478–479, 514; XXVIII (Sept. 1893), 222; (Oct. 1893), 349; (Nov. 1893), 364–365; and XXIX (Dec. 1893), 76–77.

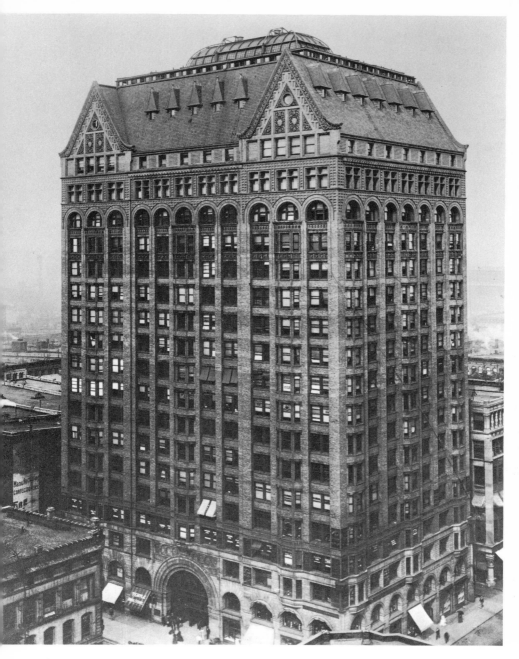

Fig. 137. Masonic Temple, northeast corner of State and Randolph, Chicago, 1890–1892. Destroyed. Photo by Chicago Architectural Photo Co.

197 *THE LAST YEAR: 1890*

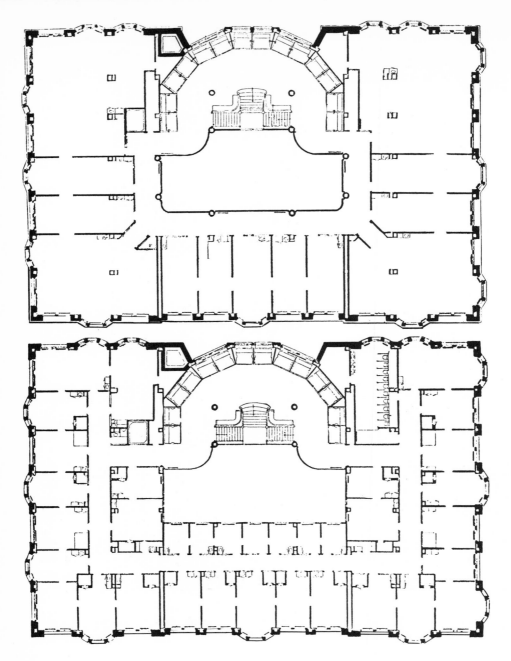

Fig. 138. (top) *Masonic Temple. Typical plan of floors 4–10. From the* Engineering Record.

Fig. 139. (bottom) *Masonic Temple. Typical plan of floors 11–16. From the* Engineering Record.

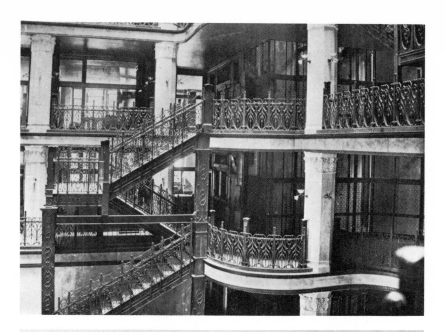

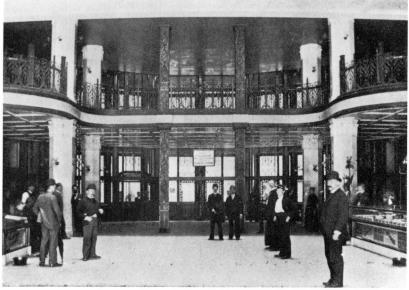

Fig. 140. (top) *Masonic Temple. Detail of internal court. From the* Inland Architect.

Fig. 141. (bottom) *Masonic Temple. Floor of court. From the* Inland Architect.

199 *THE LAST YEAR: 1890*

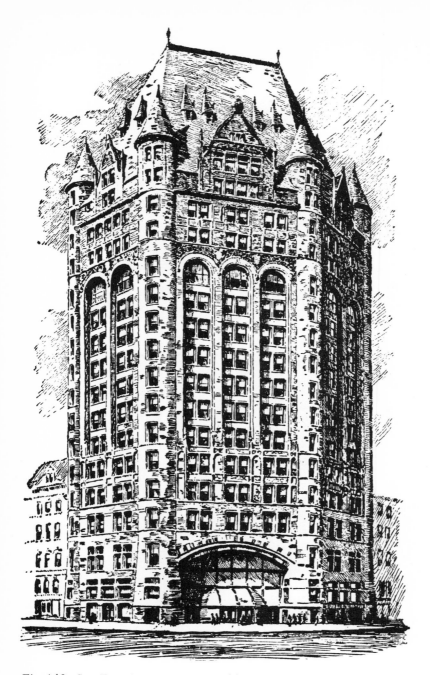

Fig. 142. San Francisco Examiner Building project, 1890. From Harriet Monroe, John Wellborn Root.

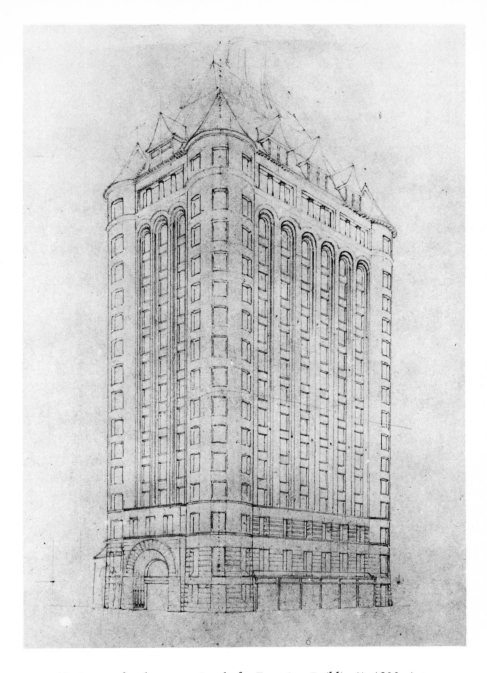

Fig. 143. Project for skyscraper (study for Examiner Building?), 1890. Art Institute of Chicago, gift of E. S. Fetcher.

201 THE LAST YEAR: 1890

tenants could lease as little as 10 feet by 14 feet or as much as 60 feet by 100 feet (Fig. 139). Masonic conclaves took the last four stories, except for the barber shop and lavatories, and the roof was designed as a summer garden and observatory. The internal light well, vaulted at the roof, became an extraordinary space almost twice the height of the choir at Beauvais (Figs. 140–141). The balustrades were of an airy tracery, the columns were sheathed in alabaster, the floors and soffits were of marble; a ride in one of the transparent elevator cages must have been intoxicating. The structure of the building impressed upon the State Street front in two peculiar ways. The widened piers, which seemed to define end pavilions, were simply due to the channels of vertical windbracing, a system of swayrods intended to guard the fabric against gusts up to 135 miles an hour. The blind arcade above the entrance arch, its eight shallow niches filled with fraternal symbols (the All-Seeing Eye, the Knights Templar, and so on), served to face a 25-ton box girder, 7 feet deep and 43 feet long. This great girder relieved the arch of all loads, carrying the columns and brick piers, the fourth-floor beams and the spandrel facing itself, so that any unequal settlements would not crack the granite voussoirs. Elsewhere, the roof and floor loads were carried by columns built-up in heights of two stories, the masonry piers divided into three parts and carried by brackets at only the fifth and sixteenth stories. At the eighteenth story, the ceiling was 20½ feet high and was trussed to create galleried clear-spaces for Masonic ceremonies.

Root handled the middle stories in an almost neutral way. Henry Van Brunt, examining a perspective drawing, found them committed to "a perpendicular tyranny of pilasters."[9] In truth, they were little more than the fireproofed frame, and thus sufficiently barren to appeal to only the most ardent admirer of the structural cage. The wall lacked the dynamic expression of the Chicago Hotel. But the real difficulties resided in the base and attic. The first three stories, walled in gray granite ashlar and uneasily demarcated from the mottled gray pressed brick above, were dominated by the entrance arch. Root tried to subdue this Gargantuan portal, this den "of a primitive race, continually receiving and pouring forth a stream of people,"[10] by progressively diminishing the motif through the arcade of the second story, the arcading above the first story transoms, the blind arcade across the box girder, and the tiny arcuation on the face of the voussoirs. The attic—which may have seemed a final flourish of the Queen Anne revival, in monstrous

[9] Henry Van Brunt, "John Wellborn Root," *Inland Architect*, XVI (Jan. 1891), 87.

[10] Paul Bourget, *Outre-Mer* (New York, 1895), p. 118.

Fig. 144. Daily News Building façade, 15 North Wells,
Chicago, 1890–1891. Destroyed. Courtesy the Chicago Daily News.

203 *THE LAST YEAR: 1890*

scale—represented Root's attempt to express the presence of the Masonic bodies, whose mysterious precincts were more than a private residence, yet less than a public place.[11] Once more, he had accepted the program in all its strangeness.

Harriet Monroe described the project for the San Francisco Examiner Building as a promotion of Burnham's suggested by a site in the shape of an elongated hexagon (Fig. 142). The etching, after a lost rendering, shows an eighteen-story building with an outsized segmental portal and a roofline hardly appropriate to the climate of San Francisco. There is no indication of how the interior was to be lighted. There survives a holograph sketch, however, which may represent the Examiner project at another site (Fig. 143). The wall of plate glass at the base suggests the intention of displaying a newspaper's presses. At the roof Root indicates a great skylight. Despite the slight archaicisms, it is a remarkably confident drawing and a thoroughly integrated design.

The 25-foot front for the Daily News Building, at 15 North Wells Street in Chicago, was only a remodeling of existing premises (Fig. 144).[12] A new structure of four stories on a raised basement was built at the rear, on a plan of 81 feet by 84 feet, reaching north to Calhoun Place. The budget was slight and the construction was of posts and beams of oiled Georgia pine. The little façade on Wells Street nevertheless was notable for its sharp wall plane, as severe as the wall of the Valentine house.

Root's last railroad station was built near the west bank of the Mississippi River, at Keokuk, Iowa (Figs. 145–146). Five roads approved the plans in 1890, and the station was opened in June 1891. It was a simple and true building, with walls of red pressed brick, sills of Colorado sandstone, and archivolts of terra cotta terminating in spare bosses. Inside, the wainscoting and hammerbeam roof framing were of oak. At the tracks the bony framing of the free-standing canopy spoke again of Root's familiarity with the drawings of Viollet-le-Duc.

[11] The gable of the Edward Burdett house on Bellevue Place seems oddly kindred. Root admired the gabled rooflines of the Owings Building of 1888–1890, at the southeast corner of Dearborn and Adams, by Cobb & Frost; cf. "Architects of Chicago," *Inland Architect*, XVI (Jan. 1891), 92.

[12] The addition of two stories and two oriels to the Brunswick Hotel, at the northwest corner of Michigan and Adams—which can be detected by comparing the views on p. 288 and p. 294 in Paul Gilbert and Charles Lee Bryson, *Chicago and Its Makers* (Chicago, 1929)—was probably carried out after March 1890, when the hotel was sold. This remodeling also may have been Burnham & Root's. Certainly, the original hotel was not designed by Root, and it should not have been so identified in my 1967 collection of his writings.

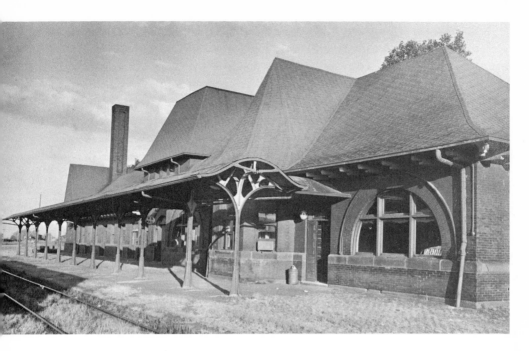

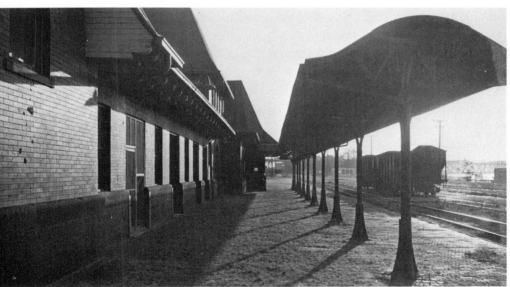

Fig. 145. (top) *Union Depot, Exchange and Water, Keokuk, Ia., 1890–1891. Photo by author.*

Fig. 146. (bottom) *Union Depot, Keokuk. Photo by author.*

In the summer of 1890, Darius Ogden Mills decided to build not a large hotel in Chicago (in anticipation of the Fair), but a large office block on the West coast.[13] Owen Aldis wrote Peter Brooks on 5 July 1890 that Burnham & Root had the commission. According to Harriet Monroe, the plans and elevations were said to have been completed in two days; but Root had at least two months to think about them. In two studies (one of them now lost) of the principal elevation, he half-heartedly sketched a Late Gothic façade and a Romanesque façade. In both he emphasized the entrance bay at the expense of the angles. But by early September he had radically purified the design. The site, in the financial heart of San Francisco, fronting 159½ feet on Montgomery Street and 137 feet on Bush Street, was cleared that month, and the Mills Building was finished in 1892 (Fig. 147).

If the structural system, a steel frame anchored to masonry piers, was like that of the Chronicle Building, and the plan (Fig. 148) like that of the Rookery, in each instance Root was not reverting to formula, but providing the best solution he could devise—a buttressing of the metal frame for resistance to earthquakes, and a quadrangular plan for light and dynamic space. The entrance on Montgomery Street, an arch incisively and beautifully finished (Fig. 149), opened to a vestibule in which the directional controls essentially were the same as in the west vestibule of the Rookery. The internal court was smaller (56 feet 8 inches by 50 feet 6 inches) and unfortunately was intruded upon by shop fronts under the galleries. At the southwest corner (Fig. 150) a sinuous staircase rose to the stair oriel. The cast-iron shell work across the framing members of the skylight (Fig. 151) was gold-leafed, and as freely organic as any of Root's ornamentation.[14]

In the street elevations, Root maintained a sedate yet rhythmic balance untroubled by a picturesque skyline or grandiose portal. Bounded by the broadened corner piers, all the intermediate piers were of equal width. The side elevation, on Bush Street, by catching more sun, became fully as prominent as the west front. In the middle stories, the spandrels were withdrawn and directly expressive of the sills and lintels, their simplicity countering the

[13] The San Francisco *Chronicle*, LII (29 Aug. 1890), 5, reported that "San Francisco suits him best for speculation at present." See also San Francisco *Chronicle*, LII (13 Oct. 1890), 10, and *California Architect and Building News*, XIV (April 1893), 42.

[14] The interior organization of Adler & Sullivan's Wainwright Building, designed a few months later, is by comparison impoverished. Moreover, its narrow light court faces north, the least satisfactory light source. The elevations of the Wainwright Building, while more incisive, bear similarities to the Mills Building which should not be overlooked.

enriched detail of the pilasters. The arcade at the eighth story and the rather dainty arched corbel table above the ninth were free from the anxiety of the Romanesque motif in the Masonic Temple. All the detail in cut brick and moulded brick graced the wall. The materials and colors that Root chose were consummately accurate: a soft white marble from the Inyo Mountains, dressed but not polished, and Roman brick and terra cotta of mottled orange hues. In the brilliant light of the Bay area the Mills Building assumed a noble, joyful stance.[15]

The house at 1300 Astor Street in Chicago (Fig. 152), announced in September 1890, was built for William J. Goudy, a very young lawyer, whose father lived close by at Goethe Street and Ritchie Place, and who was general counsel for the Chicago & North Western Railway. At some time earlier, however, Root had planned it for his own family. A perspective study in pencil and blue wash, fresh as a fine English watercolor, survives (Fig. 153). Root began with a historicist conception, and, without the inhibitions which would have deadened the performance of a more academic architect, proceeded to lay the style bare. The silhouette remained châteauesque, but the stringcourses and pilasters were stripped away, the window openings pulled apart from static clusters, and the rustication of the basement forsaken. Root said that Richardsonian rock-faced masonry had become so ubiquitous in the Middle West that people often had difficulty in understanding how cut stone could sometimes have greater aesthetic value.[16] He made the wall continuous and smooth, taking it around corners as quickly as the curved plate glass of the windows. Like the great château at Azay-le-Rideau, hovering by the lily pond, the house seemed poised on its streamlined podium as if ready to sail away.

The commission for the Equitable Building in Atlanta, Georgia, was reported in September 1890. The building was finished in 1892 as the first high office block in the South (Figs. 154–156). The client (whom Root must have found congenial, for he was a native of Georgia and was trained as a civil engineer) was Joel Hurt, of the East Atlanta Land Company.[17] It is significant that Hurt secured his financing with the Equitable Life Assurance Society in New York yet went to Chicago to find an architect. In January 1891, only a

[15]The frame withstood the earthquake of 1906. When it was repaired, six bays were added along Bush Street, and, in later years, five more. The light court disappeared in remodelings after World War II.

[16]John W. Root, "The City House in the West," *Scribner's Magazine*, VIII (Oct. 1890), 430.

[17]See Elizabeth A. Lyon, "Atlanta's Pioneer Skyscraper," *Georgia Review*, XIX (Summer 1965), 1–7; and "Skyscrapers in Atlanta, 1890–1915," M. A. thesis, Emory University, 1962.

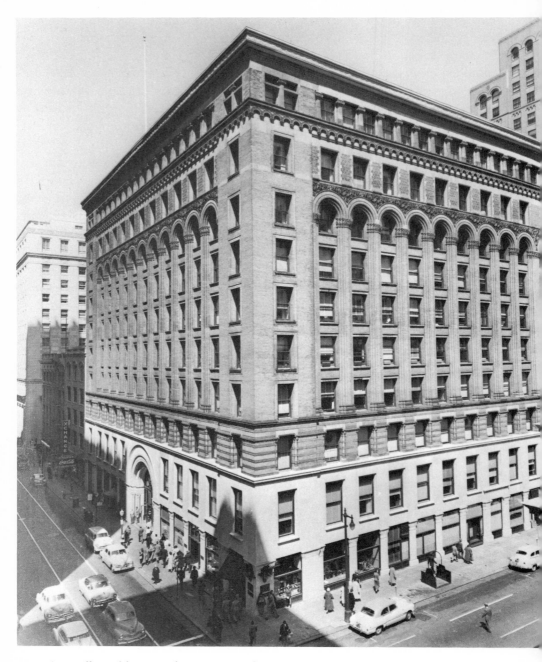

Fig. 147. Mills Building, northeast corner of Montgomery and Bush, San Francisco, 1890–1892. Photo by D. Downey, courtesy the San Francisco Chronicle.

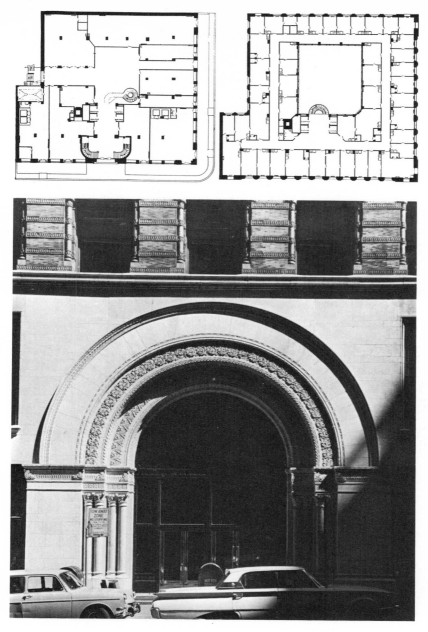

Fig. 148. (top) *Mills Building. Plans of first* (left) *and fifth floors. From the* Architectural Record.

Fig. 149. (bottom) *Mills Building. Entrance. Photo by author.*

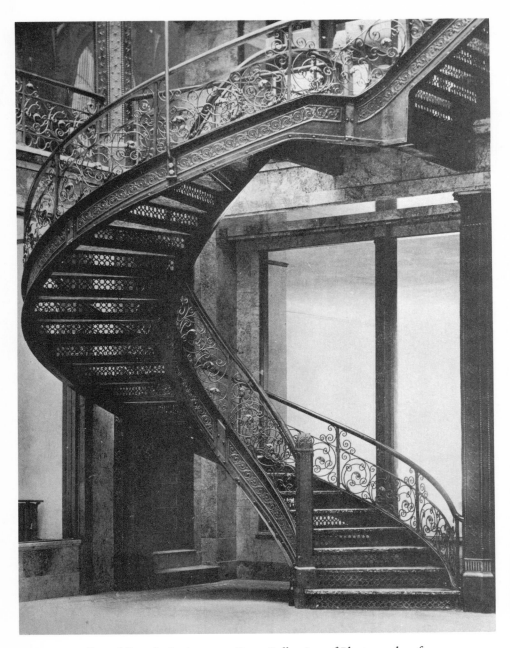

Fig. 150. Mills Building. Stairs in court. From Collection of Photographs of "Ornamental Iron," *courtesy the Art Institute of Chicago.*

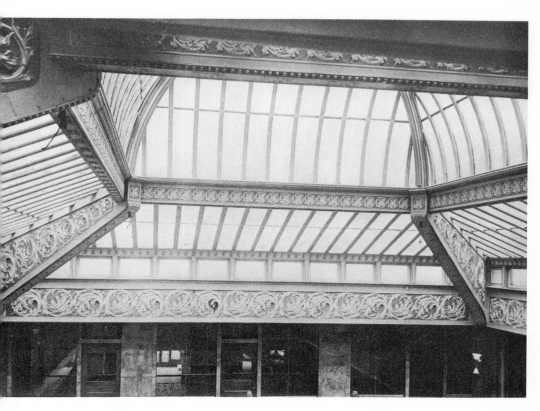

Fig. 151. Mills Building. Gallery and vault of court. From Collection of Photographs of "Ornamental Iron," *courtesy the Art Institute of Chicago.*

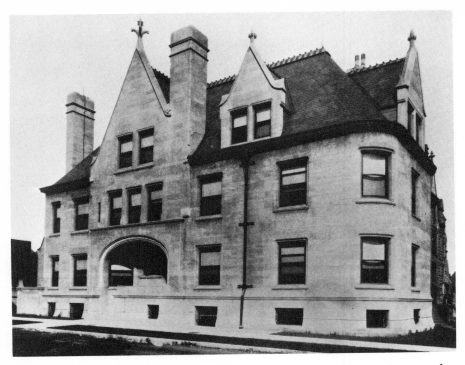

Fig. 152. William J. Goudy house, 1300 Astor, Chicago, 1890–1891. Destroyed. From the Inland Architect.

week before his death, Root took the drawings to Atlanta, where in a long interview he told exactly how he approached a large office building:

The building will extend 160 feet on Pryor Street, 185 on Edgewood Avenue, and 89 on Porter's Alley. It will be eight stories and a basement high, making a total height from the sidewalk at the corner of Edgewood Avenue and Pryor Street of 120 feet. . . . The principal entrances will be in the centers of [the] Pryor Street and Edgewood Avenue fronts, each being 14 feet wide and leading into a hall 21 feet wide, where the four elevators are grouped, plainly visible from both streets. Light is admitted to the intersection of the halls both in this story and stories above by windows opening from the interior court. To the right and left of the elevators, and still plainly visible from the streets, are two hallways, each 8½ feet wide, leading into a rotunda 48 × 60 feet, which occupies the first story of the open court, separated from it by a roof of glass. The line of intersection of this skylight with the walls of the court comes somewhat below the ceiling of the first story, so that the windows of the first story open below the line of the glass and above it by transoms into the open air. Above this story the court thus occupied becomes entirely open, affording to the offices surrounding it light and ventilation equal to that obtained by offices fronting the streets.

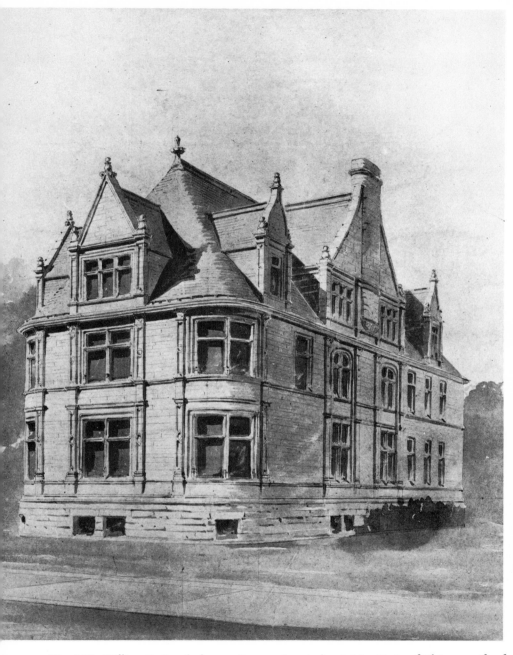

Fig. 153. *William J. Goudy house. Perspective study. Art Institute of Chicago, gift of E. S. Fetcher.*

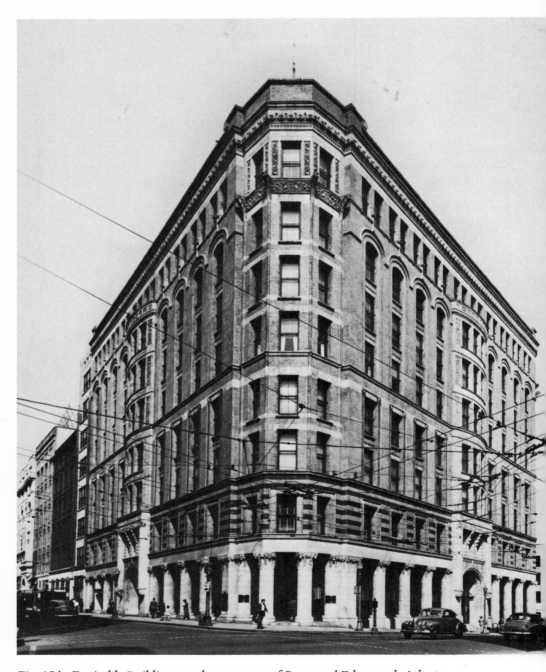

Fig. 154. Equitable Building, northeast corner of Pryor and Edgewood, Atlanta, 1890–1892. Destroyed. Courtesy the Trust Company of Georgia.

214 JOHN WELLBORN ROOT

Fig. 155. Equitable Building.
Plan of second floor. Courtesy
the Trust Company of Georgia.

Fig. 156. Equitable Building. Entrance. Courtesy the Trust Company of Georgia.

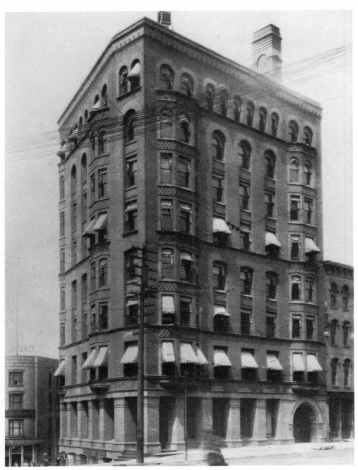

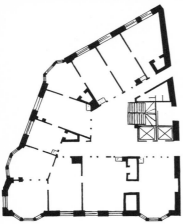

Fig. 157. Western Reserve Building, northwest corner of Superior and Water, Cleveland, 1890–1892. From the Inland Architect.

Fig. 158. Western Reserve Building. Plan of second floor. Courtesy of G. E. Goleb.

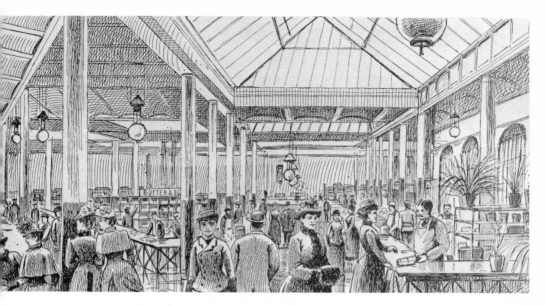

Fig. 159. Central Market, State Street at the river, Chicago, 1890–1891. Destroyed. From the Graphic, *courtesy the Chicago Historical Society.*

In the stories above the first, the offices are arranged in two tiers. The outer tier gives upon the street, and is separated by a corridor from the inner tier, which gives upon the court. Adequate light for the corridor, which is paved and wainscoted with marble, is obtained by outer windows, at the end, and by glass transom lights opening at the line of the door transoms from the offices into the corridor. In relation to the subdivisions of all of the stories, it should be stated that all interior partitions are non-constructive, being carried by—instead of carrying—the metal. Partitions, therefore, may be placed at any point to suit the requirements of tenants, whether in their first occupancy or in response to their future expanding needs.

The arrangement in the basement contemplates the possibility—in finish, in height, in taste and beauty of access—for its partial use by a large and complete café, which may be connected by interior stairs and lifts with a first-class and elegant restaurant in the rotunda beneath the open court. In the eighth or top story are located barber shops, toilet rooms, etc., lighted from the open court and skylights.

In the construction of the building, the utmost care will be taken, that judged from the most critical standpoint and by the widest and latest experience, it shall be absolutely fireproof. Whatever constructive material is used, such as wrought steel columns and rolled steel beams, upon which the interior construction depends, is thoroughly protected from possible heat by enclosure in burned fire clay separated from the metal by air spaces. . . . When it is remembered that both interior and exterior are incombustible equally, and that

any fire originating within the building could be only so important as might be made by the furniture and other contents of a room, the comprehensiveness with which the word "fireproof" is used in this building will be understood. In exterior design, the building . . . is characterized by marked simplicity and dignity. With the exception of the two main entrances, which are richly decorated by significant and suggestive carvings, and of the curved bays which are carried above these entrances, decorative carvings are very sparingly employed. The first story, which will be of stone—probably of granite—is composed, in the main, of circular columns 3 feet in diameter, behind which the first story windows are placed. Light brick and terra cotta are the chief materials in the upper stories. The type of architecture employed could not, in the nature of the case, be a servile copy of any pre-existing type, since it has never happened in the earlier history of architectural development that structures of this class were erected. As far as is consistent with the essentially novel uses in the building, as viewed from an architectural standpoint, the style employed is that in vogue at the end of the fifteenth century in France. . . .[18]

Nearly every aspect of the building—the dimensions, the entrances and circulatory pattern, the details due to the overriding concerns of light and ventilation, the flexibility in partitioning, the public amenities, the structure, and the fireproofing—Root discussed in a rational manner. Only when he came to the elevations did he feel obliged to excuse an overall departure from historic precedent, while at the same time offering no explanation for the stylistic detail he had chosen. And, indeed, the wall of the Equitable Building did not really assimilate the horned spouts at the eighth floor, the knobby corbels beneath the oriels, the sillcourses that so sedulously pursued each reëntrant, or the stripes of brown brick stratifying the third story, like rustication. Root had not persevered as he had in the Mills Building. He had failed to bring forth an intrinsic order.

The Western Reserve Building, announced in October 1890, was a lesser scheme, but perhaps more successful (Fig. 157).[19] It was built on the northwest corner of Superior and Water streets in Cleveland, Ohio, on a site even more irregular than that of the Equitable Building. The plan shows an east front of about 72 feet, a deflecting north wall of 92 feet, and an angled southwest wall of 119 feet (Fig. 158). Samuel Mather (not the same man as the president of the Society for Savings) and James Pickands, who were partners in an iron and coal company, commissioned the building, and in July

18 Atlanta *Constitution* (9 Jan. 1891), 5. I am indebted to Mrs. Lyon for this source.

19 The same month, Burnham & Root reported the eight-story "Parmelee Building" at the southeast corner of Public Square and Superior, in Cleveland. During a delay of a year and a half, the frontage on Superior was increased from 132 feet to 166 feet. New drawings, over the name of D. H. Burnham, are dated in the spring of 1892. The building was called the Cuyahoga.

1892 organized the Western Reserve National Bank as its prestige tenant. Office suites were fanned from the core of elevators, stairs, and lavatories. They were well-lighted and delightfully varied in plan and aspect. The brick wall surface, rising to a most handsome corbel table, was plain and almost formidable, but its severity was relieved by the occasional oriels, faced in terra cotta.

In Chicago, near the end of the year, Wilson K. Nixon commissioned two more buildings from Burnham & Root. One was the Central Market, a produce outlet at the east side of State Street, just south of the bridge over the river (Fig. 159). Customers entered the second story; wholesale cold storage vaults occupied the entire ground story. The interior was spare. For the little front on State Street, which measured less than 16 feet wide, Root arranged to have gold and green glass mosaics executed in Paris from his designs. In the decorative gable he repeated a detail from the gateway he had once designed for the Union Stock Yards, a roundel representing a bull's head.

The other commission from Nixon called for a sixteen-story office building that would have fronted 94½ feet on Dearborn Street, across from the reconstructed Grannis Block. The plans were announced on 10 January 1891, the day Root returned from Atlanta. Although the editors of *Industrial Chicago* prematurely described the Dearborn Street front as if it already existed,[20] there is no evidence that the building for the "Columbian Vault Company" ever got past the drawing board.

[20]*Industrial Chicago* (Chicago, 1891), I, 217. The project was also reported in *Economist*, V (10 Jan. 1891), 46; and Chicago *Tribune*, LI (11 Jan. 1891), 28. The façade evidently would have repeated some of the failings of the Phenix Building. The Ashland Block, which was built at the northeast corner of Clark and Randolph, can be ascribed to the firm of D. H. Burnham. The drawings date from late in 1891 to early in 1892, the permit having been issued in May 1891. It was derived, essentially, from the Chicago Hotel.

X · THE WORLD'S
COLUMBIAN EXPOSITION

John Root's last, weary thoughts about the World's Columbian Exposition of 1893 were concentrated on the design of only one building, the Art Building. After he died, an entirely different building was erected from plans by Burnham's new "assistant," Charles B. Atwood. Burnham always remembered Atwood as a gentle and sweet man whose early death in 1895 harbored a dark tragedy.[1] Atwood's building pleased Burnham beyond reason: he thought it chastely beautiful, the most beautiful building he had ever seen; and he told his biographer that Atwood stood "on the page of history as the greatest architect of our times." Burnham said the sculptor Augustus Saint-Gaudens had seemed to recognize instinctively the merit of the building. "He took me by the shoulders," Burnham recalled, "and said, 'Old fellow, do you realize the rank of Atwood's building? In my judgment, it is the best thing done since the Parthenon.' "[2] Burnham agreed.

Atwood, in truth, was publicly accused of plagiarism—of taking his design from a Frenchman's much earlier Prix de Rome project. In an interview,

[1] Burnham's office diaries, now in the Burnham Library, document Atwood's fitful attendance during 1895. When he did arrive at the office he often stayed only a few hours. At last, on 10 December 1895, he was retired from the firm. He died only nine days later. He had lived in Chicago as a bachelor; but, after his death, a woman on the East coast claimed to have been his wife. Burnham told Charles Moore that Atwood had "got himself into difficulty and started to use dope. I did not know it, none of us did." Moore suppressed this remark and some others from what he published as "Lessons of the Chicago World's Fair: An Interview With the Late Daniel H. Burnham," in *Architectural Record*, XXXIII (1913), 34–44. The interview was conducted on 8 April 1908. Other quotations in this chapter are taken from the original typescript in the Burnham Library.

[2] Letter from Burnham to Homer Saint-Gaudens, in *The Reminiscences of Augustus Saint-Gaudens*, 2 vols. (New York, 1913), II, 66. See also Burnham, "The Buildings of the Exposition," in *A Week at the Fair* (Chicago, 1893), p. 32; and Burnham, "Charles Bowler Atwood," *Inland Architect*, XXVI (Jan. 1896), 57.

Atwood said the charge had no validity at all, except in reference to the south portico:

In designing that I took as a motive the portico of Benoit's [*sic*] design. I made no secret of it. . . . I wanted a Greek building. . . . in Benoit's capitals he had introduced a change in the direction of the volute, which I regarded as a blemish, and in my design I recurred to the model of the Erechtheum. Even in regard to the proportions I did not rely on Benoit, but sent a man all the way to Boston to measure the plaster cast of the Erechtheum in order that I might follow it without any mistake. . . . The difference between me and some other architects is that I know what to take and what to leave, and know how to combine things that come from different sources, while they do not.[3]

The Art Building stood at the north end of the grounds (see Fig. 167). It did not border on the grand *cour d'honneur* forming the most memorable part of the exposition (Fig. 160). Burnham, however, regarded Atwood as the designer-in-chief and entrusted him with all that was not assigned to other architects—the architectural details of the terraces, bridges, and approaches; the Forestry and Dairy buildings and various ancillary structures; and the three axial closures of the court: the Music Hall, Casino, and Peristyle at the east, the obelisk and colonnade at the south, and the railroad station at the west. It was to Atwood's critical taste, said Burnham, that the architecture of the Fair as a whole owed its final finish: "More of the actual beauty of the Fair was due to him and his associated work with Codman than to anyone else."

Atwood's academic attitude delighted Burnham. "He was a great user of books, and constantly referred to the measurements made by scholars," Burnham recalled, relishing how Charles F. McKim, who at first shook his head about Atwood, came from New York and spent most of an afternoon comparing Atwood's drawings to plates in books, exclaiming, "Damn him, he is right every time!" For a temporary exposition, such control over finish was indeed remarkable (Fig. 161). P. B. Wight could concede that much; he even saw in the *cour d'honneur* a lesson for city planning, to the extent that the buildings of the real world could learn to respect their neighbors. But the impulse to order, he thought, need not entail another revival of the Classic;

[3] Chicago *Tribune*, LII (15 Jan. 1893), 6. C. A. Benoit and his son L. F. Benoit were church architects whose work was around Lyon. Atwood meant, rather, Henri-Jean-Emile Bénard, who won the Grand Prix in 1867, when the subject of the competition was a palace of fine arts. Bénard's design was much more lavish than Atwood's; but Atwood borrowed from many of its trappings (the flanking colonnades and obelisks, the rostral columns and profuse statuary) in creating the "finish" for the *cour d'honneur.* Cf. *Les Grands Prix de Rome d'Architecture de 1850 à 1900,* 3 vols. (Paris, 1900–1909), I, plates 85–91.

surely the buildings of the Fair would never be copied by anyone but a second-rate plagiarist. Already, however, he discerned a tendency in the drawings on exhibition:

All the architectural exhibits are distinctly national except those from the United States. . . . The largest spaces are taken up by projects by students in the *École des Beaux Arts* at Paris, and drawings in a similar style by young men who have not yet achieved professional reputation.[4]

This long summer's holiday by the lake shore, this "impressive spectacle, homogeneous and scholarly, being a triumph of the aesthetical,"[5] rebuked the ambitions which had informed more than a decade. John Root had never called for a chaste and scholarly architecture, and he had never been afraid to make a mistake. He would not have sent a man to Boston to measure a plaster cast. The differences in attitude between Root and Atwood were fundamental. It seemed to matter very little that the buildings of the Fair—which, by all accounts, were most effective by night and under artificial illumination—had been called into being as nothing more than ephemeral display halls; or that behind their most elaborate costuming in a material called "staff"—a mixture of long hemp fibers with five parts plaster of Paris and one part Portland cement—lay a program as simplistic as it was specialized. The cosmetic assemblage of the White City was taken to be a model for civic pomp and grandeur, a corrective to American architecture, a kind of revelation (Fig. 162).

John Root lived long enough to know that the crowning element in the plan for the Fair was to be the *cour d'honneur*. What he did not know, evidently, were the implications. In September 1887 the *Building Budget* published a bird's-eye rendering of the Champ de Mars ensemble for the Paris Universal Exposition of 1889 (Fig. 163), and in June 1889 a photograph of the Central Dome, taken from the Eiffel Tower. In July 1889 the mayor of Chicago appointed a committee to campaign for the Columbian exposition. Popular journals and the newspapers were deluged with reports from Paris, and, typically, Mrs. Schuyler van Rensselaer found it hard to say whether she was more impressed by the two great feats of construction, the Eiffel Tower

[4]P. B. Wight, "The Great Exhibition Reviewed," *American Architect*, XLII (Oct.–Dec. 1893), 58.
[5]Hubert Howe Bancroft, *The Book of the Fair* (Chicago and San Francisco, 1893 [–1894]), preface.

and the Machinery Palace, or by the ensemble aspect—"a magnificent whole, not a casual massing of independent parts."[6] Now the competitive spirit in Chicago has always been charmingly ingenuous; by the fall of 1890 it was decided that a building at the Fair should have a clear span surpassing that of the Machinery Palace to set a new world's record, and that all the main halls should enclose a third more space than their counterparts in Paris—a proposal by Edward T. Jeffery, who had succeeded Joseph Medill on the committee on grounds and buildings.[7] Most important, and contrary to the original recommendations of Frederick Law Olmsted, it was decided that the site plan should embrace a grand formal court, enframed by the principal exhibition halls.[8]

Much of the planning was accomplished before appointments were announced, and some of it before appointments were made. Journalists were left to speculate about matters already decided, as Burnham's part of the "Final Official Report" makes all too evident. In 1889, nearly a year before his appointment as a consultant, Burnham was already advising the all-important committee on grounds and buildings. Root, likewise, was preparing plan-sketches for three possible sites even before the House of Representatives, in February 1890, passed the bill awarding the Columbian observance to the city of Chicago.[9] One of the most active members of the committee, until his resignation effective 1 April 1891, was Owen Aldis. Another member was Eugene Pike, the client and partner of Burnham & Root in building the Chicago Hotel. When the most eligible site for the Fair was rumored to be Jackson Park (then merely a polite name for a miserable tract on the south lake shore), no close observer could have failed to notice that Jeffery, of the committee, was president of the railroad passing most conveniently nearby, and that John B. Sherman, a member of the South Park Commission, was Burnham's father-in-law. The president of the South Park Commission,

[6]M. G. van Rensselaer, "Impressions of the International Exhibition of 1889," *Century*, XXXIX (Nov. 1889–April 1890), 316. Other parts of her report indicate that she had lost sight of the principles she had championed in her 1888 biography of Richardson.

[7]The clear span episode is discussed in my note, "Clear Span Rivalry: The World's Fairs of 1889–1893," *JSAH*, XXIX (1970), 48–50. Jeffery's contribution is noted in D. H. Burnham *et al.*, "Final Official Report of the Director of Works of the World's Columbian Exposition," 8 vols. MSS (1894) in the Burnham Library, a key reference and the source of much that is not otherwise documented in this chapter.

[8]To credit Olmsted with the site plan of the Fair, as is still the custom even among Olmsted scholars, is a major error.

[9]*Western Architect*, XXI (March 1915), 18.

James Ellsworth, was not a member of the committee, and yet he went to Brookline, Massachusetts, in July 1890, to offer Olmsted $1,000 to furnish a report on Jackson Park. Olmsted discerned that his expert counsel as a landscape architect was sought for the purpose of ending the debate over sites, through the prestige that would attend his recommendations.[10] In a letter of 26 July 1890, Ellsworth confirmed the offer and discussed his "idea," apparently unilateral, that the South Park Commission would issue bonds and spend part of the proceeds "in improving Jackson Park as originally designed, placing the work just that far in advance, and it being done in such manner that the results can be utilized temporarily by the World's Fair Directory."[11]

On 9 August 1890, Olmsted and his assistant, Henry Sargent Codman, met with certain directors of the Fair and inspected Jackson Park. On the same weekend they visited six other possible sites. Olmsted was hardly eager to associate himself either with the Fair or with Chicago: "Of the seven sites to which our attention was called, there was not one the scenery of which would recommend it if it had been near Boston, New York or Philadelphia." Behind his rather supercilious attitude was the circumstance that twenty years earlier he and Calvert Vaux had prepared plans for the South Park system: almost nothing had been done toward creating Jackson Park, except for the walkways at the north end and Root's little pavilion; and, regarding Washington Park, Olmsted considered *it* the poorest performance he had witnessed during his long professional experience. Every attention had been paid to detail, he said, to the entire disadvantage of the elements of mystery in an extended composition of masses, as seen in perspective.

Olmsted, Codman, and Root agreed that any of the three sites along the lake shore would, at the least, be enhanced by the one scenic aspect of the city. It said much for Olmsted's integrity that, despite the nature of his retainer, he declared a site on the north shore the best candidate. After the railroads refused to lay special track, the deliberations reverted to Jackson Park, a depressing expanse of swales and sandy ridges with a few scrub oaks fighting for precarious existence. "If a search had been made for the least parklike ground within miles of the city," said Olmsted, "nothing better meeting the requirement could have been found." Nonetheless, Olmsted's thinking now coincided with Ellsworth's wishes. The members of the South Park Commis-

[10]F. L. Olmsted, "The Landscape Architecture of the World's Columbian Exposition," *Proceedings of the American Institute of Architects*, XXVII (1893), pp. 162 ff. Subsequent quotations from Olmsted not otherwise identified are taken from this source.

[11]The letter appears in Burnham, "Final Official Report," I, 2.

sion may have lacked a sensibility for the mysteries of extended landscape composition, and they may have been ignorant of Olmsted's intentions of creating a subtle scenery capable of inspiring the confined citizen with a sense of enlarged freedom; but they thought they had finished with Washington Park, and that now the Fair conveniently could become the agency for finishing Jackson Park.

Typically enough, although it was not until 21 August 1890 that F. L. Olmsted & Co. were appointed consulting landscape architects and Root was appointed consulting architect (both appointments were the result of private meetings the day before), Olmsted had already stated his recommendations in a letter of 12 August to Lyman J. Gage, president of the Fair's board.[12] He suggested a continuation of the levee to inhibit encroachments of the lake upon the land, and a picturesque bayou, which would encompass the large Wooded Island. The temporary exhibition halls of the Fair would be sited on 112 acres, and twenty to thirty of the smaller buildings could be accommodated on the island. All the elements of the plan were to be curvilinear:

The dredged channels are to be winding, and an effect of intricacy is to be produced by numerous bays, points and islands; these to be so planned that the play of light and shadow in, under and between the bits of foliage, aided by reflections from the water, would secure the charm of landscape mysterious in an unusual degree.[13]

By 9 September 1890, the choice of the site at last seemed settled: on a third ballot, the directors voted unanimously in favor of Jackson Park and the Midway Plaisance, a mall reaching westward to Washington Park, and also included the downtown Lake Front. Jackson Park was surveyed at 620.85 acres, the Midway at 66.50 acres. It was understood that if any obstacle should arise, the Lake Front could be abandoned. Some months later, it was. Throughout the fall of 1890, Root continued to make plan-sketches. So did Codman, to whom Olmsted evidently had delegated much of his authority.[14] Root's sketches, according to P. B. Wight, were characterized by a great basin and surrounding ensemble of exhibition halls. This *cour d'honneur*—clearly alien to Olmsted's thinking—so obviously was derived from the Paris Universal Exposition that it could have been suggested by almost anyone else. Jules

[12]This early site plan is shown in Burnham, "Final Official Report," I, 33–34.

[13]Cf. Burnham, "Final Official Report," I, 33.

[14]Cf. *Forty Years of Landscape Architecture*, ed. F. L. Olmsted, Jr., and Theodora Kimball, 2 vols. (New York, 1922), I, 36. Olmsted was more seriously engaged with works for the Boston metropolitan park system.

Wegman, one of Root's draftsmen, traveled to the Paris exposition. Two men from Olmsted's office were guided over the Champ de Mars while it was being landscaped. Codman lived in Paris several months while the exposition was under way. Octave Chanute, a railway engineer who now spent most of his time on aerodynamic theory, was sent to Paris with Jeffery, specifically to scout the exposition. Chanute already had studied a thorough description published in the *Engineering* of London for 3 May 1889.

In November 1890, in his new role as chief of construction, Burnham was directed to present a site plan. More sketches were made, and the plan was finally presented on 21 November, first to the committee, then to the board and to the National Commission. "The borders of the canal and the basin in the court are to be treated formally," Burnham & Root explained in letters of that date to the directors, "with embankments of stone or brick; surmounted by parapets or balustrades. . . . " The Wooded Island, they said, would be preserved as "the basis of a passage of natural landscape to supply an episode of scenery in refreshing relief to the grandeur of the buildings."[15] Burnham later recalled the presentation:

After consideration of the sketches made on the grounds by Mr. Olmsted's partner, Mr. Henry Sargent Codman, indicating the manner in which the idea could be worked out suitably to the purposes of the Exposition without sacrificing any of the advantages of the site for a park, the crude plan on a large scale of the whole scheme was rapidly drawn on brown paper, mostly with a pencil in the hands of Mr. Root, whose architectural prescience and coördinating talent was of invaluable service to the result. . . . The plat . . . contemplated the following as leading features of design: that there should be a great architectural court with a body of water therein; that this court should serve as a suitably dignified and impressive entrance hall to the Exposition, and that visitors arriving by train or boat should all pass through it; that there should be a formal canal leading northward from this court to a series of broader waters of a lagoon character . . . ; that near the middle of this lagoon system there should be an island . . . [kept] free from conspicuous buildings [and given a] natural sylvan aspect. . . . [16]

Artificial formality and artificial sylvan scenery—those two themes formed the basis of the final plan of the World's Columbian Exposition (See Fig. 167). The suggestions Olmsted had made in August 1890 were compromised. Later, Olmsted tried to explain the court by the requirements. The

[15]Letters of D. H. Burnham, 21 vols. in the Burnham Library, I, 29. These copybooks also contain some letters signed by Root, and some signed on behalf of the partnership.
[16]See either Burnham, "Final Official Report," I, 39–40, or Olmsted, "Landscape Architecture," pp. 166–167.

basin and the stiffly architectural canals were to accommodate motor launches, and because the exhibition halls were to be founded on sandy ridges bordered by violently fluctuating water levels, fortified terraces and retaining walls were necessary. Burnham was rather more frank. There was nothing original about the plan, he said, except for the canal, the lagoons, and the Wooded Island; the court was like the one in Paris, with a central basin, a dome at the vista, and a great fountain. [17] It would seem that Burnham was never bothered by the disparity between the architectural pomp and the mysterious sylvan scenery. He grew especially fond of Codman, whose "special designing," as he called it, came after Root died. Codman, he thought, could never fail (presumably, like Atwood, he chose to make no mistakes) and possessed more knowledge of formal settings than all the others. "Nature spoke through him direct," Burnham concluded, curiously.

A straight line, to Olmsted, was the least mysterious distance between two points, and "nature" was hardly what spoke through Codman direct. The colossal garnishments of the court, emulating Baroque Rome, and the canals (popularly regarded as Venetian) became brazen intrusions upon the park. Although he had originally offered the Wooded Island as a site for smaller buildings, Olmsted now fought to keep the island entirely natural—he was not wholly successful, one encroachment being the scale model of the Japanese temple known as the Ho-o-den—so it might serve "as a foil to the artificial grandeur and sumptuousness of the other parts." In the revised general plan of 1895 for Jackson Park, Olmsted left not the slightest trace of the *cour d'honneur*. He did not even try to adapt it as a harbor for pleasure craft. Only near Atwood's crumbling Art Building, now lingering on as the home of the Field Columbian Museum, did he specify landscaping kept "upon formal lines for the sake of architectural harmony." [18]

Surely it was given to John Root to envision very early the essential parts of the plan. Burnham liked to recall how the plan gradually evolved until the last months before the gates were opened. In detail, it had. But the

[17]D. H. Burnham, "The Organization of the World's Columbian Exposition," *Inland Architect*, XXII (Aug. 1893), 6.

[18]The plan is conveniently reproduced in J. G. Fabos *et al.*, *Frederick Law Olmsted, Sr.* (Amherst, Mass., 1968), p. 41. For a collection of papers expressing Olmsted's philosophy, see *Landscape into Cityscape*, ed. Albert Fein (Ithaca, N.Y., 1968), or *Civilizing American Cities*, ed. S. B. Sutton (Cambridge, Mass., 1971).

visual effects, said Olmsted, were considered from the beginning: boats and bridges, shadows and reflections, even the movement of wildfowl. When the National Commission adjourned on 26 November 1890, the plan had been ratified. The next day the Chicago *Tribune* published the "Architect's Plans Showing Relative Position of Buildings." This plan of November (Fig. 164) can be conveniently compared with three later stages: the plan Root furnished for publication in the New York *Tribune* of 21 December 1890 (Fig. 165); a plan "substantially as outlined by late Consulting Architect Root" published, again, in the Chicago *Tribune,* on 23 January 1891 (Fig. 166); and the final plan of 1893 (Fig. 167).

Almost every revision was a step toward greater formality, toward more obvious axiality. In November, Root could not have been unaware of the problem at the east end of the *cour d'honneur.* The outer harbor pushed the pier north of the great basin, and the south inlet, its amorphous shape an existing feature of the park, entered the basin too casually. In the December and January plans the basin was shifted north from the inlet and onto axis with the pier, paralleling the relationship of the basin at the Champ de Mars to the Pont de Jena (the basin in Chicago kept getting longer, until at last it reached 1,300 feet, again exceeding the counterpart at Paris). Root contemplated that the buildings on the court would be linked by sheltering arcades—except at the east, where the view over the lake would be unobstructed. Later, the outer harbor was in effect abandoned; Atwood closed the court with a monumental screen consisting of the Music Hall, the Casino, the Peristyle (see Fig. 162)—its columns named, at the suggestion of Saint-Gaudens, for the states of the Union—and a triumphal arch bearing the words Burnham had taken as his motto: "Ye Shall Know the Truth and the Truth Shall Make You Free." The pier was displaced to the south and aligned with the Casino, and a sea wall framed an axial water gate to the basin.

In November, Root assigned the Agriculture Building and livestock area to the southwest corner of the site; Olmsted, in August, had implied that the animals would best be quartered as far as possible from the lake. In December, the expansion of the railroad yards inconveniently estranged the Agriculture Building from the animal pens. In January, Louis Sullivan suggested that the Transportation Building, which was to have been only an adjunct of the Machinery Building, exchange places with the Agriculture Building. After his proposal was accepted, the Transportation Building was moved northward. Burnham asked Sullivan to put his "Golden Doorway" on axis with the west entrance of George Post's Manufactures and Liberal Arts Building, which re-

tained the same orientation and nearly the same dimensions through all stages of the plan. In another change between December and January, the Mines and Electricity buildings were rotated, so the corridor between them could create a vista toward the dome of R. M. Hunt's Administration Building. Hunt's building underwent a kind of mitosis, finally assuming an independent ground plan strangely like that of the Eiffel Tower. Because the original intention had been a strict control of the flow of visitors into the *cour d'honneur*, this development, caused by difficulties with the railroad, seemed unfortunate to both Burnham and Olmsted.

Burnham said he suggested an impressive fountain at the west end of the basin; he admitted that he took the idea from the Paris exposition. Codman later moved the fountain farther west in order to clarify the axis of the canal. At first, Root contemplated a rudimentary south canal; then he eliminated it because it was leading nowhere. During the meetings of the architects in February 1891, Charles McKim said R. S. Peabody wanted to carry the canal south between their respective buildings—the Agriculture and Machinery buildings. Such was the origin of what Olmsted called the south transept. Atwood closed this vista with an obelisk and grand colonnade, a very odd portal to the livestock pavilion.

The Horticulture Building had already found its site in December. Later it was shifted slightly eastward, thereby constricting the picturesque lagoon, much to Olmsted's distress. By March 1891, two other major buildings of the north sector, those for the Fisheries and for the U. S. Government, had been dragged onto axis with the Manufactures and Liberal Arts Building.[19]

Burnham & Root occupied a very delicate position regarding the architecture of the *cour d'honneur*. Without any formal commission, they had enjoyed for too many months the favor of the committee on grounds and buildings. There were bound to be jealousies. In August 1890 it was rumored that R. M. Hunt, as dean of architects in America, would be appointed consulting architect. It was said that Dankmar Adler, William Le Baron Jenney, and even Burnham expressed their approval. [20] Adler, despite his vehemence in asserting that the Western Association could survive very well without the American Institute, had extended the professional courtesy of nominating Hunt as

[19]The plan of March 1891 is recorded on microfilm, roll 13, frame 3, in the Burnham Library.
[20]Cf. *Inter Ocean*, XIX (22 Aug. 1890), 6, and *Architecture and Building*, XIII (Aug. 1890), 97.

president of the reconstituted Institute. Now he was serving on the board, while Root served as secretary. Root of course had been appointed consulting architect on 21 August, yet his appointment was rescinded only a week later; he was out of the city and seemingly uncertain about when he would return. The Chicago *Tribune* speculated whether Burnham & Root, Adler & Sullivan, or S. S. Beman might win the appointment, Beman's eligibility stemming from the efficiency with which he had built the town of Pullman. On 3 September 1890, Burnham & Root were elected the consulting architects. They immediately announced that they would refrain from designing the buildings, but would develop the plan and provide advice and criticism to other architects. Their gesture seemed conciliatory.

At the same time, because the Fair was a national celebration and because other cities were disappointed by the award of the site to Chicago, it seemed eminently diplomatic to invite guest architects. Root, recalled R. C. McLean, had *never* expected to design many buildings. Far in advance, he had predicted the architects who would be invited:

During the agitation in Congress and before the selection of Chicago was made, the writer asked Root, "Who will design the Fair buildings?" His answer was, "No one architect should design these buildings, but a number of the best architects in the United States, all working together as one commission." Estimating that from ten to fifteen main structures would be required, the next question was, "Who are the best architects in the United States?" Root took up a card, and as the talent of each architect was weighed, the names of those deemed most proficient, about fifteen in number, were set down. . . . it is interesting to note that all the names [of the architects finally appointed] were on that card.[21]

On 8 November 1890, the directors created for Burnham the post of chief of construction. At his request, all the prior appointees, including Olmsted & Co., the consulting engineer A. Gottlieb, and even his own partner, were formally discharged and then reappointed to supervisory posts, effective 1 December—a maneuvering, evidently, to sanction his newly acquired preëminence. Later he took up residence at Jackson Park, in a little shack, which he made into a command point through which all decisions had to be channeled. Meetings with the National Commission, a body Burnham regarded as merely an obstruction, continued through much of November, and after the ratification of the general plan it was not until 8 December that another decisive step was taken: a memorandum to the committee on grounds and

[21] *Western Architect*, XXI (1915), 18. McLean repeated the account in XXXI (1922), 69, and in XXXV (1926), 81.

buildings, drafted by Burnham, altered slightly by Olmsted, entirely rewritten by Root, and signed by all three, along with Gottlieb. (Burnham, in saying later that Gottlieb was hardly known to the other consultants, implied that Gottlieb's voice counted for very little.) The memorandum argued against appointment of a single architect and against a competition, whether open or limited; it recommended direct selection of a certain number of architects to meet and settle upon some general scheme.

By 12 December, Burnham had convinced the committee to confirm a list of five architectural offices, none of which was in Chicago. The next day he addressed confidential letters of invitation to Peabody & Stearns of Boston, Van Brunt & Howe of Kansas City (and lately of Boston), and R. M. Hunt, George B. Post, and McKim, Mead & White of New York. The letters strongly implied the intention of an ensemble effect, and they explicitly delimited the authority of Root: "Our consulting architect, Mr. Root, would act as your interpreter when you are absent, without importing [sic] into the work anything of his own feeling." [22]

If the buildings on the court were to be an ensemble, what did Root expect from the invited architects? He must have been aware of their familial ties, of what Van Brunt later described as their personal allegiances and their direct or indirect connection with the École des Beaux Arts in Paris. Peabody, once an apologist for the Queen Anne revival, had, like Stearns, come from Van Brunt's office (as, indeed, had Charles B. Atwood), and their own office was successful in an equally innocuous way. They had done some ill-organized shingled houses, some châteauesque work, and a little Classical; and they were drifting toward the Italian Renaissance. Van Brunt had been a pupil in Hunt's atelier. His most recent work, with Frank Maynard Howe, was generally Richardsonian and specifically not very distinguished. Richard Morris Hunt, everyone knew, had become the master of the châteauesque. His work, once he forsook a structural expressionism, was so well digested that Charles McKim liked to walk up Fifth Avenue before his last cigar of the evening to look at the house of W. K. Vanderbilt; according to McKim, the sight of it made him sleep better. George B. Post was another of Hunt's former pupils. Post was an old hand at large commercial buildings. Basically a classicist, with a penchant for domes and high attics, he was capable of anything from the sedate Produce Exchange, his masterwork, to that egregious babble of classicistic nonsense piled nineteen stories high, the New York World Building.

[22] Letters of D. H. Burnham, I, 65.

McKim, Mead & White had delved into the Colonial and had done some superb shingled structures. But their work was becoming increasingly Italianate. Joseph M. Wells, a junior member, who died of pneumonia in February 1890, left his mark as early as 1882, when he was allowed to revise the elevations for the group of six townhouses that Henry Villard was to build behind St. Patrick's Cathedral, on Madison Avenue. Wells had also designed the Russell and Erwin Building in New Britain, Connecticut, and, in 1888, had revised the elevations of the New York Life Insurance Building in Kansas City and supplanted an incongruous cupola with an Italianate tower. In 1889 he was occupied with the Century Club on Fifth Avenue. The critic Royal Cortissoz had worked in the same office, and he recalled how he would find Wells with his eyes dreamily fixed on a large illustration tacked above his drafting board. It was a photograph of the courtyard of the Cancelleria. Cortissoz nicely characterized Wells's tendencies by saying his Bible was constituted of the works of Bramante.

So it is strange that Root may have failed to perceive the classicistic forces waiting in the wings. Soon after he was reinstated as consulting architect, he said the Fair should be a "crystallization and condensation of American art." [23] A month later, in a private letter, he wrote that the entire exposition should be dominated by "some great monumental design to give to the mass of the buildings that architectural interest and splendor which an exposition of this magnitude demands." [24] Evidently he meant the site plan. His thoughts regarding the architecture again were best recorded by McLean:

In the opinion of the consulting architects, the general direction in design should be as little historical and as greatly illustrative of the present status of American architecture as possible. It might be said that three distinct styles have developed in the United States, with sufficient distinctness to be generalized under the headings of "Romanesque," "Francis I," and "Colonial." The architects may advise that the buildings be largely conferred to these adaptations of styles—the heavier or permanent buildings in the Romanesque, the lighter and more ornamental in Francis I, and others, where wood is largely used, in Colonial; the entire idea being to show that we have a beginning, at least, of an American style. . . . [25]

Root made many rapid sketches of Fair buildings for his own amusement; Burnham said they tended toward variety in style and color. The holograph

[23] Chicago *Tribune*, L (6 Sept. 1890), 2.

[24] Letter of 4 Oct. 1890 to E. L. Corthell, in letters of D. H. Burnham, I, 15.

[25] *Inland Architect*, XVI (Sept. 1890), 14–15.

drawing donated only recently to the Art Institute of Chicago is perhaps the best sketch (Fig. 168). The building springs over one of the canals, and, as a "lighter and more ornamental" structure, its Romanesque elements quickly dissolve into the spirit of the early Renaissance in France. Much of the interior appears to be given to observation decks: the building looks outward. The color probably is red, and certainly not white. The lanterns and finials are festive, the specialized program is manifest. There is no hint of permanent civic symbolism.

Not long after the confidential letters were mailed, Burnham traveled to New York to meet the invited architects as he had promised. Van Brunt wired his acceptance from Kansas City. On 22 December 1890, Burnham dined with Hunt, Post, Peabody, and Mead; they agreed to begin meetings in Chicago on 10 January 1891. In later years, Burnham carefully avoided saying whether he had learned in New York that the Eastern architects, of their own accord, had met in the offices of McKim, Mead & White shortly after receiving the letters of invitation. McKim already advocated the adoption of the classical language as a control for the style of the *cour d'honneur*. Mead, his partner, later told Charles Moore that McKim's proposal met with no opposition and that the architects decided also on a common height of cornice. And when Moore was so bold as to ask Burnham why the Romanesque, which had been more characteristic of American architecture, was not adopted for the halls on the *cour d'honneur*, Burnham responded that the only style ever discussed (clearly he was forgetting Root's notions) was the "Italian Renaissance":

H. H. Richardson had the lead in architecture up to the time of his death His art died with him. He had mastership, and made vital the style he used. By 1890, however, no one any longer cared for his sort of work.[26]

At the time, Burnham was not worried about the imposition of what Van Brunt was to call an academical discipline. He was under fire for having gone out of the city for the architects of the main buildings. In an attempt to forestall a skirmish, Burnham on 27 December 1890 addressed another memorandum to the committee: "By this prior recognition of the profession at large you have removed all doubt as to Chicago's attitude toward the entire country, and have secured the cordial approval of architects everywhere and

[26]This interchange appears only in the typescript of Moore's interview. Burnham obviously distorted history to his own advantage.

thus of the end for which your action was taken." [27] Only a few days later, Ferdinand Peck and Potter Palmer, both of whose wishes most men would choose to disregard only at great peril, upset a meeting of the committee (Peck was not a member, and Palmer had previously resigned and been replaced by R. A. Waller) by demanding to be told why, when there were so many architects in Chicago, the out-of-towners were to be given the buildings on the *cour d'honneur*. On 2 January 1891, the committee instructed Burnham to present a list of ten architects—five from Chicago, and five not. Burnham confused the issue on 5 January by submitting the names of *eleven* Chicago architects. After an intense debate—which he interpreted as a challenge to his professionalism from the "politicians"—Burnham asked permission to name five Chicago architects, as he was instructed in the first place. He named Adler & Sullivan, William Le Baron Jenney, S. S. Beman, Henry Ives Cobb, and Burling & Whitehouse; and the list was approved, along with the five out-of-town firms named previously. Burnham was given authority to assign the buildings.

On 6 January, Burnham called personally on the Chicago architects. He said he found them receptive, except for Dankmar Adler, who appeared disgruntled and said he was undecided. "I think he—Adler—had hoped to be in the position I was in," Burnham told Charles Moore. Burnham on 6 January also wrote the Eastern architects to warn them of the situation: "There is some feeling here about our going outside for so much of the work, and the committee desires to retain the designing of the agricultural building for a Chicago man. . . ." [28] Only a week later Burnham assigned the Agriculture Building to McKim, Mead & White.

Root, meantime, had written the Eastern architects on 30 December that he intended to be in New York by 3 January 1891, and that he would make a point of seeing them. He mailed them a plan-sketch made only on 27 December. His trip went as scheduled, and he talked with the architects after attending a meeting of the board of the American Institute. Then he left for Atlanta, where he presented the drawings for the Equitable Building. When he returned to Chicago on the morning of 10 January (it was his forty-first birthday), he told McLean how tired he felt. The architects from the East had just arrived. Burnham conducted them to Jackson Park to inspect the site. When they returned to the library in the Rookery, they met Root;

[27]Burnham, "Final Official Report," I, 6.
[28]Letters of D. H. Burnham, I, 125–129.

he invited them to his house the following evening. The committee already had arranged a dinner that first night at the University Club, and when Burnham was asked to speak, he said the Fair was going to be the third great American event, after 1776 and 1861. ("It was the same old appeal that the Chicago men had been brought up on," he remarked later to Charles Moore.)

The next day, Sunday, Root did a little work on a commission for a commercial building and walked to the studio he had designed for the sculptor Johannes Gelert, at 18 West Oak Street. Gelert showed him some casts. Later, in trying to overcome his fatigue, Root took a Turkish bath. That night, when he escorted the visiting architects to their carriages as they were leaving his house on Astor Street, he caught cold. He awoke at 5 o'clock in the morning with chest pains; he had pneumonia. The first formal sessions of the commission of architects began that day. Root could not attend, and he was never to see his office again.

R. M. Hunt was also ill. George B. Post was appointed acting chairman. Root's plan-sketch of the Fair was debated, then accepted as to general scheme. It was agreed that the buildings on the *cour d'honneur* would be controlled by the "classic motive." Louis Sullivan was free of stylistic restraints insofar as the Transportation Building bordered on the lagoon. There is no evidence that he raised his voice before 1893. Having won a victory over Potter Palmer and Ferdinand Peck, Burnham now asserted his professionalism even more freely. M. E. Bell, who was supposed to be his assistant chief of construction, soon complained he had too much private work to do. Burnham replaced him on 7 March 1891 with Ernest R. Graham, who was barely past his majority but who had been recommended by William Holabird. Burnham was unhappy with Gottlieb, the consulting engineer. He told Gottlieb he was not making sufficient allowance for windbracing in the timber framing; when Gottlieb protested that *he* was the engineer, Burnham answered that his own opinion should be given more weight because of his long practice in architecture. Gottlieb resigned in August 1891, and Burnham brought in his resident engineer, E. C. Shankland. Root's friend William Pretyman suffered a similar fate. Pretyman had been appointed director of color. He conducted experiments in which he applied various hues to the material called staff, evidently concluding that the base color should be amber. He was out of the city when Burnham ruled that the *cour d'honneur* would be all white—Burnham told Charles Moore he could not remember whose suggestion it was, but that the decision was his—and when Pretyman returned he felt obliged to resign. Burnham warmly remembered the painters as "the whitewash gang." The first

building he had them paint white was the only building on the court designed by a Chicago architect, Beman's Mines Building.

As early as August 1890, Root began to make studies for an Art Building. On 17 October, Charles L. Hutchinson, the president of the Art Institute, was authorized by his executive committee to negotiate with the World's Columbian Exposition and with the Public Library about plans for a building on the Lake Front that could survive the Fair as a permanent civic institution. Before the month was over, the Commercial Club had also voted to work toward a new home for the Art Institute. On 9 December, Burnham's department of construction was directed to furnish plans for an Art Building. The drawings Root presented by 22 December still represented preliminary studies; one description mentioned a low dome, and another said the elevations were in the "Roman style." [29]

A surviving holograph study (Fig. 169) appears to be his last sketch of the entire west front and, indeed, one of his very last drawings. The front is shown at more than 600 feet in length, yet the scale is not as disturbing, perhaps, as the manner in which the long blind arcades and the gabled end pavilions conspire to suppress the vigor of the Romanesque center pavilion. Although he proposed a rich coloration—reddish-brown granite for the basement, pink granite above, and a roof of brown Spanish tiles below the cool reflections of a continuous and prominent skylight—it was all too apparent that the chastened classicism of the Boston Public Library had left its impress.

On 20 February 1891, more than a month after Root died, the directors of the Fair voted to abandon the auxiliary site at the Lake Front. In April, Burnham asked Atwood to design an Art Building for the Jackson Park site. But as late as 8 May the directors voted $200,000 toward a permanent building on the Lake Front to serve the Fair as the setting for various world's congresses, one more idea taken from the Paris exposition. It was not until 4 June that the Art Institute appointed a building committee. With both Root and Richardson gone, the committee settled on plans by Shepley, Rutan & Coolidge (Richardson's successor firm) and got a design that was

[29] See Chicago *Tribune*, L (23 Dec. 1890), 7; Chicago *Evening Journal*, XLVII (23 Dec. 1890), 2; and *Inter Ocean*, XIX (25 Jan. 1891), 8. Paul Lautrup prepared a large watercolor rendering from two of Root's early sketches. Later he presented the rendering to John W. Root II, who donated it to the Burnham Library. It shows a gold-framed dome with gold sculptures. The tympanum above the portal is colored blue and gold, and the wall is pink.

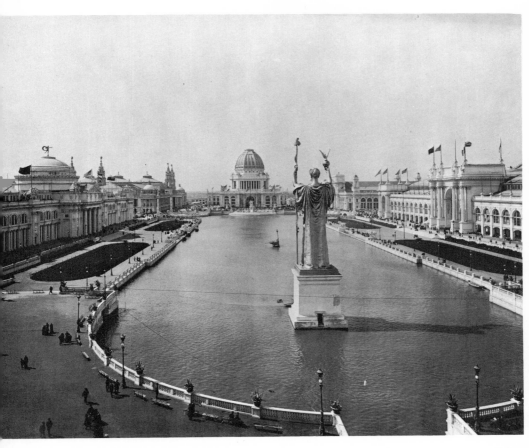

Fig. 160. World's Columbian Exposition, Jackson Park, Chicago, 1893. Westward view of the cour d'honneur. *Courtesy the American Institute of Architects.*

Fig. 161. World's Columbian Exposition. Bronze term, 3½ inches high. Collection of the author.

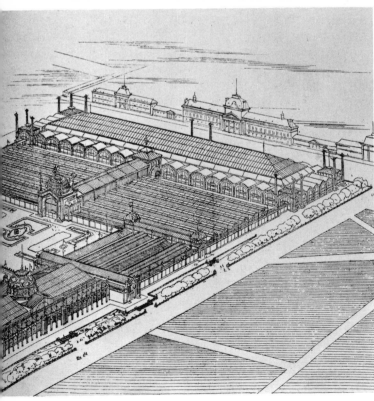

Fig. 162. World's
Columbian Exposition.
Burnham inspecting the
Peristyle before column
bases are in place.
Courtesy the Art
Institute of Chicago.

Fig. 163. Paris Universal
Exposition of 1889.
Champ de Mars ensemble.
From the Building Budget.

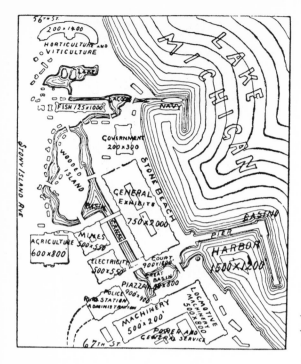

Fig. 164. World's Columbian
Exposition. Plan of November
1890. From the Chicago Tribune.

Fig. 165. World's Columbian
Exposition. Plan of December
1890. From the New York
Tribune.

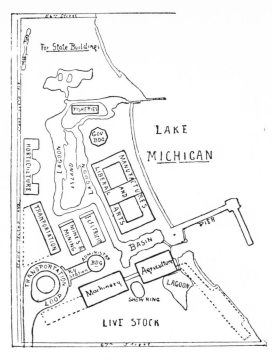

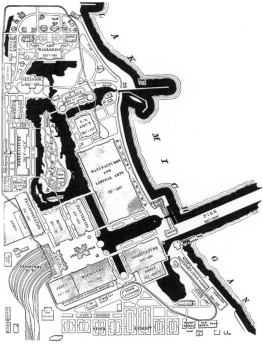

Fig. 166. World's Columbian Exposition. Plan of January 1891. From the Chicago Tribune.

Fig. 167. World's Columbian Exposition. Final plan of 1893. From a map by J. Manz & Co., courtesy Kansas City Public Library.

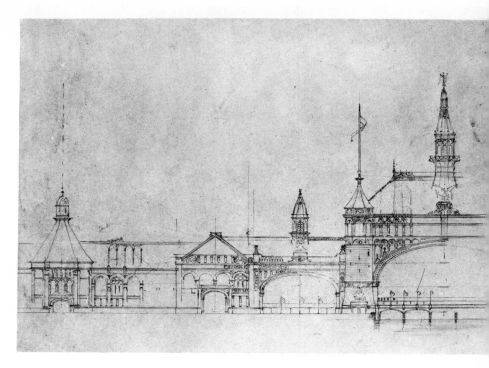

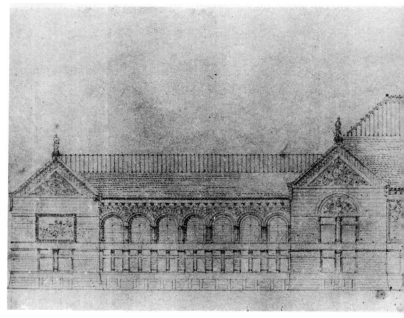

242 JOHN WELLBORN ROOT

Fig. 168. World's Columbian Exposition. Study for canal portal, 1890. Art Institute of Chicago, gift of E. S. Fetcher.

Fig. 169. Study for west elevation of Art Building project, 1890. Collection of E. S. Fetcher.

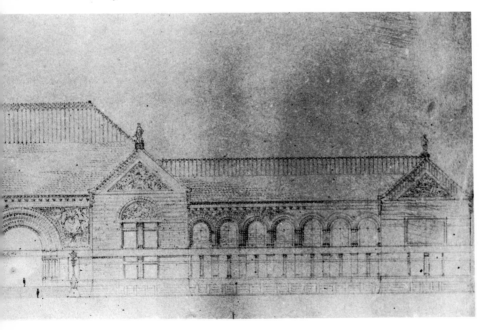

considered "Italian Renaissance, the details classic." [30] The design was even more strongly in the spirit of McKim's library building. It was formally accepted on 17 October 1891.

John Root died on 15 January 1891. Possibly, from having talked with the out-of-town architects, he was aware of the direction in which the Fair was headed. Henry Van Brunt, torn between loyalties old and new, in 1892 cautioned foreign visitors that if they were coming to see the true expression of American architecture, they should expect to find it not at the Fair, but in or near the larger cities. On 5 August 1893, at the last session of the World's Congress of Architects, Louis Sullivan chose to speak on polychromy, a subject which, in the face of the whitewashed *cour d'honneur*, posed basic questions. He demonstrated how form could be developed organically from simple geometric shapes. He warned that Americans were not Greeks, that any attempt at such substitution was clear perversion. [31] Dankmar Adler spoke out, less than three months later, as the Fair was closing:

The immediate effect of the example of the Fair buildings will be a general and indiscriminate use of the classic in American architecture. Efforts will be made to force into the garb of the classic Renaissance structures of every kind and quality devoted to every conceivable purpose . . . in palace and cottage, in residence and out-house, in sky-scraping temple of Mammon on city streets, and in humble chapel and schoolhouse of the country roadside. [32]

At the time, Adler thought such an abuse of the Classic would only hasten its end. Three years later, at the annual convention of the American Institute, he found it still necessary to challenge the abject devotion to precedent. "What I have written," he said, "is intended to be a protest against the dogma that art in architecture ended with the Renaissance. . . . " [33] A few weeks later, R. C. McLean recalled how the work of Richardson and Root began to

[30] See the *Annual Report of the Trustees* of the Art Institute for 1891 and 1892. The surviving minutes of the trustees begin only on 17 Dec. 1891 and rarely reflect the reasons for decisions.

[31] *Inland Architect*, XXII (Aug. 1893), 11. In a conversation of 1965, Root's younger daughter recalled: "My mother was always so sad about the way the Fair turned out—bastard Greek."

[32] Chicago *Tribune*, LII (29 Oct. 1893), 37. I am indebted to Titus M. Karlowicz for this significant reference.

[33] Dankmar Adler, "Influence of Steel Construction and of Plate Glass upon the Development of Modern Style," *Inland Architect*, XXVIII (Nov. 1896), 35.

be overshadowed, in the East, by the influence of what he called the modern French school:

By the time that the World's Columbian Exposition at Chicago was projected and formulated this influence became most potent, and it is safe to say that in the West it dates from the sudden and unfortunate death of John W. Root, in January 1891. The adoption of a classic treatment for the main buildings of the Exposition gave a stamp of approval from high authority . . . and the influence exerted by the wonderful object lesson afforded by the aggregation of classic architecture around the Court of Honor, as it was called, has been felt throughout the country ever since. [34]

Burnham, certainly, had no regrets. Atwood had satisfied McKim, and, as far as Burnham could see, had performed on a level with the Parthenon. In 1893, Burnham said that if Root had lived, the architecture of the Fair would have been impressed with something of his great individuality, but it would not have been better. Burnham thought he was doing very well without Root.

[34]R. C. McLean, "Architects and Architecture in the United States," *Inland Architect*, XXVIII (Jan. 1897), 61.

CONCLUSION

John Root entered the profession of architecture when historicism persisted in all its superabundance of seemingly eligible styles. There existed no single tradition in which an architect could readily assent, knowing that even mediocre work would meet accepted taste and would likely secure a professional reputation. It was a peculiarly challenging time in American architecture. The way was not at all clear. Beyond the inspiration in the writings of men such as Ruskin, Semper, and Viollet-le-Duc, there was little to be gained from abroad.

The great expanse of America at last had to acknowledge the boundless energies of city life. The wayward course of the picturesque in American architecture was doomed to collision with urban capitalism, its exacting economics and austere rationalism. In his earlier years, Root indulged a musical talent, speculated about the potentialities of color hues and the inner correspondences among the arts, and subscribed to a notion of an all-pervasive spirituality—those typically Romantic obsessions of his which so impressed Harriet Monroe and even Daniel Burnham. He nevertheless discerned very soon that the driving forces of the life about him increasingly had to do with an intense concentration of business enterprise and with the emergence of corporate organization. Montgomery Schuyler said Root enjoyed a clearer perception than one found elsewhere of the limitations and conditions of commercial architecture. Owen Aldis wrote Peter Brooks that he always considered Root a genius and that Root had far more good sense and good judgment than one usually encountered in an artistic temperament.

Root quickened to his time and place. He believed in that progressive theory which emphasized the claims of environment upon art, and indeed he

helped propagate it. Contrary to what Frank Lloyd Wright would have had us believe, he strove to interpret the demands of the day. He held another great advantage over nearly all his contemporaries: a thoroughly architectural mind. He felt structure and he felt space. He knew the basic reality of a building. He apprehended structural principles which gave rise to new technics, and he proceeded to build huge and heavy structures with a confidence perhaps bordering on recklessness, for constructional knowledge was far from exact. When space was a matter of ubiquitous unconcern in the profession, he experienced architecture as the theater of life and realized that the modulation of space was one of the most crucial imperatives of his art. Concerning architectural materials, then so commonly abused and put to masquerade, once again he stood apart, loving each material for its intrinsic values, whether for structure or ornament, and seeking for each that justice in manifesting its special strength and beauty.

Root's methods in conceiving a building derived from both predisposition and his need to accomplish so much work. He could only have been encouraged by the stable and sympathetic presence of Burnham; in the testimony of everyone except Louis Sullivan (whose embittered memory scarcely could be trusted), their partnership was an ideal union. Root weighed the specific requirements and circumstances of each commission in an entirely rational way. Once the conditions were settled in his mind, he surrendered to a showering of alternative conceptions and motifs ruled by no one grammar of expression. He lacked that protestant rigor which Wright later spoke of as the self-sacrifice of interior discipline. His attitude was rather one of amused virtuosity. Sometimes he was mistaken as shallow. What his stance really meant, as he himself was the first to write, in 1890, was a predictably erratic body of work, not infrequently at the mercy of the haste or mood of the hour.

The days of Root's life passed with a poignant swiftness. He looked back on many buildings. Most were successful, and some were magnificent. He never allowed the failures to dim for long his splendid exuberance. In spite of the eccentric trajectory that his career had assumed long since, it should be clear why Schuyler deplored his death by saying he knew no greater loss that could have happened to the architecture of America and to the architecture of the future than Root's dying before his prime. Chicago was the place to which one looked most often for the finest architecture. John Root was the architect. He had led the way in the art of the high office building. His architecture embraced some of the most excellent buildings of the nineteenth century.

BIBLIOGRAPHICAL NOTE

Much of the urban architecture of late nineteenth-century America has suffered a more dismal fate than the architecture of Herculaneum: nature sometimes leaves traces, man usually does not. Of the more than two hundred buildings from the partnership of Burnham & Root very few survive. Neither dates nor street addresses are given in the building lists published in the Chicago *Tribune* for 17 January 1891 and in the January 1891 issue of the *Inland Architect*. The list appended to Harriet Monroe's memoir of 1896 does not pretend to be complete. In addition, it is marred by sundry inaccuracies in addresses and in sequence, and again by the absence of dates. The list that Charles Moore published in 1921 in his biography of Daniel Burnham is the most useful, although deficient in addresses and sometimes as much as ten years in error in dates. Today it is an impossible task, I think, to compile a thorough and accurate building list: too much of what is gone was never documented. Street addresses have been changed, documents pertaining to building permits have been destroyed.

During many of the years of Burnham & Root's partnership, according to Harriet Monroe, drawings considered no longer useful were simply thrown away. Many drawings were lost in the Grannis Block fire. Oddly enough, Miss Monroe herself made no effort to conserve the documents she had at hand while writing her memoir—the letters, the manuscript essays, and some of the drawings. (In her diaries, now in the Harriet Monroe Modern Poetry Library at the University of Chicago, she did record some of Root's witticisms around the time he was courting her sister, who became his second wife.)

In a microfilming project sponsored by the Art Institute of Chicago and the University of Illinois, plans for the Monadnock Block, Armour Mission, Phenix Building, Rookery, First Regiment Armory, Woman's Temple, Masonic Temple, and Reliance Building were recorded. Some of the originals were donated to the Burnham Library, and some were returned to the vaults of various architectural offices in Chicago.

Peter B. Wight presented his own large portfolio to the Burnham Library in 1919. It included three delineations by Root and one by Burnham. In 1947, John W. Root II presented to the library about a dozen of his father's drawings, most of them in pencil, and all representing either preliminary studies or projects. They include the south front of the

Kansas City Board of Trade, the Montgomery Street front of the Mills Building, two versions of St. Gabriel's Church, the Examiner project, the entrance to the Art Building project, a canal portal for the Fair, a "habitation" for the Fair, the Soldiers' and Sailors' Monument project, three projected row houses on Lake Shore Drive for Messrs. Turner, Potter, and Armour, and several studies for the Cincinnati Chamber of Commerce project.

In 1970, E. S. Fetcher, a grandson of John Root, donated to the library sketches for the Goudy house, the project which seems connected with the Examiner Building, the Cincinnati Chamber of Commerce project, and a different canal portal for the Fair. Mr. Fetcher retains the study for the west front of the Art Building project and an elevation for the Charles Needham house in Chicago.

Thus, in relation to the entire body of John Root's architecture, the archival material is very limited. But illuminating facts have a way of turning up almost anywhere. Much basic information can be found in the various city directories and in local newspapers, such as the *Constitution* in Atlanta; the *Daily News*, *Evening Journal*, *Herald*, *Inter Ocean*, *Times*, and *Tribune* in Chicago; the *Plain Dealer* in Cleveland; the *Star* in Kansas City; the *Chronicle* and the *Examiner* in San Francisco; and the *Daily Ledger* in Tacoma.

The periodicals intended for general readership, such as *Atlantic Monthly*, *Century*, *Graphic* (Chicago), *Harper's Monthly*, *Harper's Weekly*, *Lippincott's*, and *Scribner's Magazine*, are also helpful, particularly in defining the attitudes of the time.

Most important are the specialized journals, ephemeral as they may have been. In architecture, *American Architect*, *Architect* (London), *Architectural Record*, *Architectural Review* (Boston), *Architecture*, *Architecture and Building*, *Brickbuilder*, *Building Budget*, *California Architect and Building News*, *Illinois Society of Architects Bulletin*, *Inland Architect*, *Ornamental Iron* (Chicago), and *Western Architect*. In real estate, the *Economist*, *Land Owner*, and *Real Estate and Building Journal*, all of Chicago. And in engineering, *Engineering* (London), *Engineering and Building Record*, *Engineering Magazine*, *Engineering News*, *Engineering News-Record*, *Engineering Record*, *Railroad Gazette*, and the *Sanitary Engineer*.

In addition to the sources cited in footnotes to the text, the following books, articles, pamphlets, and unpublished studies have been found of value or, at least, of related interest.

Root, Burnham, and the Burnham Office

The Architectural Work of Graham, Anderson, Probst & White and Their Predecessors.
2 vols. London: privately printed, 1933.

Biographical Catalogue of the Chancellors, Professors and Graduates of the Department of Arts and Sciences of the University of the City of New York. New York, 1894.

[Gilbert, Cass *et al.*]. "An Appreciation of Daniel H. Burnham." *Architectural Record*, XXXII (1912), 175–185.

"In Memoriam: John Wellborn Root." Chicago Literary Club, 1891.

"John Wellborn Root." *American Society Legion of Honor Magazine*, XXIII (1952), 139–152.

"John W. Root at Rest." *Inter Ocean*, XIX (16 Jan. 1891), 6.

McNally, Alexander C. "Burnham and Root, Architects." Senior thesis, Princeton University, 1956.

Monroe, Harriet. *A Poet's Life*. New York, 1938.

Ninth Annual Report of the Oxford Delegacy of Local Examinations. Oxford, 1866.

"Our Illustrious Dead." *Elite News* (Chicago), 24 Jan. 1891.

Rebori, A. N. "The Work of Burnham & Root, D. H. Burnham, D. H. Burnham & Co., and Graham, Burnham & Co." *Architectural Record*, XXXVIII (1915), 32–168.

Robertson, Thomas Burns. "John Wellborn Root, Architect." M. A. thesis, Institute of Fine Arts, New York University, 1942.

Starrett, Theodore. "John Wellborn Root." *Architecture and Building*, XLIV (1912), 429–431.

Guidebooks, Surveys, and Histories of Chicago

Andreas, A. T. *History of Chicago*. 3 vols. Chicago, 1884–1886.

Andrews, Wayne. *Architecture in Chicago and Mid-America*. New York, 1968.

Chicago of To-Day, the Metropolis of the West. Chicago, 1891.

Chicago's Famous Buildings. Ed. Arthur Siegel. Chicago, 1965.

Chicago's First Half Century. Chicago, 1883.

Commercial and Architectural Chicago. Chicago, 1887.

Flinn, John J. *Chicago, the Marvelous City of the West*. Chicago, 1891.

Guide to Chicago & Midwestern Architecture. Chicago, 1963.

Historic American Buildings Survey, Chicago and Nearby Illinois Areas. Ed. J. William Rudd. Park Forest, Ill., 1966.

Jones, John H., and Britten, Fred A. *A Half Century of Chicago Building*. Chicago, 1910.

Kirkland, Joseph, and Kirkland, Caroline. *The Story of Chicago*. 2 vols. Chicago, 1892–1894.

Maehl, William Henry, Jr. "Report of Survey of Aldis & Company Records, 1879–1920." Unpublished MS, 1957.

Marquis' Hand-Book of Chicago. Chicago, 1887.

Picturesque Chicago and Guide to the World's Fair. Hartford, Conn. [1893?].

Prominent Men of the Great West. Chicago, 1894.

Ralph, Julian. *Harper's Chicago and the World's Fair*. New York, 1893.

Rand, McNally & Co.'s Handy Guide to Chicago. Chicago, 1893.

Randall, John D. *A Guide to Significant Chicago Architecture of 1872 to 1922*. Glencoe, Ill.: privately printed, 1958.

Schick, L. *Chicago and Its Environs*. Chicago, 1891.

Seeger, Eugen. *Chicago, the Wonder City*. Chicago, 1893.

Sheahan, James W., and Upton, George P. *Chicago: Its Past, Present and Future*. Chicago, 1871.

Tallmadge, Thomas E. *Architecture in Old Chicago*. Chicago, 1941.

Taylor, J. W. *View Album of Chicago*. Columbus, Ohio, 1893.

Tyson, Russell. "History of Aldis & Company." Unpublished MS, 1944.

Webster, J. Carson. *Architecture of Chicago and Vicinity*. Philadelphia, 1965.

Aspects of the Office Building

Banham, Reyner. *The Architecture of the Well-Tempered Environment*. Chicago and London, 1969.

Birkmire, William H. *Skeleton Construction in Buildings*. New York, 1893.

Collection of Photographs of "Ornamental Iron" Executed by The Winslow Bros. Co. Chicago, 1893.

Condit, Carl W. *American Building*. Chicago and London, 1968.

Ferree, Barr. "Structure and Material in High Design." *Brickbuilder*, III (1894), 43–45.

Morrison, Elizabeth Newman. "The Development of Skyscraper Style, 1874–1922." M.A. thesis, University of Chicago, 1931.

Peck, Ralph B. "History of Building Foundations in Chicago." *University of Illinois Bulletin*, XLV (1948), 1–64.

Prominent Buildings Erected by the George A. Fuller Company. New York, 1904.

Purdy, Corydon T. "Steel Foundations." *Engineering News*, XXVI (1891), 116–117.

Randall, Frank A. *History of the Development of Building Construction in Chicago*. Urbana, Ill., 1949.

Starrett, W. A. *Skyscrapers and the Men Who Build Them*. New York and London, 1928.

Twose, G. "Steel and Terra-Cotta Buildings in Chicago, and Some Deductions." *Brickbuilder*, III (1894), 1-5.

Webster, J. Carson. "The Skyscraper: Logical and Historical Considerations." *JSAH*, XVIII (1959), 126–139.

Weisman, Winston. "Commercial Palaces of New York: 1845–1875." *Art Bulletin*, XXXVI (1954), 285–302.

————. "New York and the Problem of the First Skyscraper." *JSAH*, XII (1953), 13–21.

————. "Philadelphia Functionalism and Sullivan." *JSAH*, XX (1961), 3–19.

The World's Columbian Exposition

Architecture in America: A Battle of Styles. Ed. William A. Coles and Henry Hope Reed, Jr. New York, 1961.

Arnold, C. D., and Higinbotham, H. D. *Official Views of the World's Columbian Exposition.* Chicago, 1893.

Crook, David Heathcote. "Louis Sullivan, The World's Columbian Exposition and American Life." Ph.D. diss., Harvard University, 1963.

————. "Louis Sullivan and the Golden Doorway." *JSAH*, XXVI (1967), 250–258.

Dedicatory and Opening Ceremonies of the World's Columbian Exposition. Chicago, 1893.

Glimpses of the World's Fair. Chicago, 1893.

Karlowicz, Titus M. "The Architecture of the World's Columbian Exposition." Ph.D. diss., Northwestern University, 1965.

————. "D. H. Burnham's Role in the Selection of Architects for the World's Columbian Exposition." *JSAH*, XXIX (1970), 247–254.

Peterson, Jon Alvah. "The Origins of the Comprehensive City Planning Ideal in the United States, 1840–1911." Ph.D. diss., Harvard University, 1967.

Photographs of the World's Fair. Chicago, 1893.

Report of the President to the Board of Directors of the World's Columbian Exposition. Chicago, 1898.

Tallmadge, Thomas E. "Daniel Hudson Burnham and the World's Columbian Exposition of 1893." *Building for the Future* (May 1933).

Truman, Ben C. *History of the World's Fair.* [Chicago], 1893.

Walton, William. *Art and Architecture, World's Columbian Exposition.* 3 vols. Philadelphia, 1893–1895.

Nineteenth-Century Theory and Tendencies

Adams, Richard P. "Architecture and the Romantic Tradition: Coleridge to Wright." *American Quarterly*, IX (1957), 46–62.

Arnheim, Rudolf. "From Function to Expression." *Journal of Aesthetics and Art Criticism*, XXIII (1964), 29–41.

Aslin, Elizabeth. *The Aesthetic Movement.* New York, 1969.

Bentley, Nicolas. *The Victorian Scene: 1837–1901.* London, 1968.

Bing, Samuel. *Artistic America, Tiffany Glass, and Art Nouveau.* Ed. Robert Koch. Cambridge, Mass., 1970.

Brown, Robert F. *The Architecture of Henry Hobson Richardson in North Easton Massachusetts.* North Easton, 1969.

Brown, Theodore M. "Greenough, Paine, Emerson and the Organic Esthetic." *Journal of Aesthetics and Art Criticism*, XIV (1956), 304–317.

Bunting, Bainbridge. *Houses of Boston's Back Bay*. Cambridge, Mass., 1967.

Burnham, Daniel H., and Bennett, Edward H. *Plan of Chicago*. Ed. Charles Moore. Chicago, 1909.

Bush-Brown, Albert. *Louis Sullivan*. New York, 1960.

Carrott, Richard. "The Egyptian Revival: Its Sources, Monuments, and Meaning, 1808–1858." Ph.D. diss., Yale University, 1961.

Collins, Peter. *Changing Ideals in Modern Architecture*. Montreal, 1967.

Connely, Willard. *Louis Sullivan As He Lived*. New York, 1960.

Cortissoz, Royal. *Art and Common Sense*. New York, 1913.

————. "Charles F. McKim." *Scribner's Magazine*, XLVII (1910), 125–128.

————. *The Painter's Craft*. New York, 1930.

De Zurko, Edward Robert. *Origins of Functionalist Theory*. New York, 1957.

Dickason, David Howard. *The Daring Young Men*. Bloomington, Ind., 1953.

Downing, Antoinette F., and Scully, Vincent J., Jr. *The Architectural Heritage of Newport Rhode Island*. 2nd rev. ed. New York, 1967.

Early, James. *Romanticism and American Architecture*. New York, 1965.

Egbert, Donald Drew. "The Idea of Organic Expression and American Architecture." In *Evolutionary Thought in America*, ed. Stow Persons, New Haven, 1950. pp. 336–396.

————, and Sprague, Paul E. "In Search of John Edelmann, Architect and Anarchist." *A.I.A. Journal*, XLV (1966), 35–41.

Elmslie, George Grant. *Chicago School of Architecture: Its Inheritance and Bequest*. Pamphlet, 1939.

Elstein, Rochelle S. "The Architectural Style of Dankmar Adler." M.A. thesis, University of Chicago, 1963.

————. "The Architecture of Dankmar Adler." *JSAH*, XXVI (1967), 242–249.

Forbes, J. D. "Shepley, Bulfinch, Richardson & Abbott, Architects; An Introduction." *JSAH*, XVII (1958), 19–31.

Giedion, Sigfried. *Space, Time and Architecture*. 4th rev. ed. Cambridge, Mass., 1963.

Gloag, John. *Victorian Taste*. New York, 1962.

Greenough, Horatio. *Form and Function*. Ed. Harold A. Small. Berkeley, 1958.

Hitchcock, Henry-Russell. "Art of the United States: Architecture." In *Encyclopedia of World Art*, I,246–277. New York, 1959.

————. *Early Victorian Architecture in Britain*. 2 vols. New Haven, 1954.

————. "Frank Lloyd Wright and the 'Academic Tradition' of the Early Eighteen-Nineties." *Journal of the Warburg and Courtauld Institutes*, VII (1944), 46–63.

————. *In the Nature of Materials*. New York, 1942.

————. *Modern Architecture*. New York, 1929.

————. "Ruskin and American Architecture, or Regeneration Long Delayed." In *Concerning Architecture*, pp. 166–208. London, 1968.

———— et al. *The Rise of an American Architecture*. Ed. Edgar Kaufmann, Jr. New York, 1970.

Jordy, William H. "The Commercial Style and the 'Chicago School.' " In *Perspectives in American History*, I, 390–400. Cambridge, Mass., 1967.

Kimball, Fiske. *American Architecture*. Indianapolis and New York, 1928.

The Literature of Architecture. Ed. Don Gifford. New York, 1966.

Louis Sullivan and the Architecture of Free Enterprise. Ed. Edgar Kaufmann, Jr. Chicago, 1956.

McKenna, George L. "Horatio Greenough's Washington, A Study in Greenough's Theory and Practice." M.A. thesis, Wayne University, 1951.

McKenna, Rosalie Thorne. "James Renwick, Jr., and the Second Empire Style in the United States." *Magazine of Art*, XLIV (1951), 97–101.

Manson, Grant Carpenter. *Frank Lloyd Wright to 1910*. New York, 1958.

Mast, Alan. "American Architecture and the Academic Reform, 1876–1893." M.A. thesis, University of Chicago, 1961.

Meeks, Carroll L. V. "Romanesque Before Richardson in the United States." *Art Bulletin*, XXXV (1953), 17–33.

Metzger, Charles Reid. *Emerson and Greenough*. Berkeley, 1954.

A Monograph of the Work of McKim, Mead & White, 1879–1915. 4 vols. New York, 1915.

Mumford, Lewis. *The Brown Decades*. 2nd rev. ed. New York, 1955.

————. *The South in Architecture*. New York, 1941.

————. *Sticks and Stones*. 2nd rev. ed. New York, 1955.

Omoto, Sadayoshi. "The Queen Anne Style and Architectural Criticism." *JSAH*, XXIII (1964), 29–37.

Paul, Sherman. *Louis Sullivan*. Englewood Cliffs, N. J., 1962.

Peisch, Mark L. *The Chicago School of Architecture*. New York, 1964.

Pevsner, Nikolaus. *Ruskin and Viollet-le-Duc*. London, 1969.

————. *The Sources of Modern Architecture and Design*. New York and London, 1968.

Reilly, C. H. *McKim, Mead & White*. New York, 1924.

Rensselaer, Mrs. Schuyler van. *Henry Hobson Richardson and His Works*. Boston and New York, 1888.

Roots of Contemporary American Architecture. Ed. Lewis Mumford. New York, 1952.

Schuyler, Montgomery. *American Architecture and Other Writings*. Ed. William H. Jordy and Ralph Coe. 2 vols. Cambridge, Mass., 1961.

Scully, Vincent J., Jr. *Modern Architecture*. New York, 1961.

————. *The Shingle Style*. New Haven, 1955.

Stanton, Phoebe B. *The Gothic Revival & American Church Architecture*. Baltimore, 1968.

Stein, Roger B. *John Ruskin and Aesthetic Thought in America, 1840–1900*. Cambridge, Mass., 1967.

Summerson, John. *Heavenly Mansions*. New York, 1963.

————. *Victorian Architecture*. New York, 1970.

Tallmadge, Thomas E. *The Story of Architecture in America*. New York, 1936.

Turak, Theodore. "The École Centrale and Modern Architecture: The Education of William Le Baron Jenney." *JSAH*, XXIX (1970), 40–47.

Van Brunt, Henry. *Architecture and Society*. Ed. William A. Coles. Cambridge, Mass., 1969.

Whitaker, Charles Harris. *Rameses to Rockefeller*. New York, 1934.

Winter, Robert W. "Fergusson and Garbett in American Architectural Theory." *JSAH*, XVII (1958), 25–30.

Wright, Frank Lloyd. *An Autobiography*. 2nd rev. ed. New York, 1943.

————. *On Architecture*. Ed. Frederick Gutheim. New York, 1941.

————. *A Testament*. New York, 1957.

Wright, Nathalia. *Horatio Greenough*. Philadelphia, 1963.

Wynne, Nancy, and Newhall, Beaumont. "Horatio Greenough: Herald of Functionalism." *Magazine of Art*, XXXII (1939), 12–15.

Miscellaneous

Hungerford, Edward. *Men and Iron: The History of the New York Central*. New York, 1938.

Peixotto, Ernest C. "Architecture in San Francisco." *Overland Monthly*, 2nd ser., XXI (May 1893), 449–463.

Rudd, J. William. "The Cincinnati Chamber of Commerce Building." *JSAH*, XXVII (1968), 115–123.

Scott, Mel. *The San Francisco Bay Area*. Berkeley, 1959.

Wight, P. B. "A Portrait Gallery of Chicago Architects—IV, Asher Carter." *Western Architect*, XXXIV (1925), 10–13.

INDEX

National Bank of Illinois, Chicago, *22*
National Commission, Fair of 1893, 226, 228, 230
National Guard, 142n
Needham, Charles, house, Chicago, 114n, 249
Nelson, H. L., 89n
New Path, 9
New York Evening Post Building, 155n
New York Life Insurance Building, Kansas City, Mo. (McKim, Mead & White), 232
New York University, 4
New York World Building (George B. Post), 231
Nixon, W. K., 41, 43, 146, 219
"Norman" style, 5, 28
North Easton, Mass., 95
Northern Pacific Railroad, 146
Northwestern Architect (Minneapolis), 94

Obelisk, Fair of 1893, 221, 229
Olmsted, Frederick Law, 192, 223–231
Olmsted, Frederick Law, Jr., 225n
Omoto, Sadayoshi, 23n
Oriel Chambers, Liverpool (Peter Ellis, Jr.), 4
Oriels, 55, 83, 98, 100, 103, 107, 117, 150, 154, 160n, 161, 165, 166, 184, 185, 206, 219
Our Lady of Lourdes Church, New York, 6n
Owings Building, Chicago (Cobb & Frost), 45n, 204n
Oxford University, 4

Pacific National Bank Building, Tacoma, Wash., 148, 150
Palazzo Strozzi, 94
Palmer, Potter, 234, 235
Panic of 1873, 12
Papyrus forms, 166, 167, *174*, 176
Paris Universal Exposition of 1889, 222, 225, 226, 228, 229, 236, *238–239*
"Parmelee Building," Cleveland, 218n
Parthenon, 220, 245
Peabody, Robert S., 229, 231, 233
Peabody & Stearns, Boston, 90, 103, 231
Peck, Ferdinand, 130n, 234, 235
Peoples Gas, Light & Coke Building, Chicago (D. H. Burnham & Co.), 69n
Peristyle, Fair of 1893 (C. B. Atwood), 221, 228, *239*
Pevsner, Nikolaus, 158n
Phenix Building, Chicago, 54, 55, *61–63*, 64, 98, 103, 219n, 248
Phenix Insurance Company of Brooklyn, 55
Philadelphia, 14, 15, 142
Pickands, James, 218
Pickwick Flats, Chicago, 98, 99, *101*
Pike, Eugene, 150, 223
Piranesi, 83, 88
Plan of Chicago (Burnham and Bennett), 90n

Plans and Details of the Alhambra (Owen Jones), 68
Pond, Irving K., 12, 69n, 90, 91, 93, 94, 158, 163
Pont de Jena, Paris, 228
Pontiac Building, Chicago (Holabird & Roche), 165
Portland Block, Chicago (W. L. B. Jenney), 19, 23
Post, George B., 103, 144n, 228, 231, 233, 235
Potter Palmer Building, Chicago, 179
Prairie School, 97
Pre-Raphaelite Movement, 9
Pretyman, William, 126, 180, 235
Price, Bruce, 182
Price, Charles, 95n
Probst, Edward, 182n
Produce Exchange Building, New York (George B. Post), 231
Pullman, George, 89
Pullman, Ill., 89, 90, 230
Purdy, Corydon T., 86, 96, 194n

"Quamquisset" Building (Monadnock Block), 156, 158
Queen Anne revival, 17, 23, 32, 35, 48, 160n, 202, 231

Railroad station, Fair of 1893 (C. B. Atwood), 221, 229
Railroad station architecture, 32
Ralph, Julian, 85
Rand-McNally Building, Chicago, 132, 133, *134–136*, 137, 150
Real Estate and Building Journal (Chicago), 181
Real estate values, 85, 106, 156, 159, 160, 177, 178, 180, 194, 196
Ream, Norman, 100, 193
Ream warehouse, Chicago, 100
Reed's Temple of Music, Chicago, 6, 12
Reliance Building, Chicago, 146, 177–185, *186–191*, 248
Rensselaer, Mrs. Schuyler van, 222, 223
Renwick, James, Jr., 5, 8
Renwick & Sands, 5, 8
Revell Building, Chicago (Adler & Sullivan), 181
Rialto Building, Chicago, 41, *42*, 43, 69, 98, 178
Richardson, H. H., 17, 32, 38, 39, 41, 43, 47, 48, 49, 67, 68, 87, 94, 95, 99, 117, 132, 157, 158, 207, 223n, 233, 236, 244
Ricker, N. Clifford, 4n, 94
Roche, Martin, 16, 90
Romanesque motifs, 17, 45, 49, 67, 68, 94–95, 103, 107, 117, 138, 149, 158n, 206, 207, 232, 233, 236
Roman style, 236

THE JOHNS HOPKINS UNIVERSITY PRESS

This book was composed in Aldine Roman text and Bookman display type
by Jones Composition Company from a design by Victoria Dudley.
It was printed by The Murray Printing Company on Lindenmeyr's 60-lb.
Decision Offset paper, in a white shade, smooth finish and bound
by Moore and Company in Joanna Arrestox.

Library of Congress Cataloging in Publication Data

Hoffmann, Donald.
 The architecture of John Wellborn Root.

 (The Johns Hopkins studies in nineteenth-century
architecture)
 Bibliography: p.
 1. Root, John Wellborn, 1850-1891. I. Title.
II. Series.
NA737.R6H6 720'.92'4 72-4008
ISBN 0-8018-1371-9